The *Suffragettes*

IN PICTURES

DIANE ATKINSON

FOREWORD BY GLENDA JACKSON

SUTTON PUBLISHING

museum of
LONDON

First published in 1996 by
Sutton Publishing Limited · Phoenix Mill
Thrupp · Stroud · Gloucestershire · GL5 2BU

Museum of London
London Wall · London · EC2Y 5HN

British Library Cataloguing in Publication Data

A catalogue record for this book is available from the British Library

ISBN 0-7509-1017-8

ALAN SUTTON™ and SUTTON™ are the trademarks of Sutton Publishing Limited

Typeset in 11/16 Sabon.
Typesetting and origination by
Sutton Publishing Limited.
Printed in Great Britain by
Butler & Tanner, Frome, Somerset.

For Peggy Atkinson

CONTENTS

FOREWORD

Members of Parliament may select from the available Westminster archive pictures to hang on their Parliamentary office walls. Having at long last obtained an office, I enquired as to the images of women in politics I might view.

The archivist, with no small embarrassment, replied that with the exception of Nancy, Lady Astor and Margaret Thatcher, female representation was conspicuous by its absence but she responded with alacrity and great enthusiasm to my suggestion that approaches be made to other archives, as neither the first woman MP to take her seat nor this country's first woman PM fitted my particular bill.

My office walls are now graced by three great posters – 'The Cat and Mouse Act', 'What a Woman may be and yet NOT have the Vote', and 'Votes for Women' – all appearing in this book as they featured in its progenitor, The Museum of London's Suffragette exhibition, presented in 1993. I was privileged to open that exhibition at the kind invitation of its curator Diane Atkinson, who is also the creator of this book.

It is wonderful to see, gathered together again, such powerful, imaginative, varied and inspiring images, images consistently used by the Suffragette movement to argue the case and further the cause for female suffrage. They caught the eye, grabbed attention and used the minimum of words and indeed colours, but the words and the colours were urgent and strong. Votes For Women says it all.

Purple, green and white were not only powerful in themselves but their symbolic value, representing as they did nobility, purity and industry, made the case, without as many words as I am now having to employ. That these female virtues were deserving of recognition, and indeed a hearing in the political life of their country, and in such responsible hands, suggested that the franchise would be exercised with due seriousness. The colours were also used to transform an established, indeed establishment symbol, such as the House of

Commons' portcullis, from one synonymous with the defence of democratic freedoms into one of political oppression.

The campaign was organized, newspapers, leaflets, postcards, posters, banners produced, marches walked, rallies attended, windows smashed, pillar-boxes set alight by women wearing huge hats, long skirts, heeled boots, clutching umbrellas, hand-bags, bedecked with necklaces, earrings, flowers and frills. They were political radicals and reformers, dubbed by their enemies anarchists, communists, traitors, socialists, non-women, jailed for their activities, suffering the appalling process of force-feeding while in jail, yet still they looked like women. And they still managed their homes and families, and the thousands of working-class women who also had these domestic duties, plus long hours in factories, mills and laundries, also presented themselves as women, respectable, redoubtable, resilient and responsible. More than anything, ready for the right to vote.

The United Kingdom is still more than thirty years away from celebrating the centenary of universal female suffrage, we are still a very long way from real equality and nowhere is this more marked than in the ironically named Mother of Parliaments, where women MPs still number less than 10 per cent.

Women still work in appalling conditions for appalling pay. We are still having to struggle to break through the glass ceiling. Equal pay, despite Acts of Parliament is yet to be a reality. Equality of opportunity, of training and retraining are more apparent in the design than in the fact, but we have made progress and we continue to work, argue, reason, demand even, that positive changes in our society increase, not only for the benefit of women, but for the nation as a whole.

The women this book celebrates took the first step on the road towards equality. We must keep faith with their struggle and sacrifice, always exercising what they so hardly won for us.

Glenda Jackson
1996

ACKNOWLEDGEMENTS

The author and publishers wish to thank the following for their kind permission to reproduce illustrations and extracts: the Imperial War Museum; the Hulton Getty Picture Collection; the Mary Evans Picture Library; Hamish Hamilton Publishing. Extracts from *The Suffragette Movement* by Sylvia Pankhurst are reproduced by kind permission of Addison Wesley Longman.

Every effort has been made to trace the copyright holders of material used in this book. The author would be pleased to rectify any omissions in future editions.

Thanks are extended to colleagues in the Photographic Department and Picture Library at the Museum of London and also to Suzie Burt for her encouragement throughout the production of this book.

Unless otherwise stated, all the photographs in this book are from the Museum of London's Suffragette Fellowship Collection.

INTRODUCTION

The suffragette campaign made a huge impact on Edwardian society on many different levels, and shocked it into reappraising the role of women. Women proved their strength in fund-raising, propaganda, organization and publicity stunts. Behind it all lay hard work, and total commitment to the cause. They also proved they were brave, fearless and dedicated. By 1914 their message had spread far and wide; four years later the sex barrier had been breached, and by 1928 all women had achieved the vote.

The suffragettes were members of the Women's Social and Political Union (WSPU), an Edwardian women's suffrage organization. Founded in 1903 by the Pankhurst family, its approach was very different from the moderate and law-abiding National Union of Women's Suffrage Societies (NUWSS) led by Mrs Millicent Garrett Fawcett. Bursting on to the women's suffrage scene, its motto 'Deeds Not Words' informed and described the policies and tactics of its campaign and supporters, and because of their actions in 1906 the *Daily Mail* gave them the name the 'Suffragettes'. The motto, and its execution, was a deliberate distancing from Mrs Fawcett's suffragists who had been active since the 1860s. They had campaigned peacefully, lobbying for support from MPs, and holding garden-party and drawing-room meetings. But forty years of this approach had not persuaded many politicians to take the demand seriously, mostly treating the issue with ridicule whenever it was raised in Parliament.

Although the NUWSS is quite accurately described as moderate, and the WSPU as militant, it did not mean that women could not join both organizations if they so wished. Many women did, not finding it incompatible to be identified with both organizations and their respective styles of campaigning. Mrs Fawcett's suffragists went on suffragette marches and processions, and vice versa. It was not until two or three years before the outbreak of the First World War in 1914, that growing numbers of women resigned their WSPU membership, unhappy about the suffragettes' escalating militancy, nationwide arson attacks, the slashing of works of art and outrageous acts of vandalism. Sometimes newspapers, and even suffragette newspapers, called them 'suffragist' when quite clearly the action

being reported was that of militant activism. This can be puzzling, but we should not attach too much importance to this terminology. If it is a militant act then we can assume that the woman or women involved were suffragettes.

While their tactics were different, the aims of the two organizations were the same: 'to secure for women the Parliamentary vote as it is, or may be, granted to men; to use the power thus obtained to establish the quality of rights and opportunities between the sexes; to promote the social and industrial well-being of the community'. Not all men had the vote: by the turn of the century, 7 million men, that is two-thirds of all adult men in England and Wales, could vote in Parliamentary elections. Large numbers of working-class men, like all women, were unenfranchised.

The growth of nineteenth-century Parliamentary democracy had been achieved in the three Reform Acts of 1832, 1867 and 1884. The first Reform Act of 1832 gave the vote to half a million more men, adding middle-class men to the already enfranchised landowners. After 1832 one-fifth of all men would vote. But this Act now excluded women specifically. By using the term 'male person' for the first time, women were legally prevented from voting in Parliamentary elections.

In 1867 the second Reform Act gave the vote to about 2½ million male householders out of a total population of 22 million. The MP for Westminster, John Stuart Mill, made the first plea for women's suffrage in Parliament. Emmeline Pankhurst's husband, Dr Richard Pankhurst, in an electioneering speech, gave many examples of women voting in the past, in particular during the Middle Ages. But no progress was then made on votes for women.

The third Reform Act of 1884 enfranchised 5 million men, approximately two-thirds of the adult male population. For the first time large numbers of working men could vote. Those excluded were the poorest; servants who lived in the homes of their employers; criminals; and lunatics. Women were not included under the terms of the Act and thus joined the ranks of criminals and lunatics, a point both wings of the women's suffrage movement made repeatedly in argument and posters, postcards, leaflets, books and handbills.

Mindful of the Parliamentary legislation which had safeguarded the interests of men, the women's suffrage movement argued that women's lives would not improve until politicians were made accountable to a female electorate. The many legal, economic and educational inequalities which women faced would not be redressed until women had the vote. Women fought for the vote as a means to an

end. Emmeline Pankhurst described it: 'First of all it is a symbol, secondly a safeguard, and thirdly an instrument.' Put alongside the size of the existing electorate the women's claim was certainly conservative in its scope. They were prepared to accept, in the first stage at least, votes for about 1 million women. Other women would have to wait until later. The priority was to break the sex barrier. Once that was achieved their sisters would be enfranchised in stages.

It is true to say that by the turn of the century the number of people who wanted women to have the vote was a tiny minority of the population as a whole. The vast majority of British people were opposed to it in varying degrees. Politicians were the major obstacle to votes for women. Most wanted women to have the vote only if their party benefited: Conservative MPs generally believed in maintaining the *status quo*. They also feared that if women were enfranchised they would vote for the Liberals or for the new Labour Party. The Liberals in general believed that women should have the vote, but were also afraid that their opponents would benefit. While many Liberal MPs worked for women's suffrage, Asquith, the Liberal Prime Minister, and many of his senior Cabinet Ministers were die-hard opponents, and they ensured that no progress was made on the issue during the Edwardian campaign. The Labour Party, a new party founded in 1892 to represent the interests of working men, was afraid that unless all adults were given the vote, they would not benefit from any changes to the franchise. If property-owning women got the vote and not working-class women, they argued that the Conservative and Liberal Parties would gain an important advantage. Many in the Labour Party were committed to votes for everyone, but more believed that all men should have the vote first, and women afterwards.

Those, including women, who strongly opposed women's demand for the vote were known as 'Antis'. They had their own organization, the National League for Opposing Woman Suffrage (NLOWS), which was founded in 1908 in response to the high-profile suffragette campaign. Well-known women like Mrs Humphrey Ward, the bestselling novelist and campaigner for women's education, were violently opposed to women's suffrage. The 'Antis' held a range of views which the suffragettes lampooned as so old-fashioned as to be positively antediluvian. They believed women would be corrupted by politics and chivalry would die; that if women became involved in politics they would stop marrying and the British race would die out; that women's brains were smaller than men's, making them less intelligent; that women were emotional

creatures and thus incapable of making a sound and reasoned political decision. These ideas are laughable now, but at the time were taken seriously by a wide cross-section of women as well as men. However, while in each of the three political parties there *were* supporters of women's suffrage, their numbers were small, and sometimes promises of support were empty gestures.

The WSPU's first headquarters was the Pankhurst family home in Nelson Street, Manchester. For three years they did valuable propaganda work in the cotton towns of the north of England. Dinner-hour meetings at factory and mill gates and door-to-door canvassing recruited working women's support for the cause. A dressmaker's apprentice from Bolton remembered: 'It was a wonderful experience, like putting a match to a ready-built fire. . . . There was a unity of purpose in the suffrage movement which made social distinction seem of little importance.'

For the women's suffrage movement 1906 was an important year. The Liberal Party had won a landslide victory in the 1905 General Election, and moderate and militant campaigners alike were optimistic about the prospects of women's enfranchisement; there was real hope that new ideals and policies would emerge. In the autumn of that year (1906) the WSPU moved its headquarters to No. 4 Clement's Inn, The Strand, London. Three years of campaigning and the earliest episodes of militant action had demonstrated to the Pankhurst family the need to relocate the nerve centre of their operations to the capital, to be near the Houses of Parliament, the 'mother' of democracy; to be near Fleet Street, the heart of the newspaper industry, for maximum publicity for the cause; and to be near the Law Courts in The Strand, where many of their anticipated legal contests with the Government would be waged. The nation had to be 'roused' to take an interest in votes for women, and this could be best spearheaded in London. This is not to say that towns and cities in the provinces played no part in the suffragette campaign. They did, and a number of the images in this book bear witness to this work. Suffragettes all over the country were campaigning against the Liberal Party at by-elections and the two General Elections of 1910, hosting large set-piece demonstrations and rallies, often having their own committee rooms and shops selling a range of their purple, white and green 'Votes For Women' merchandise. Suffragettes from all over the country came to London to take part in deputations to Parliament and rallies and processions to venues such as the Royal Albert Hall, the Queen's Hall and Hyde Park.

In the spring of 1908 the WSPU launched the purple, white and green colour scheme with which it would become identified. Their treasurer, Mrs Pethick-Lawrence, announced that suffragettes should wear these three colours at all times so that the public would instantly recognize them and the cause for which they fought. Purple, she said, was the colour of dignity, white represented purity and green was the symbol for fertility and hope for the future. Suffragettes were to be the living embodiment of the values behind this unusual colour scheme.

The suffragettes' tactics of taking their campaign to the streets, and insisting on being noticed and identified in this way in the public domain, was highly contentious. At this time most Edwardians subscribed to the ideology of the 'two spheres', a late eighteenth-century belief that God had ordained that a woman's place was in the home, the private sphere; and that the public domain was the world of men, work and politics. Women were called 'angels of the hearth', they were moral guardians of the family, they nurtured husbands and children and any other family members who needed caring for. This made the highly visible public presence of the suffragettes in the public domain an affront to many who regarded it as almost a blasphemy against God's plan. For some the sight of suffragettes in purple, white and green, carrying banners was beyond the pale.

The suffragettes' increasingly militant tactics earned them many enemies and put them at personal risk; and their campaign of arson, window-smashing, bombing and widespread vandalism alienated public opinion. Much of the sympathy and outrage at the Government's practices of force-feeding evaporated when newspaper headlines told of suffragette terrorism. The British public felt that the suffragettes brought all the punishments upon themselves, while the Government did not want to be seen to give into extremism.

Damage which ran into hundreds of thousands of pounds ensured that the Government maintained its entrenched 'no compromise' position. Also, the Liberals had other issues to deal with: the question of Home Rule for Ireland; major industrial disputes; a struggle with the House of Lords. Certain members of the Government were seriously afraid of widespread unrest, and revolution. In this context, Asquith dismissed the suffragettes, erroneously as it proved, as a smaller problem.

However, it is important to remember that the NUWSS and WSPU were not the only organizations which demanded the vote. It is true that they probably represented the largest numbers of women, and were the most visible, but they

worked alongside a variety of other groups which included the Friends' League for Women's Suffrage; the Conservative and Unionist Women's Franchise Association; the Artists' Suffrage League; the Men's League for Women's Suffrage; the Women's Freedom League; the Gymnastic Teachers' Suffrage Society; the Women Writers' Suffrage League; the Actresses' Franchise League; the Scottish University Women's Suffrage Union; the Church League for Women's Suffrage; the Peoples' Suffrage Federation; the Men's Political Union for Women's Enfranchisement; the Women's Tax Resistance League; the Catholic Women's Suffrage Society; the Irish Women's Suffrage Federation; the Civil Service Woman Suffrage Society; the Women Teachers' Franchise Union; the Forward Cymric Suffrage Union; and the Jewish League for Woman Suffrage.

During the eleven hectic years of the suffragette campaign which only halted at the outbreak of the First World War, thousands of women went to prison for their involvement in the WSPU's daring, dangerous and clever campaign. Many of them were sent to prison for quite trivial offences. Fewer for the serious convictions ranging from breaking a window, or setting fire to letters in pillar-boxes, to arson attacks on (empty) private houses and churches and attacking works of art and museum displays. Very few suffragette prisoners were given the political status in prison they demanded, and which would have given them certain privileges, which had been fought for and won by male political prisoners during the nineteenth century. Consequently, they went on hunger strike in protest, refusing all food until privileges were granted. Many suffragettes were force fed, three times a day, for days and weeks at a time. This was undertaken by prison doctors under instructions from the Liberal government, who were afraid that the women would starve to death and become martyrs for the cause.

The motivation to join the WSPU derived from a real sense of grievance at the many inequalities between men's and women's lives, a worship of the heroines of the organization, and the excitement and daring the campaign offered to women, bored by a role-bound lady-like domestic life. Suffragettes were attracted by the camaraderie, and sense of purpose, even notoriety, membership of this bold and often 'unlady-like' campaign gave. This book describes some of the experiences of some of the women who risked family disapproval, unemployment, poverty, physical assaults, prison and death, for their contribution to the fight for votes for women.

DEEDS NOT WORDS

The Foundation of the
Suffragette Campaign

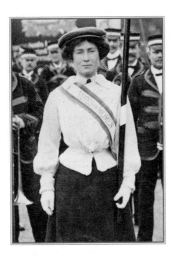

The images portrayed in the photographs in this chapter are shadows of some of the personalities and events of the suffragette movement of the early twentieth century, shadows cast by the glare of publicity in which the women found themselves, and into which they sometimes very purposefully threw themselves as they embarked on their campaign.

The leaders of the campaign, in particular Emmeline and Christabel Pankhurst, were at times accused of being autocratic, and their actions and pronouncements even undemocratic, alienating not only themselves but other members and sympathizers of the movement. But their style was uncompromising; they led from the front and would brook no criticism of their policies and methods. In her memoir of 1914, Emmeline Pankhurst was unapologetic:

There was little formality about joining the Union. Any woman could become a member by paying a shilling, but at the same time she was required to sign a declaration of loyal adherence to our policy. . . . Autocratic? Quite so. But, you may object, a suffrage organization ought to be democratic. Well the members of the WSPU [Women's Social and Political Union] do not agree with you. We do not believe in the effectiveness of the ordinary suffrage organization. The WSPU is not hampered by a complexity of rules. We have no constitution and by-laws; nothing to be amended or tinkered with or quarrelled over at annual meetings. . . . The WSPU is simply a suffrage army

in the field . . . no one is obliged to remain in it. Indeed we don't want anybody to remain in it who does not ardently believe in the policy of the army.

But for most WSPU members their leaders were inspiring and wonderful role models: how else could they have recruited so many women from varied backgrounds into a campaign which, according to public opinion across the country, was unpopular?

The rhetoric of the movement used strong religio-militaristic imagery. Joan of Arc, who was canonized in 1909, was its patron saint. The WSPU leaders portrayed the fight for the vote as a holy crusade for women's freedom: they called each other comrades and holy warriors; their campaign fund was the 'War Chest'. It was a language which was attractive to many.

As evidenced by these photographs, we know most about the upper-class and middle-class suffragettes who appeared, fashionably dressed, on processions and at fund-raising exhibitions and bazaars. However, it would be wrong to assume that the comparatively small number of photographs of working-class suffragettes reflects a less strident level of commitment, motivation and involvement. It is more to do with the realities of working-class women's lives. Domestic duties and the need for many to take whatever work was available, in order to supplement the family budget, meant that little time was left for the kind of highly visible participation captured in these images. Apart from the constraints on their time and purse, unsympathetic and hostile husbands could make membership of the WSPU difficult or impossible. There were numbers of women from all backgrounds who had to keep their support for the suffragettes a secret from their families. They could not wear the colour scheme, or a badge, having to make do with carrying a WSPU token around in their pocket. There were instances of women losing their jobs when their employers found out that they were suffragettes, or were reported after being seen on a WSPU demonstration.

For security reasons the WSPU did not keep a membership roll, and so it is difficult to gain an accurate impression of a truly 'typical' suffragette. However, the subscription lists in its annual reports identified members' donations and their marital status. Frequently members were unmarried and surviving

photographs, of which this book contains a typical selection, show mostly young women. These young and middle-class women had money to spend, fewer domestic responsibilities, servants at home, and therefore the time to involve themselves wholeheartedly in the campaign which had the enormous appeal of being daring, stylish, highly visible and noble.

'It was in October, 1903, that I invited a number of women to my house in Nelson Street, Manchester, for purposes of organization. We voted to call our new society the Women's Social and Political Union, partly to emphasize its democracy, and partly to define its object as political rather than propagandist. We resolved to limit our membership exclusively to women, to keep ourselves absolutely free from any party affiliation, to be satisfied with nothing but action on our question. Deeds, not words, was to be our permanent motto.'

EMMELINE PANKHURST, MY OWN STORY, 1914, P. 38.

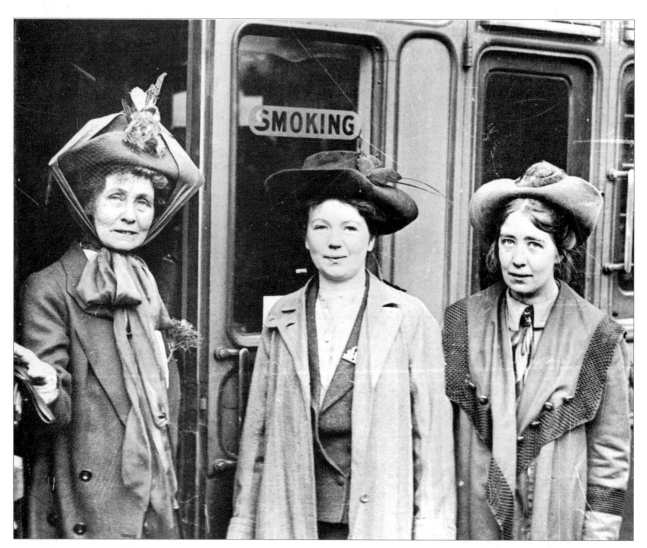

Christabel (centre) and Sylvia Pankhurst (right) with their mother, Emmeline, at Waterloo station, 4 October 1911. Emmeline was setting off for a lecture tour of the United States and Canada. Between 1869 and 1911 women in Wyoming (1869); Colorado (1893); Utah and Idaho (1896); and Washington and California had been enfranchised. Within two years of this visit Oregon, Kansas, Arizona and Alaska would give their women the vote.

'Our by-election work was such a new thing in English politics that we attracted an enormous amount of attention wherever we went. It was our custom to begin work the very hour we entered a town. If, on our way from the station to the hotel, we encountered a group of men, say in the market-place, we either stopped and held a meeting on the spot, or else we stayed long enough to tell them when and where our meetings were to be held, and to urge them to attend. The usual first step after securing lodgings was to hire a vacant shop, fill the windows with suffrage literature, and fling out our purple, white and green flag. Meanwhile, some of us were busy hiring the best available hall. If we got possession of the battle-ground before the men, we sometimes "cornered" all the good halls and left the candidate nothing but schoolhouses for his indoor meetings. Truth to tell, our meetings were so much more popular than theirs that we really needed the larger halls.'

EMMELINE PANKHURST, MY OWN STORY,
1914, P. 87.

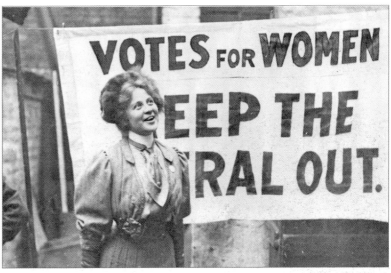

Gladice Keevil campaigning at the Manchester North West by-election, April 1908. The suffragettes were determined to defeat Winston Churchill, the Liberal MP for the constituency. He had recently been promoted to President of the Board of Trade and had to stand for re-election. He lost his Manchester seat to the Conservative candidate Joynson Hicks, but was quickly elected as MP for Dundee, a seat he would hold until 1922.

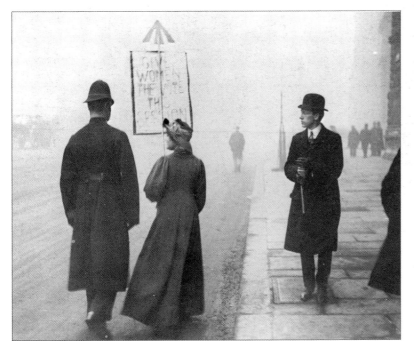

A suffragette demonstrating in Whitehall, c. 1908. The contemporary note, perhaps by a picture editor, on the reverse of this photograph reads: 'Personally conducted or is it a mild flirtation?' The arrow at the top of the placard indicates that this suffragette had been to prison for her involvement in the campaign. To avoid being arrested for obstruction she walks in the road and not on the pavement.

'The woman voter would be pernicious to the State not only because she could not back her vote by physical force, but also by reason of her intellectual defects.

'Woman's mind attends in appraising primarily to the mental images which it evokes, and only secondarily – and sometimes not at all – to what is predicated in the statement. It is over-influenced by individual instances; arrives at conclusions on incomplete evidence; has a very imperfect sense of proportion; accepts the congenial as true, and rejects the uncongenial as false; takes the imaginary which is desired for reality, and treats the undesired reality which is out of sight as non-existent – building up for itself in this way, when biased by predilections and aversions, a very unreal picture of the external world.'

SIR A. E. WRIGHT, THE UNEXPURGATED CASE
AGAINST WOMAN SUFFRAGE, 1913, PP. 35–6.

'You will have heard of the large amount of space devoted to Suffragette meetings by the local Press. The reports of the Newcastle Chronicle *have been particularly fair-minded and faithful. We have had our – I hope pardonable – smile at the spectacle of reporters breaking in upon us breathless as we sat at our supper to ask if it were true that so-and-so's meeting had been broken up. No, we hadn't heard of it. But if we had not, the reporter had; moreover, he was in no real doubt as to the truth of the rumour – all he wanted of us was the horrid details! Failing to get them at the Turk's Head he left us in further pursuit.*

'Hardly had he gone when the person who held the meeting in question appears as calm as a summer's day. "Well", we ask, anxiously, "what happened?" "Capital meeting" is the quiet reply. "Not broken up?" "What nonsense! They couldn't have behaved better." And still each night the reporters swarm – meekly taking down lists of meetings at street corners, at factory gates and town halls – all the while hungering so palpably for something to report in the way of a disaster, that one is very nearly corrupted into presenting them with a more or less dreadful fabrication. They have had to be content in these last days with the tragedy of Miss Una Dugdale's wicked stealing of a Liberal orator's audience. They have told a listening world how the unprincipled young lady left the gentleman haranguing his own agent, a small boy and a yellow dog.'

VOTES FOR WOMEN, 17 SEPTEMBER 1908, P. 452.

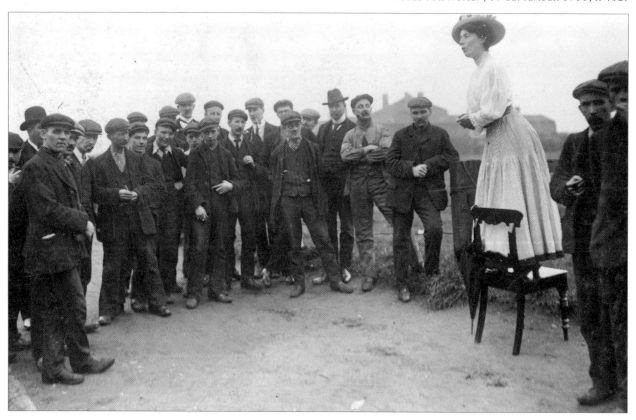

Una Dugdale addressing a small crowd of men while canvassing at the Newcastle by-election, September 1908. Her sisters Joan and Daisy (see p. 10) were also suffragettes. Una accompanied Mrs Pankhurst on both of her Scottish tours. In 1912 she married Victor Duval, founder and Honorary Secretary of the Men's Political Union for Women's Enfranchisement, causing a stir when she refused to repeat the word 'obey' in the marriage vows.

'The greatest suffragist demonstration held in the provinces took place yesterday afternoon in Heaton Park, when the fine weather tempted thousands to the neighbourhood of the circle of lurries which served as platforms for the speakers. A large number of special tramcars was put on all the routes to the Park, and the procession of crowded cars continued until well after four o'clock. From the thirteen platforms did these speakers urge "Votes for Women" to the thirteen separate crowds, the combined number of which were estimated by the police in attendance at 150,000.'

THE MANCHESTER COURIER CITED IN VOTES FOR WOMEN, 23 JULY 1908, P. 333.

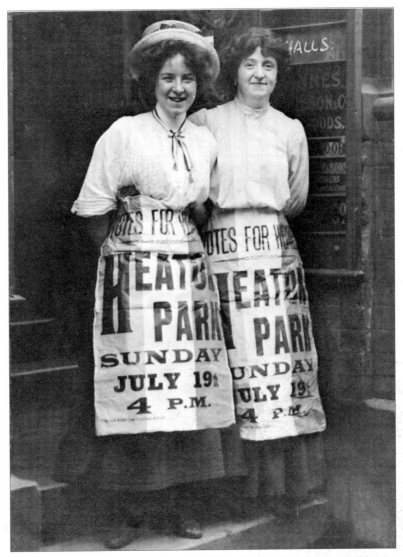

Mabel Capper (left) and Patricia Woodlock (right) advertising a 'monster' meeting to be held in Heaton Park, Manchester, on 19 July 1908. Mabel Capper, aged twenty, was a local woman, 'who had taken part in by-elections and had several amusing encounters with Cabinet Ministers.' By 1913 she had been to prison four times. Her friend Patricia Woodlock (see pp. 130–1) was a leading light of the WSPU's branch in Liverpool.

'The recruiting field for the militant suffragists is the million of our excess female population – that million which had better long ago have gone out to mate with its complement of men beyond the sea.

'Among them there are the following different types of women:– (a) First – let us put them first – come a class of women, who hold, with minds otherwise unwarped, that they may, whenever it is to their advantage, lawfully resort to physical violence. . . . (b) There file past next a class of women who have all their life-long been been strangers to joy, when women in whom instincts long suppressed have in the end broken into flame. These are the sexually embittered women in whom everything has turned into gall and bitterness of heart, and hatred of men. . . . (c) Next file past the incomplete. One side of their nature has undergone atrophy, with the result that they have lost touch with their living fellow men and women.'

SIR A.E. WRIGHT, *THE UNEXPURGATED CASE AGAINST WOMAN SUFFRAGE, 1913, p. 78.*

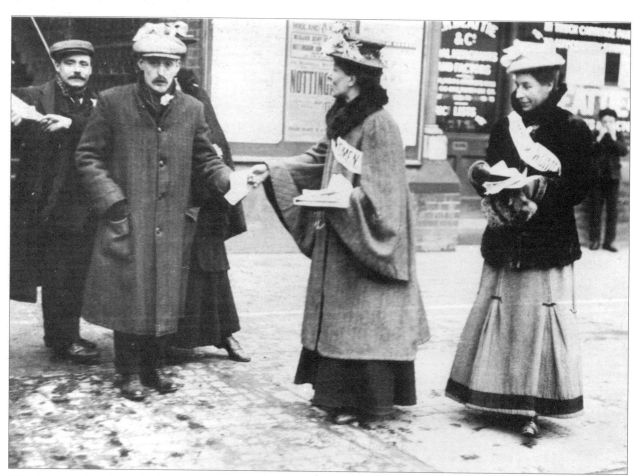

Minnie Baldock (left) and a Mrs Coombes (right) handing out suffragette propaganda in Nottingham, c. December 1907. Baldock was the organizer of the Canning Town branch of the WSPU. As a working woman and Poor Law Guardian she brought first-hand knowledge of the daily lives of working-class women.

'Members of the Union will never forget Clement's Inn, the scene of so many events in the militant campaign; but as they are always looking forward and not back, they will welcome the new home, not only for its beauty and suitability, but as an actual proof of the triumphant progress of the Union. Built with all the latest conveniences of a business house, Lincoln's Inn House was suggested as suitable for "an important Government office". It has a greater destination — it will be the headquarters not of a Government department, but of the greatest movement in the history of the world.'

VOTES FOR WOMEN, 20 SEPTEMBER 1912, P. 811.

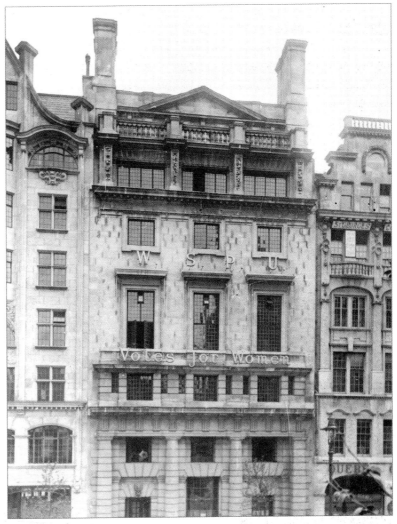

The WSPU's new London headquarters at Lincoln's Inn House, Kingsway, 1912. From the autumn of 1906 the WSPU's national headquarters had been at No. 4 Clement's Inn, The Strand, which was destroyed in the London Blitz. In 1912 Frederick and Emmeline Pethick-Lawrence, the WSPU's business managers and editors of the weekly newspaper *Votes for Women*, expressed concern at the escalating militancy and were expelled from the WSPU.

'We heartily urge all those who can do so to make a special effort to wear the uniform. It will consist of a short skirt of purple or green, a white jersey golf coat and a simple hat of purple or green. The regalia will be worn over the right shoulder and will be fastened under the left arm. In order to meet the convenience of our busy workers we have laid in a small stock of white golf coats which will be sold at the very reasonable price of seven shillings and six pence each and we shall also have the hats for two shillings each . . . the uniform will be worn again on 9 January [1909] when Mrs Pankhurst's carriage will be drawn through the streets by members of the Union in this dress. Those who wear the uniform will walk in front of Mrs Pankhurst's carriage, those who cannot will form a procession at the back of . . . [the] carriage and they will be asked to carry flags of the tricolour in order that this part of the procession may be as full of colour and interest as the rest.'

VOTES FOR WOMEN, 17 DECEMBER 1908, P. 194.

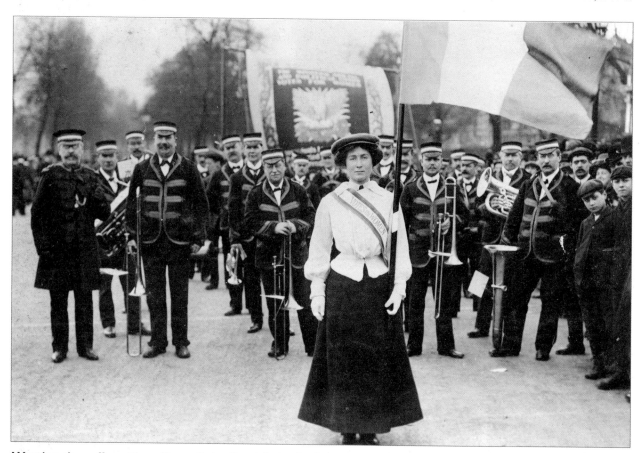

Wearing the suffragette uniform, Daisy Dugdale leads the procession to welcome Mrs Pankhurst and Christabel Pankhurst, 19 December 1908. The two women had been released early from Holloway Gaol. Brass bands and marching songs were a regular feature of suffragette demonstrations.

'She saturated her mind with politics. From the daily Press, assiduously studied as the first business of every day, from the memoirs and writings of prominent politicians, and the standard works on Parliament and the Constitution, she drew the material for her speeches. Street corner meetings heard from her a keen and ruthless analysis of the Government's latest proposals in home and foreign affairs, enlivened by saucy quips and scathing denunciation. . . . That she was slender, young, with the flawless colouring of a briar rose, and an easy grace cultivated by her enthusiastic practice of the dance, were delicious embellishments to the sterner features of her discourse. Yet the real secret of her attraction was her audacity, fluent in its assurance, confidently gay.'

SYLVIA PANKHURST, THE SUFFRAGETTE MOVEMENT, 1931, PP. 220–1.

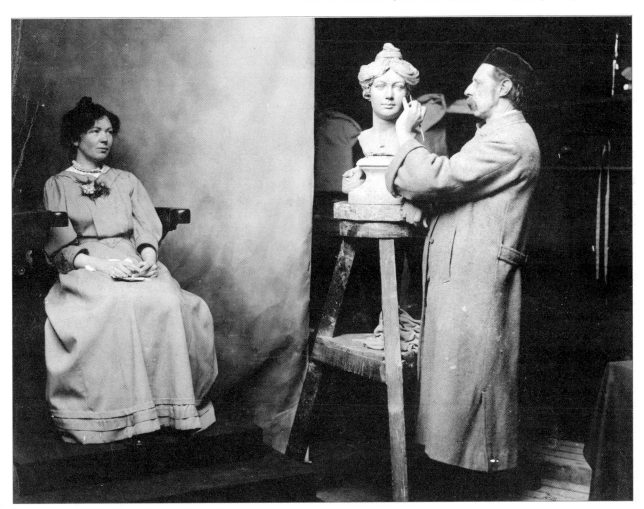

Christabel Pankhurst being modelled by Jean Tussaud, 1908. Even though their demand for the vote was not supported by a majority of the male electorate, it did not prevent Christabel Pankhurst, Annie Kenney and Emmeline Pethick-Lawrence from taking their place at Madame Tussaud's. Even at this relatively early stage in the campaign, this is one of the several indicators of their high public profile. Statuettes, photographic portraits, posters and badges of the leaders testified to their enormous popularity.

'The shop itself is a blaze of purple, white and green. . . . Just now the Woman's Press is showing some beautiful motor and other scarves in various shades of purple as well as white muslin summer blouses and among the almost unending variety of bags, belts, etc are the noticeable "The Emmeline" and "The Christabel" bags and "The Pethick" tobacco pouch. In addition to books, pamphlets and leaflets, stationery, games, blotters, playing cards and indeed almost everything that can be produced in purple, white or green, or a combination of all three is to be found here.'

VOTES FOR WOMEN, JULY 1910, P. 651.

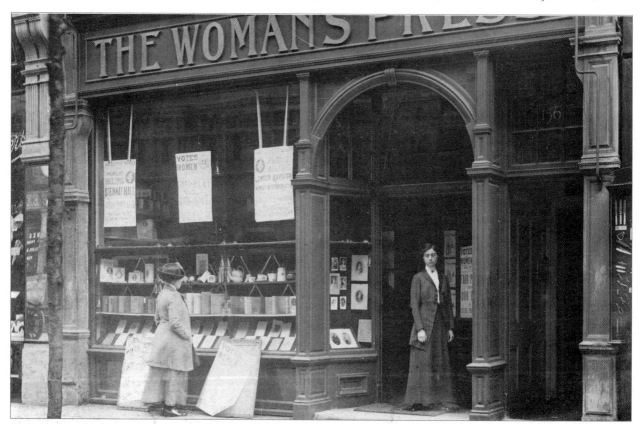

Mrs May looking at the range of purple, white and green merchandise in the window of The Woman's Press shop. The premises at No. 156 Charing Cross Road was newly opened in May 1910. The rapid growth in the sales of suffragette literature and merchandise necessitated the new business in this central London location.

RECIPE FOR COOKING AND PRESERVING A GOOD SUFFRAGE SPEAKER

'First: Butter the speaker, when asking her to come, with a stamped and addressed envelope, post-card, or telegraph form for reply.

'Second: Grease the dish by paying all the speaker's expenses.

'Third: Put her to cool or to warm, as the case may be, in a room by herself before the meeting, so that she may be fresh and in good condition for speaking.

'Fourth: Beat her to a froth with an optimistic spoon, making light of all disappointments. Carefully avoid too strong a flavour of apologies.

'Fifth: Do not let her cool too rapidly after the meeting, but place her considerately by a nice bedroom fire, with a light supper to be taken in solitude.

'(If this recipe is carefully followed, the speaker will be found to preserve her flavour to the last moment, and will do her utmost to make the meeting a success.)'

MRS AUBREY DOWSON (COMPILER), THE WOMEN'S SUFFRAGE COOKERY BOOK, 1910, P. 73.

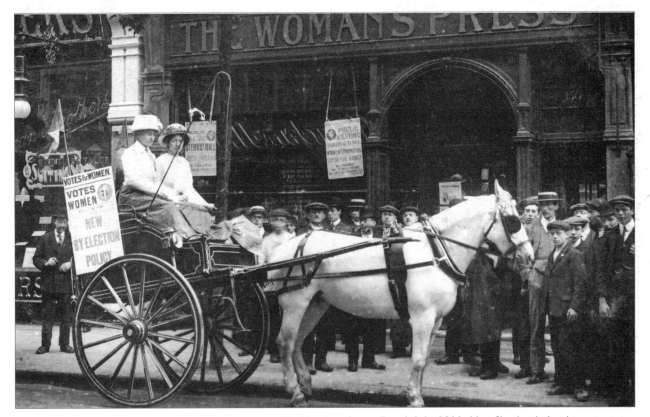

A 'press cart' outside The Woman's Press, No. 156 Charing Cross Road, July 1911. Miss Shepherd, the driver, is sitting next to Helen Craggs, who was in charge of the distribution of *Votes for Women* in central London. She made sure that all their pitches were supplied with copies. Craggs, twenty, had been arrested in Downing Street on 'Black Friday', 18 November 1910. Later, she was convicted of trying to set fire to a house at Nuneham Courtney, Oxford, and was sentenced to nine months in prison with hard labour.

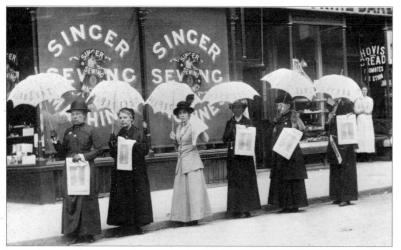

BRIGHTON

'Many thanks to Miss Kelly for speaking at the meeting last Tuesday. A member has kindly paid for the SUFFRAGETTE poster to be shown at Lewes station for six months. SUFFRAGETTE is being sold in town regularly on market day. Paper sales have been brisk this week; stock of 300 sold out by Wednesday. Visitors invited to tea at office on Thursdays, and to Miss Turner's, 13 Victoria Road, on Sundays, during August. . . . Office, 9 North Street Quadrant.'

THE SUFFRAGETTE, 29 AUGUST 1913, P. 806.

A parasol parade in Brighton selling *The Suffragette* newspaper, April 1914. From left to right: Miss Reid, Mrs Goodier, Miss Gye, Mrs Brandon, Miss Rae, Mrs Bouvier. Brighton and Hove was one of the first WSPU branches, founded in May 1907. By June 1908 they had a banner 'beautifully designed and embroidered by members with the arms of Brighton'. Parasol parades were a regular feature of the union's sales drives to increase its newspaper circulation in the summer months. Umbrellas were used in the rainy season.

'The Shop is now open, and reported to be very alluring. Call and see it, volunteers to help to "keep" it, especially during the afternoons. The open-air campaign is in full swing; special dinner-hour meetings for factory girls are being arranged, in addition to four evening meetings weekly. Will volunteers help to sell Votes for Women on Friday mornings, so that a second pitch may be started? Much depends on the political situation being thoroughly understood, and Votes for Women is the only sure source.'

VOTES FOR WOMEN, 1 JULY 1910, P. 656.

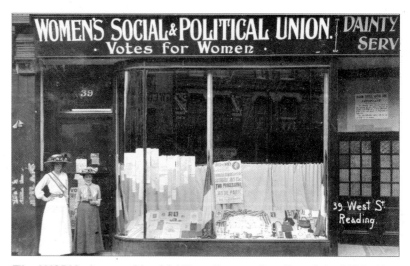

The WSPU shop at No. 39 West Street, Reading, July 1910. Miss Margesson, of No. 7 Lawn Road, was the organizer of the Reading branch. The local Palmer Hall was hired for 'At Homes' and the Town Hall was needed for the larger meetings, at which senior figures like Christabel Pankhurst spoke. Newbury had a 'bicycling corps' of women who would ride to outlying villages and canvass support for women's suffrage.

'. . . only woman (elected) on Council of Cyclists'
Touring Club; also on Council of Roads'
Improvement Association. . . . Born 1875 in London,
married, 1900 to Thomas Lamartine Yates, solicitor;
. . . travelled and studied at Cassel and University of
Paris; after matriculating at London University,
resided at Royal Holloway College for three years,
and passed the highest exam in Modern Languages
and Philology open to women at Oxford University;
after marriage studied law . . . went on deputation
to see Mr Asquith in February 1909, and was
charged with obstruction . . . has since built up the
Wimbledon WSPU into a strong Militant
organization; popular and convincing outdoor and
indoor speaker . . . was suspected of holding Miss
Christabel Pankhurst in hiding at the time of her
escape [1912] from the clutches of the law.'

ROSE LAMARTINE YATES'S ENTRY IN
A.J.R. (ED.), THE SUFFRAGE ANNUAL AND
WOMEN'S WHO'S WHO, 1913, PP. 404–5.

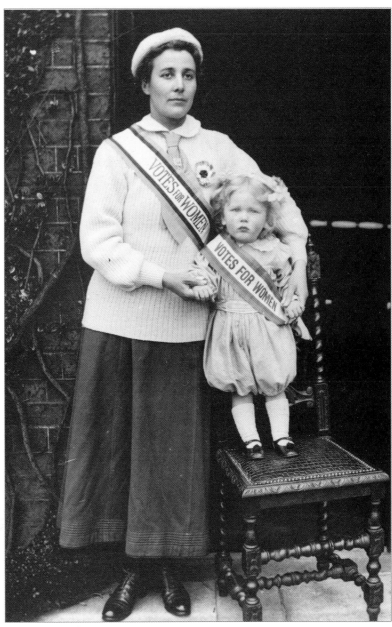

Rose Lamartine Yates wearing the suffragette uniform, with her son Paul,
at their home, Dorset Hall, Merton, Surrey, c. 1910. Mrs Yates was the Honorary
Organizing Secretary and Honorary Treasurer of the Wimbledon WSPU. Paul was
born on 19 June 1908, and when he was eight months old his mother was
arrested while on a deputation. She was charged with obstruction and sentenced
to one month in Holloway Gaol.

'SHOULDER TO SHOULDER'

The Cast List

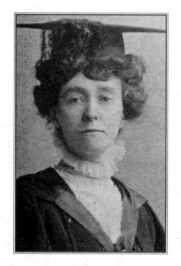

This chapter looks at some of the major and minor players and their various roles during this eleven-year epic drama. Alongside the stars, the Pankhursts, and the generous and almost saintly Pethick-Lawrences, there is a cast list of hundreds of women from all walks of life, from all social backgrounds, fighting for a common cause.

We meet women like Vera Holme, who chauffeured the leaders around the country on speaking tours in the WSPU purple, white and green motor-car, paid for by the members, and the Kenney sisters from Oldham, much admired and respected by (Lady) Constance Lytton, whose mother had been lady-in-waiting to Queen Victoria, and whose father was charged with making her Empress of India. The suffragettes' only martyr, Emily Wilding Davison, came from the more obsessive wing of the militant movement, and was present for much of the action. Welsh women, with their own suffrage organization, marched with the suffragettes, and their own Mrs Mansell-Moullin is featured.

Some of the performers had plenty of lines and were often under the spotlight; others made only the briefest of appearances, and often remained unidentified. Many were newspaper sellers, many spent time in jail, and many more still had the role of 'spear-carriers' to the stars, marching on processions, canvassing door-to-door, and baking hundreds of scones, pies and cakes for bazaars and tea-parties.

*'The most rebellious spirits grew calm in her presence,
the most obstinate grew amenable. They adored her.
There is no other word for it. Her calm, quiet, cultured
manner appealed to us all, her gentle voice, which could
become so passionate in speech, her understanding of
human frailty. . . . Ever ready to do herself anything she
had inflamed her devoted band to do, dramatic,
dignified, loving, human, cultured, pretty versatile, this
was the Mrs Pankhurst we knew in the fight.'*

ANNIE KENNEY, MEMORIES OF A MILITANT,
1924, P. 163.

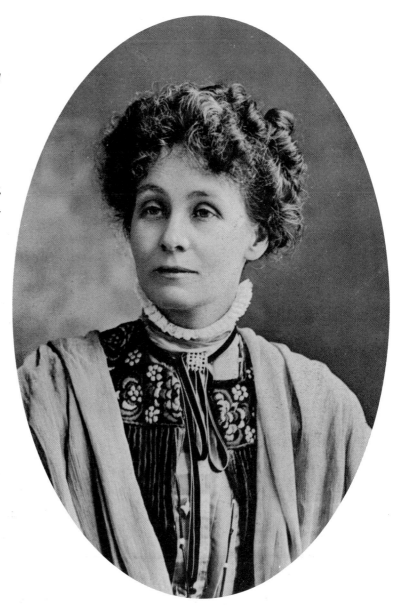

Emmeline Pankhurst (1858–1928), Honorary Secretary, and later Honorary Treasurer, of the WSPU, *c.* 1909. Born in Manchester from a Radical political background, Emmeline Goulden married Dr Richard Pankhurst (d. 1898), the 'Red Doctor' a Radical, feminist barrister. Their three daughters were all involved in the WSPU, one son died before the campaign had started, and the other died at the height of the militancy in 1910. Emmeline was a charismatic and eloquent speaker and was 'immensely popular' with the membership. By 1913 she had served three prison sentences: two in 1908 for leading a deputation to Parliament, and for inciting the public to 'rush' the House of Commons; and in the wake of the window smashing of March 1912, she was sentenced to nine months in prison for conspiracy to commit damage. She is photographed wearing the Holloway Badge, a medal of honour designed by her daughter, Sylvia, and awarded to suffragettes who had been imprisoned for their involvement in the campaign. It is an arrow of purple, white and green enamel mounted on a silver portcullis.

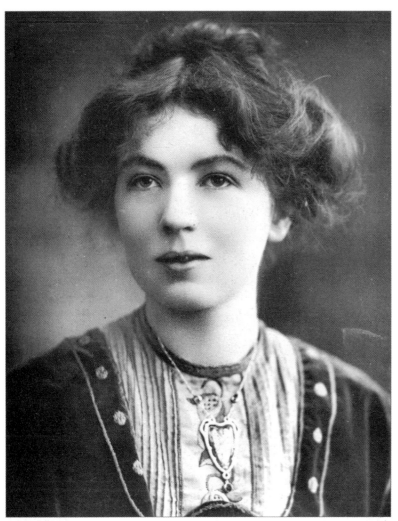

'No one will ever surpass Christabel for tactics. Not a word was lost, not a movement overlooked. The politicians, the public, the Press, were like an open book to her, and we were all placed as though she were playing a serious game of political chess, her opponent being Parliament. I never had the least objection to being moved about the chess-board, and even if I, as a pawn, was captured, I knew that she would soon recover lost ground.'

ANNIE KENNEY, MEMORIES OF A MILITANT, 1924, P. 101.

Christabel Harriette Pankhurst (1880–1958), Organizing Secretary of the WSPU and editor of *The Suffragette*, c. 1909. The eldest Pankhurst daughter, Christabel had a first class degree in law from Owen's College, Victoria University, Manchester, and a prize for international law. However, because she was a woman she was not allowed to practice as a lawyer. She devoted her considerable talent to the WSPU; she was a brilliant and popular speaker who could inspire great loyalty. Frequent parallels were drawn between her and Joan of Arc. She and Annie Kenney started militant tactics in 1905 when they continually interrupted a Liberal meeting at the Free Trade Hall, Manchester, asking when the Liberal Party would give women the vote. They were thrown out, arrested, refused to pay a fine to avoid prison and were sentenced to seven days. Christabel went to prison twice more in 1907 and 1908 and finally fled the country, exiling herself in Paris in March 1912 to avoid the conspiracy charges her mother faced. She led the WSPU, and edited the *Suffragette* newspaper from Paris and did not return to England until after the outbreak of the First World War. Her pamphlets and handbills include: *What Women Get, and What They Need*; *The Militant Methods of the WSPU*; and *Broken Windows*.

'I was at Churchill's meeting [1905] in a
schoolroom in Cheetham Hill [Manchester]. There
was a running fire of questions of all sorts.
Churchill answered them as they came. I put mine
as soon as he gave me an appropriate cue. He
attempted to ignore me, but my brother [Harry] and
some ILP [Independent Labour Party] men at the
back of the room led the audience in demanding
that I should be answered. Such a clamour was
raised that Churchill could not proceed. As soon as I
stood up again there was complete silence, but when
my question was put and again ignored, the din
began once more. This continued for some time. To
end the deadlock the chairman asked me to put my
question from the platform. I did so and turned to
go, but Churchill seized me roughly by the arm and
pushed me into a chair at the back of the platform,
saying: "No, you must wait here till you have heard
what I have to say." Then, turning to the audience,
he protested that I was "bringing my disgrace upon
an honoured name" by interrupting him, and
added: "Nothing would induce me to vote for giving
women the franchise; I am not going to be
henpecked into a question of such importance."

'I would have gone then, but in a scuffle, during
which all the men in the platform stood up to hide
what was happening from the audience, I was
pushed into a side room. I was left there, the door
being locked on the outside, but not before I had
opened the window and called to the people in the
side street to witness the conduct of an enthusiastic
Liberal, who was jumping about like a madman,
and threatening to scratch my face. It appeared that
I was a prisoner, for the windows were barred, but
the people who had gathered outside called to me
that a window at the other end of the room had a
couple of bars missing. They helped me out, and
called for a speech. Someone brought me a chair and
I had a rousing time of it.'

SYLVIA PANKHURST, THE SUFFRAGETTE
MOVEMENT, 1931, PP. 193–4.

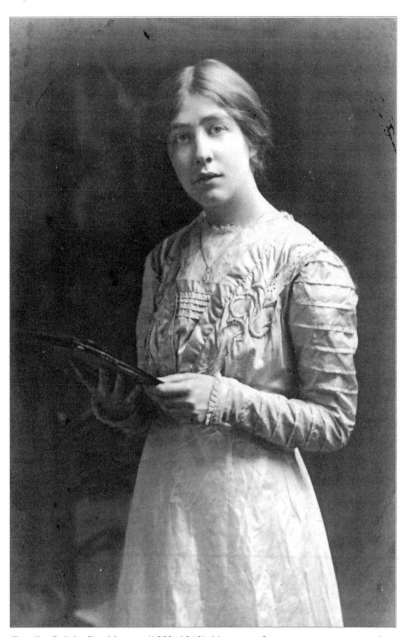

Estelle Sylvia Pankhurst (1882–1960), Honorary Secretary, organizer, speaker and author, c. 1909. Sylvia was an accomplished artist and designer who was trained at the Royal College of Art in South Kensington. Her art work and imagery gave the WSPU a coherent visual identity. Sylvia made votes for working-class women a priority and this brought her into conflict with her mother and sister, Christabel. They disapproved of her East London Federation of Suffragettes and expelled her from the WSPU in 1914. She lectured on women's suffrage in the United States (1911); Scandinavia (1913) and central Europe (1914). She was imprisoned many times for her involvement and endured weeks and months of hunger, thirst and sleep strikes in Holloway Gaol.

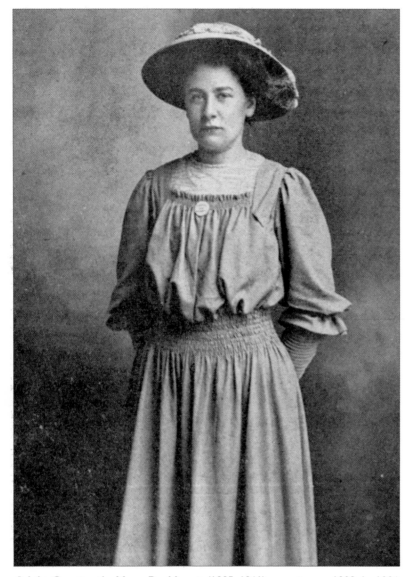

'Adela and I were sent off [1907] as recruiting sergeants, our territory being Lancashire and Yorkshire. We had a wet, wild and stormy campaign. Not only was the weather stormy but the tempers of some of the men whose wives we had coaxed or convinced into giving in their names for the deputation were stormy too. We told them that it meant arrest.'

ANNIE KENNEY, MEMORIES OF A MILITANT, *1924, P. 114.*

Adela Constantia Mary Pankhurst (1885–1961), organizer, *c*. 1908. In 1906 Adela gave up her job as an elementary school teacher in Manchester to become an organizer in Lancashire and Yorkshire. During the General Election of 1905 she repeatedly questioned Winston Churchill at large public meetings and was 'ejected night after night'. She served several short prison sentences for interrupting Liberal meetings and for participating in noisy demonstrations and deputations to the House of Commons. Adela's outspoken left-wing views were not shared by her mother and her sister, Christabel – for instance, she had encouraged Yorkshire suffragettes to support striking textile workers in Hebden Bridge. In 1911 she lost her voice, caught pleurisy and was urged to give up public speaking. Her mother and Christabel saw this as an opportunity to end her career with the WSPU and offered to send her on a gardening course – Adela had expressed an interest in this, on the understanding she would give up her role as an organizer. The gardening did not go well and in 1912 Adela went to live in Australia where she remained for the rest of her life.

'*Mr Lawrence was the only man who played an active part in the inner working of the Militant Movement. We owe him a tremendous debt for the stupendous work he did in helping to build up the society. The well-run and highly organized staff and office were the work of his brain. However good the workers were, they could never have done such perfect work without the perfect conditions which he created. Regularity, order, method, were the rules laid down. . . .*

'*The organization which the tremendous demonstrations involved was the work of one person, who mapped out the plans, who planned the innumerable details, who saw the effect of the scheme before it was finished, and that person was Mr Lawrence. . . . His capacity for detail in big schemes made it possible for the Movement to venture gigantic plans which would never have been ventured upon, if he had not been behind the scenes, working, planning, scheming to make success doubly sure.'*

ANNIE KENNEY, *MEMORIES OF A MILITANT,*
1924, PP. 18, 77–8.

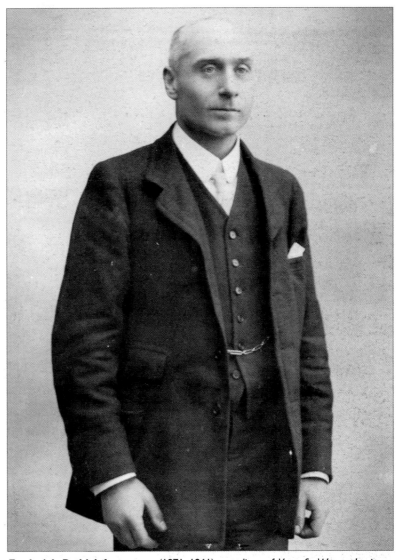

Frederick Pethick-Lawrence (1871–1961), co-editor of *Votes for Women*, business manager of the WSPU and founder of their publishing imprint The Woman's Press, c. 1909. Pethick-Lawrence was a barrister who had been involved in social reform and had been the editor of the London evening newspaper the *Star*. Like many other couples of the day with feminist principles, he and his wife Emmeline took each other's surname (he Lawrence, she Pethick). His professional expertise was invaluable to the WSPU in their legal battles with the Government, the police and the prison authorities. In May 1912 Pethick-Lawrence and his wife (and Emmeline and Christabel Pankhurst) were charged with conspiracy to incite violence and he was sentenced to nine months in Holloway Gaol. He went on hunger strike, was force-fed and was released early when prison doctors decided that he was too weak to complete his sentence without endangering his life. In the autumn of 1912 the couple were expelled from the WSPU for daring to criticize the escalating campaign of militancy. This did not deter them from continuing to fight for the vote.

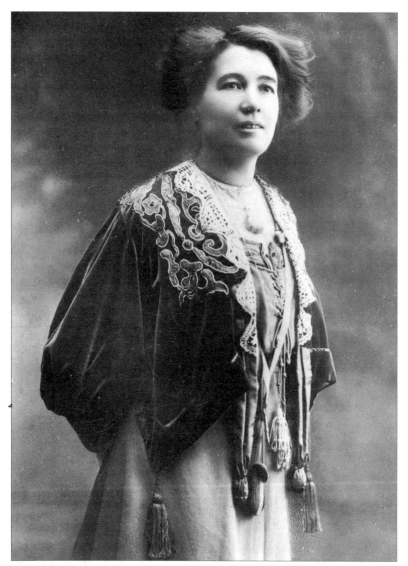

'Most of the spectacular side of the Movement was conceived in Mrs Pethick-Lawrence's brain; she understood her public. Her love of pageantry, her passion for colour and music introduced into the Movement a lighter, freer and gayer side. The pageantry of the Movement played a great part, not only in popularizing it, but also in making popular the people who were behind the builders.

'As a treasurer Mrs Lawrence had the most wonderful gift of appeal, not only in speech but in the written word . . . [her] powers of deep reflection and of vivid imagination helped Mrs Pankhurst and Christabel in building up a gigantic work that will leave its effects on generations to come.'

ANNIE KENNEY, MEMORIES OF A MILITANT, 1924, PP. 76–7.

Emmeline Pethick-Lawrence (1867–1954), co-editor of *Votes for Women*, and business manager and Treasurer of the WSPU, c. 1909. Before her involvement with the movement Emmeline Pethick-Lawrence had spent five years as a social reformer. In 1905 she founded the Esperance Girls' Club and Social Settlement, and two years later the Maison Esperance, a cooperative dressmaking business which, unusually for the time, paid the workers a minimum wage of fifteen shillings a week for an eight-hour day, and gave them an annual holiday. She proved to be a remarkable fund-raiser and treasurer for the suffragettes, raising the equivalent of £3 million in five years. Arrested four times and serving over four months in prison, her last conviction (like her husband) was in 1912 for conspiracy to incite violence. She served only five weeks of her nine-month sentence and was released early, severely debilitated after her hunger strike and force-feeding. On their expulsion from the WSPU she and her husband continued to edit *Votes for Women* (thereafter the official newspaper of the WSPU would be the *Suffragette*). They also founded the Votes for Women Fellowship, a new moderate militant organization. Emmeline's many publications include: *The Need for Women MPs*; *Women as Persons or Property?*; and *The Meaning of the Woman's Movement*.

'A little stout woman with rosy cheeks, and a most aggressive pug nose. This was Flora Drummond, a native of the island of Arran, who had a standing grievance against the Government, because after she had qualified as a post-mistress, she had been excluded by the raising of the height standard for such posts. . . . Processions and pageantry were a prominent feature of the work, and these, in their precision, their regalia, their marshals and captains, had a decided military flavour. Flora Drumond called 'The General' rode at the head of processions with an officer's cap and epaulettes.'

SYLVIA PANKHURST, THE SUFFRAGETTE
MOVEMENT, 1931, PP. 191, 266.

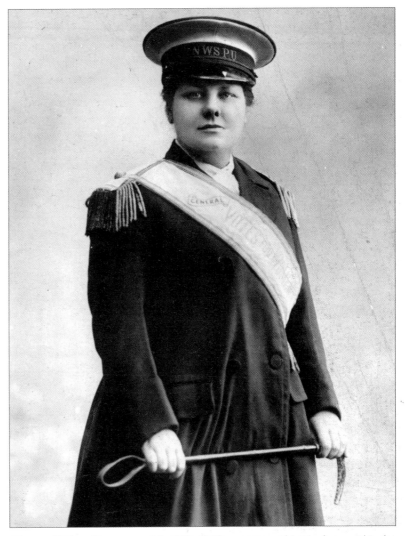

'General' Flora Drummond (c. 1879–1949), organizer and senior figure within the WSPU, June 1908. Flora Drummond was born in Manchester but grew up in the Highlands where she met her husband, Joseph Drummond. After their marriage they returned to Manchester, where she joined the suffragette campaign shortly after the first militant act – the ejection of Christabel Pankhurst and Annie Kenney from the Free Trade Hall (1905). Early in 1906 she moved to London as a paid organizer, and was always closely involved with the WSPU's campaign in Scotland. She was imprisoned at least four times, once serving three weeks for chaining herself to the railings of No. 10 Downing Street. The initials NWSPU on her peaked cap refer to the split with the Pankhursts by Charlotte Despard, Edith How-Martyn and Teresa Billington-Greig (see pp. 26–8) in 1907. This trio used the name Women's Social and Political Union until they announced their new Women's Freedom League. Not wishing to be confused or associated with the breakaway group, the Pankhursts added National to the name of their organization. The 'General', so called by other suffragettes, was a horsewoman and is seen here with her riding crop. Within a year of this occasion Flora had given birth to a son, Keir Hardie Drummond, named after Keir Hardie, the founder and first Member of Parliament of the Independent Labour Party.

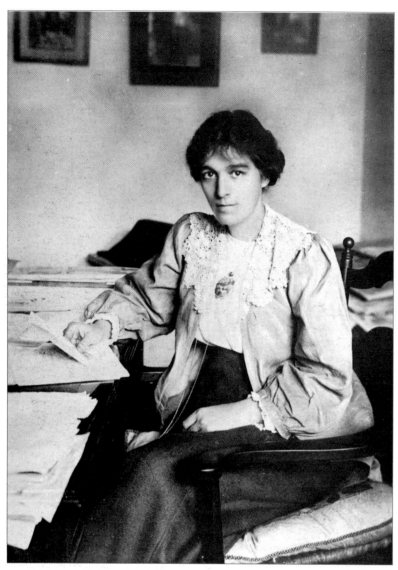

'A great discovery was Mrs Tuke, who for the longer part of the WSPU's existence was honorary secretary.... Mrs Pethick-Lawrence invited her to luncheon [1906], I being also a guest. She came, still in mourning, gentle and beautiful, the last woman in the world, it must have been supposed, to join a militant movement. Yet when, after luncheon, I remarked: "I must go now and chalk pavements for a meeting"... what did she say but "I'll come and chalk pavements too!" I knew, then, that she was of the right stuff, and all the more as she did her chalking with such will ... from that day onward she was one of us.'

CHRISTABEL PANKHURST, UNSHACKLED: THE STORY OF HOW WE WON THE VOTE, 1958, P. 67.

Mabel Tuke (1871–1962), joint Honorary Secretary of the WSPU, who was also known as Pansy, c. 1908. Mabel Tuke had spent most of her married life in South Africa, returning to England as a widow. She worked for Emmeline Pethick-Lawrence's Esperance Girls' Club and helped pioneer the revival of morris dancing. Early in 1906 she joined the WSPU and devoted herself to the campaign wholeheartedly. On 1 March 1912 she and Emmeline Pankhurst threw a stone through the window of No. 10 Downing Street. They were arrested immediately, and Mabel was sentenced to three weeks in Holloway Gaol. Years later, Sylvia Pankhurst remembered how Mabel had had the ability to impress and reassure the parents of girls who wanted to be involved in the campaign.

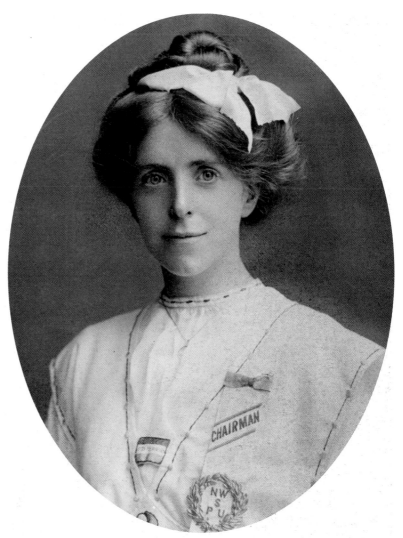

'I felt that through Annie Kenney's whole being throbbed the passion of her soul for other women, to lift from them the heavy burden, to give them life, strength, freedom, joy, and the dignity of human beings, that in all things they might be treated fairly with men. I was struck by the expression and argument, it was straight-forward in its simplicity, yet there was inspiration about her.'

CONSTANCE LYTTON, *PRISONS AND PRISONERS: SOME PERSONAL EXPERIENCES BY CONSTANCE LYTTON AND JANE WARTON,* 1914, P. 186.

Annie Kenney (1879–1953), organizer, the only working-class woman to become part of the senior hierarchy of the WSPU, June 1908. Born in Lees, near Oldham, Lancashire, Annie Kenney started work as a half-timer in 1889, attending school for half the day and working at the mill for the other half, and eventually became active in trade unionism. She met the Pankhursts and, along with Christabel, committed the first militant act at the Free Trade Hall in Manchester in October 1905. She left the mill and moved to London to become a paid organizer, operating mostly in the West Country, frequently appearing on suffragette processions dressed in her mill clothes, clogs and shawl. Annie was utterly loyal to Emmeline and Christabel, becoming deputy leader of the WSPU when the latter fled to self-imposed exile in Paris in 1912. She served four prison sentences, the first in Strangeways Gaol in Manchester, the others in London's Holloway Gaol. The Kenneys were something of a suffragette family; her three sisters, Jennie, Jessie and Nell, and a brother were all involved in the campaign.

Annie is dressed for Women's Sunday on 21 June 1908. She wears a purple, white and green Votes for Women badge, made of cotton, and her badge of office as Chairman of one of the twenty platforms in Hyde Park, from which speeches were made.

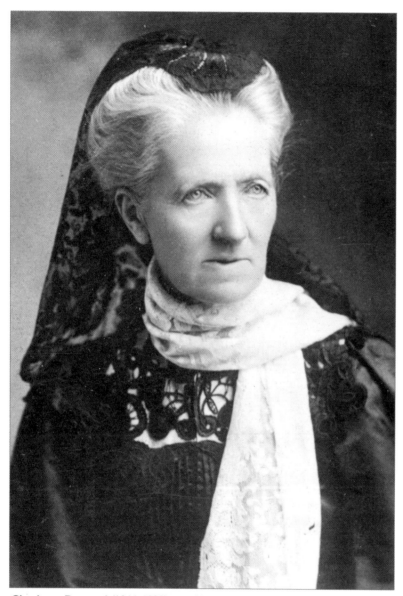

'Mrs Pankhurst had called upon the members to support her as the dictator of the Union, announcing that its committee would henceforth be appointed by herself and would serve during her pleasure to support her decisions. The majority of the committee and the membership supported Mrs Pankhurst. The minority retired. Holding a Conference on the date which had been intended for the Annual Conference of the original WSPU, they elected a new committee, with Mrs Despard as president, and opened new offices. Claiming to be the original organization they also called themselves the WSPU, until the beginning of 1908, when they adopted the new title of the "Women's Freedom League".'

SYLVIA PANKHURST, THE SUFFRAGETTE MOVEMENT, 1931, PP. 264–5.

Charlotte Despard (1844–1939), joint Honorary Secretary of the WSPU and, after the autumn of 1907, Honorary Treasurer and President of the Women's Freedom League, c. 1909. Born in Edinburgh, Charlotte Despard was already a well-known feminist and social reformer by the time she joined the WSPU. She was famous for wearing sandals all year round, and always having a Spanish lace mantilla in her hair. She was married in 1870, widowed in 1890, and went to live in Nine Elms, Battersea, where she witnessed the unremitting poverty of working-class women's lives and their treatment by the local Poor Law administration. As a member of the WSPU, Charlotte went to prison twice; the first sentence was three weeks in Holloway Gaol for leading the deputation from the First Women's Parliament in Caxton Hall to the House of Commons on 13 February 1907. Under her leadership the Women's Freedom League encouraged its members to take part in non-violent resistance such as evading the Census of 1911, refusing to pay any taxes until women were given the vote, and wearing the League's official colours of green, white and gold.

'The characteristic which chiefly distinguishes the militant suffrage societies from other Suffrage organizations is the spirit of self-sacrifice, which leads its members to protest against the exclusion of women from citizenship, even when the result of that protest is the prison cell. The fact that nearly 500 women have [by December 1909] suffered imprisonment stands unparalleled in history.'

THE VOTE, 9 DECEMBER 1909, P. 75.

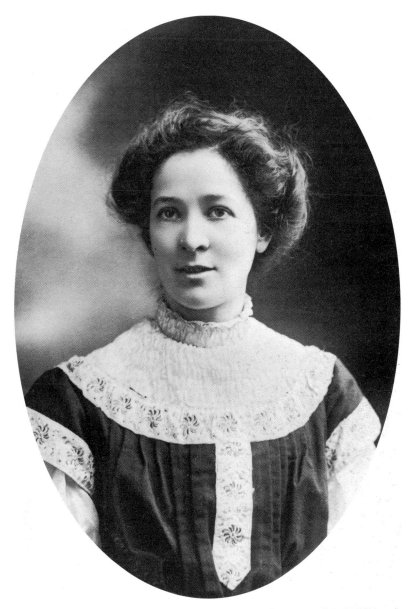

Edith How-Martyn (c. 1875–1954), joint Honorary Secretary of the WSPU and, after the autumn of 1907, co-founder and Honorary Secretary of the Women's Freedom League, c. 1909. Educated at the North London Collegiate School and University College, Aberystwyth, Edith How-Martyn gave up her lectureship in mathematics at Westfield College to work full-time for the women's suffrage movement. In 1906 she became one of the first WSPU members to serve time in Holloway Gaol; after being arrested outside the House of Commons in October 1906 she was charged with obstruction and sentenced to two months in prison. She was released after a month on a King's Pardon. She relinquished the Secretaryship of the Women's Freedom League in January 1911 to become the Honorary Head of the Political and Militancy Department until April 1912.

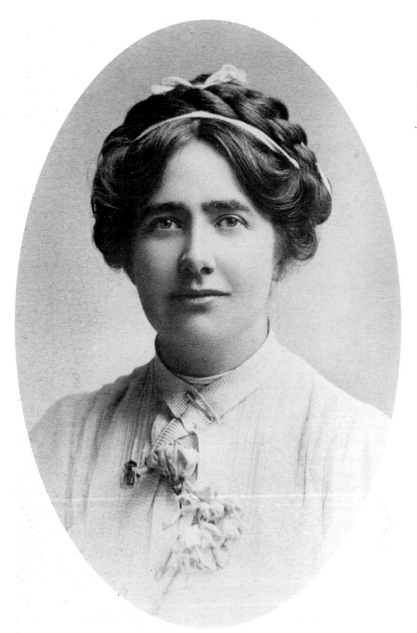

Teresa Billington-Greig (1877–1964), WSPU organizer and, after the autumn of 1907, Honorary Organizing Secretary of the Women's Freedom League, c. 1909. Born in Preston, Teresa Billington-Greig became a teacher in 1904 and Honorary Secretary of the Manchester Equal Pay Committee. She was a friend of Emmeline Pankhurst and joined the WSPU in 1905, giving up her teaching career to become an organizer and one of the first militant activists, serving two prison sentences in Holloway Gaol. Known as 'the woman with the whip', Teresa would interrupt Liberal meetings armed with a whip which she would whirl around her to prevent being ejected by the stewards. She left the WSPU in 1907 and was a senior figure in the Women's Freedom League and a leader-writer for their newspaper the *Vote*. Disillusioned with the League she left in 1911 and wrote *The Militant Movement*, which attacked militancy and the leadership style of the Pankhursts.

'Mrs Baldock, as a working woman, knows the difficulties and sorrows of their lives, and has now given up all work to fight for political power. She brings to her work the experience gained as a Poor Law Guardian and by work in the Independent Labour Party, on Distress Committees, etc. Mrs Baldock was one of the first militant suffragettes in London, heckling Mr Asquith at his Queen's Hall meeting in December, 1905, and holding up the banner at the Albert Hall. In October 1906, and again in February 1908, she suffered imprisonment for her enthusiasm.'

VOTES FOR WOMEN, 18 JUNE 1908,
p. 252.

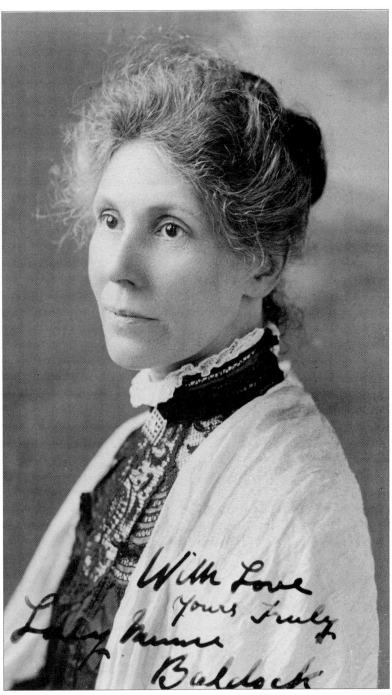

Minnie Baldock, WSPU organizer in the East End of London, c. 1908. Minnie Baldock lived in West Ham and was active in the local branch of the Independent Labour Party (ILP) – in 1892 Keir Hardie had been elected as the ILP's first Member of Parliament for South West Ham. When Annie Kenney was sent to London by Emmeline Pankhurst in 1906 she stayed with Minnie and founded the WSPU's first London branch in nearby Canning Town. Others followed in Poplar, Bow, Limehouse and Stepney.

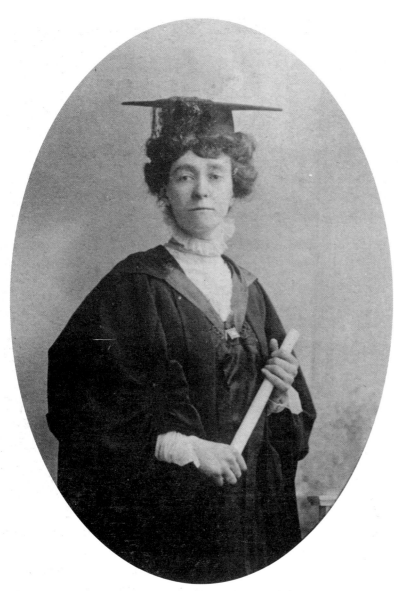

'. . . was a coach and teacher at University Extension tutorial classes. She had taken a London B.A. and a first class in the Oxford Final Honours School in English Language and Literature. She had to struggle for these distinctions, having supported herself by teaching in the meantime, her mother keeping a little confectioner's shop at Long Horsley, near Morpeth, in Northumberland. Far from the inner circle of the Union, she was one of the most daring and reckless of the militants. She was tall and slender, . . . and had red hair. Her illusive, whimsical green eyes and thin, half-smiling mouth, bore often the mocking expression of the Mona Lisa. There was little in her appearance to suggest her cool, unflinching courage, or the martyr's fate, which was finally to be hers.'

SYLVIA PANKHURST, THE SUFFRAGETTE
MOVEMENT, 1931, P. 328.

Emily Wilding Davison (1872–1913), the most famous suffragette of all, 1909. Emily Wilding Davison gave up her teaching post to become a career militant. She served nine prison sentences, and endured many sessions of force-feeding, for a wide range of offences including obstruction, stone throwing, window smashing, setting fire to pillar-boxes, and assaulting a Baptist minister whom she mistook for the Liberal Cabinet Minister David Lloyd George. In the 1913 Derby she ran out on to the racetrack and attempted to stop the king's horse, Anmer. She received serious head injuries and died four days later at Epsom Cottage Hospital, surrounded by a suffragette guard of honour and purple, white and green flags. Emily is photographed here wearing her Holloway Badge.

'I began to realize of what stuff the workers in the Movement were made; what price they paid for their services so gladly given; how far removed they were from any taint of self-glorification, and how amazingly they played the game of incessantly advertising the Cause without ever developing the cause of self-advertisement. I have never been amongst people of any sort who were so entirely free from self-consciousness, self-seeking and self-vaunting.'

CONSTANCE LYTTON, PRISONS AND
PRISONERS: SOME PERSONAL EXPERIENCES
BY CONSTANCE LYTTON AND JANE WARTON,
1914, P. 15.

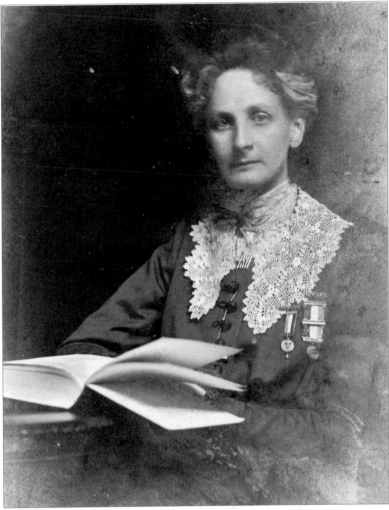

Constance Georgina Lytton (1869–1923), suffragette, 1910. The Holloway Badge (left, middle of her chest), Prison Medal (centre) and 'For Valour' Hunger-Strike Medal (right) with two silver bars, are clues to the four prison sentences that Constance Lytton served for her involvement in the WSPU's campaign. Born into an aristocratic family – her father was the first Earl of Lytton – she joined the militant movement in 1908 and was soon appalled at the hypocrisy of the authorities' class-based treatment of the suffragettes. Twice she was released early from prison allegedly for her heart condition, but in fact because of her family connections. Determined to expose this double standard, Charlotte went to Liverpool in January 1911 dressed as a working-class woman, 'Jane Warton'. She was arrested, as her *alter ego*, demonstrating outside Walton Gaol and was imprisoned there for fourteen days of hard labour. She was not medically examined, and was force-fed and released early because of her weak condition. Her treatment as 'Jane Warton' confirmed the suspicion that working-class suffragettes were dealt with more severely than their aristocratic sisters. Constance's health deteriorated because of her prison experiences. In 1912 she suffered a stroke and had to learn to write with her left hand in order to record her memoir of 1914, *Prisons and Prisoners: Some Personal Experiences by Constance Lytton and Jane Warton*.

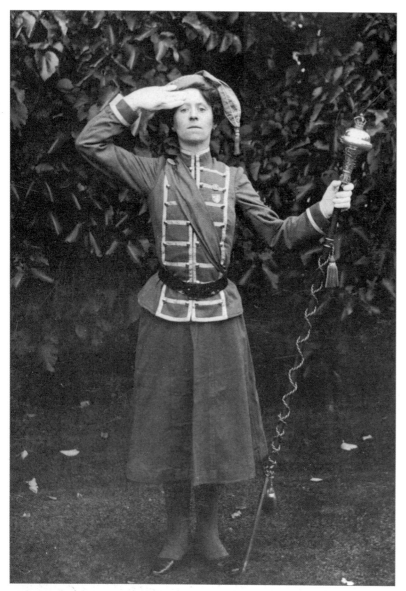

'It was women's first use of the political argument of the stone. Mary Leigh and Edith New, taking counsel with no one, had gone to Downing Street carrying stones, and had flung them at the windows of the Prime Minister's official abode. Defending this action in Court the next day [1 July 1908], the two prisoners said that having tried every other means to attain their end, and having failed, they had to take more militant measures. The responsibility for what they had done rested on those who made women outlaws by the law of the land. These two were sentenced to two months imprisonment without the option of a fine. Many questions were asked in Parliament about them.'

CHRISTABEL PANKHURST, UNSHACKLED:
THE STORY OF HOW WE WON THE VOTE,
1958, PP. 97–8.

Mary Leigh (1885–alive in 1965), organizer, 1909. Mary Leigh is photographed wearing her purple, white and green uniform as Drum Major of the Women's Band. A year earlier, she and a fellow schoolteacher friend, Edith New, became the first suffragette window-smashers. Mary served three prison sentences and was force-fed on many occasions. On 17 September 1909 she and eight other suffragettes caused pandemonium when they disrupted Prime Minister Asquith's visit to Birmingham to attend a Liberal meeting in the Bingley Hall. She and Charlotte Marsh (who often led WSPU processions on horseback, dressed as Joan of Arc) climbed onto the roof of a taller building next to the hall and hurled missiles and slates onto its roof. The two women were pelted with bricks and stones and soaked when fire hoses were turned on them. Eventually a policeman climbed on the roof and brought them down. Mary was sentenced to four months with hard labour in Winson Green Gaol, where she staged a hunger strike. After being force-fed by stomach tube, she barricaded herself into her cell to prevent the barbaric procedure from being carried out again.

'Miss Vera Holme, chauffeur to the WSPU, made her first public appearance in this capacity on Friday, when she took charge of the motor in which Mrs Pankhurst started for Scotland. Miss Holme wore a striking uniform in the colours, with a smart peaked cap decorated with her Royal Automobile Club badge of efficiency.'

VOTES FOR WOMEN, 20 AUGUST 1909,
P. 1,094.

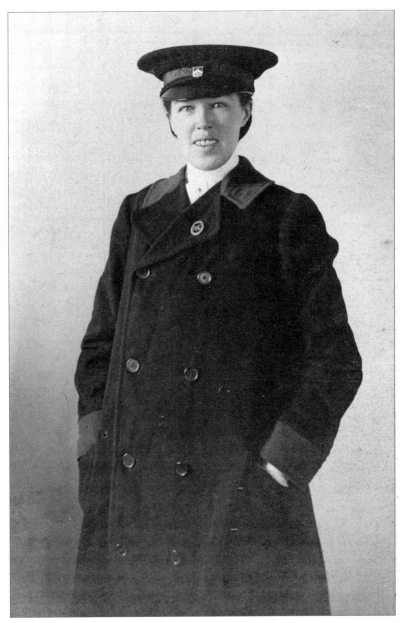

Vera Holme (1881–1969), WSPU chauffeur and horsewoman, sometimes known as 'Jack', 1909. Vera Holme was an orphan who had been educated in a French convent. Sylvia Pankhurst remembers her reputation for wildness and being 'rebuked by her elders for a lack of dignity'. In November 1911 Vera went to prison for assaulting a policeman – on horseback herself, she charged the mounted officer and snatched his horse's bridle. It took three policemen to rescue their colleague, arrest Vera and take her to the police station.

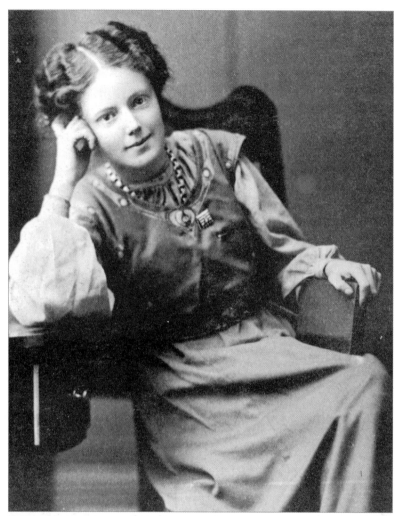

'Miss Gawthorpe is one of the most indefatigable of the WSPU organizers, and is a particularly well-known figure at by-elections. She was well described by a northern newspaper as "small, brisk, and dainty". Miss Gawthorpe has lived a life crowded with work. Whilst occupied as a teacher she succeeded in winning her way by a King's scholarship to Leeds University, where she secured a double-first. For several years she took much active interest in social problems, working especially in the Labour movement. In 1906 she joined the WSPU, and has enjoyed uncommon success as an organizer.'

VOTES FOR WOMEN, 18 JUNE 1908,
P. 251.

Mary Eleanor Gawthorpe (1881–c. 1960), organizer and member of the National Committee of the WSPU from 1907 to 1911, c. 1908. She is photographed wearing the Holloway Badge for her involvement in the campaign. Born in Leeds into a poor working-class family, Mary Eleanor Gawthorpe was a talented and popular speaker and organizer of militant campaigns and protests against Cabinet Ministers throughout the United Kingdom. Her membership of the Lord Mayor of Leeds Committee for the Feeding of [Needy] School Children, and of the Independent Labour Party, and her own family's poverty all contributed to her politicization in the women's suffrage movement. She was arrested and sent to prison four times; on one occasion, in February 1907, she was so 'badly knocked about' while demonstrating outside the House of Commons that she was unable to appear in court and the case was dismissed. In 1910 Mary became seriously ill and was an invalid for several years. However, this did not deter her from breaking a window at the Home Office in February 1912 in protest at the force-feeding of William Ball, a male supporter of the suffragettes who had been arrested and sent to prison. She was arrested immediately and sent to Holloway, her fourth and final spell in prison where she went on hunger and thirst strike. Because of her poor health she was released early, after which she continued to organize public petitions against the force-feeding of women throughout the country.

'Jessie and I had a long talk on her arrival. We agreed that in work we would act towards each other as members, that we would never confide secrets out of our own departments, or try to shelter each other if we were rebuked for any mistakes we might make; that no Union work or policy should be written about to other members of the family. . . . My sister Jessie played a unique part in the Movement. . . . It was soon found out that she had the most remarkable powers of organization for one so young.'

ANNIE KENNEY, *MEMORIES OF A MILITANT*, 1924, P. 86.

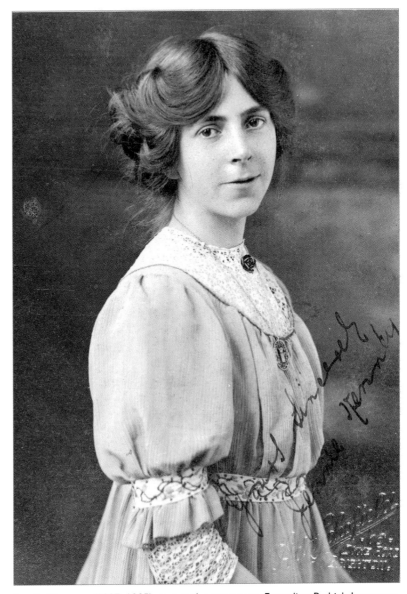

Jessie Kenney (1887–1985), personal secretary to Emmeline Pethick-Lawrence, Brighton, c. 1909. Jessie Kenney was the youngest of the Kenney family to become involved in the campaign. Militant activities, in particular the 'pestering' of Cabinet Ministers, were her speciality. Hearing her describe her experiences in prison during the summer of 1908 persuaded Constance Lytton to support the WSPU's militancy. (Up to this time the latter had been unhappy about the WSPU's escalating militant methods.) In December 1909 Jessie tried to gain admittance to a meeting with Prime Minister Asquith at No. 10 Downing Street, disguised as a telegraph boy, and nearly succeeded.

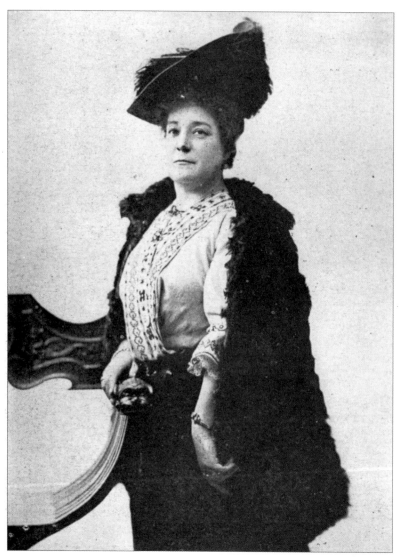

'Mrs Martel, though born in England, is an Australian, and already possesses the Parliamentary vote in her own country. She is one of those who fought hard in New South Wales from 1899 to August, 1902, to win the vote, for petitions and was for eight years the honorary receiving secretary for petitions. In 1900 she was unanimously elected President of the Women's Progressive Association and later the President of the Liberal and Reform Association of New South Wales. She was nominated for Senatorship of the Commonwealth Parliament, and obtained over 19,000 votes. She came to England in May, 1905, and has since devoted her life to the women's cause in this country. Her experience and great force make her a valuable speaker.'

VOTES FOR WOMEN, 18 JUNE 1908, P. 252.

Nellie Alma Martel, organizer and member of the London and National Committees of the WSPU, c. 1908. Nellie Alma Martel's experience of the Australian women's suffrage campaign, and of being a voter, were fully exploited by the suffragette leadership and in 1906, their imprint, The Woman's Press, published her pamphlet, *The Women's Vote in Australia*, which went into several editions before the outbreak of the First World War. Nellie was one of the first suffragette organizers in London and as such travelled widely and was particularly busy during by-election campaigns. In 1906 she and twenty other suffragettes took part in a 'raid' on the House of Commons, determined to see the Liberal Prime Minister Sir Henry Campbell-Bannerman. He refused to see them and, in protest, they stood on chairs and refused to leave the building. Nellie and nine others were arrested and charged with using 'violent and abusive language'. In court the next day she 'shouted and gesticulated' and claimed that as an enfranchised woman in Australia she had the right to enter the lobby of the House of Commons. She was sentenced to two months in Holloway Gaol. Refusing to move, she and the others had to be forced out of the dock. Two years later, in 1908, she was badly assaulted during a by-election campaign.

'... became interested in Women's movement while in Australia in 1907, returned to England and helped in the Pembrokeshire by-election in 1908; ... on many occasions was successful in tracking and interviewing Cabinet Ministers; became organizer of WSPU on 1 January 1909, and organised the first great meeting ever held in Croydon, afterwards going to Aberdeen for three months; in May 1909 went to organize in Liverpool and Cheshire and opened first Suffrage shop in Liverpool [at No. 28 Berry Street] in September of that year ... left Liverpool in 1911 to organize in Gloucestershire ...'

ADA FLATMAN'S ENTRY IN A.J.R. (ED.), THE SUFFRAGE ANNUAL AND WOMEN'S WHO'S WHO, 1913, PP. 240–1.

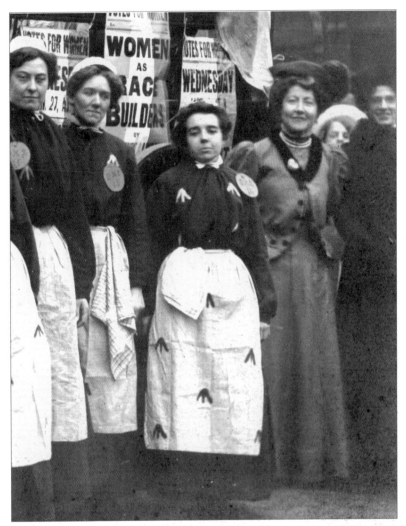

Ada Flatman (c. 1876–1951, second from right), organizer, on a demonstration, possibly in Liverpool, 1909. Included in the photograph are suffragette ex-prisoners, some of whom were local women, dressed in replica prison clothing and wearing their prison number badges. Ada Flatman herself was an ex-prisoner, having served one month in Holloway Gaol for her presence on a deputation to the House of Commons in the autumn of 1908. The backdrop to this scene consists of posters printed in purple, white and green, which refer to the Edwardians' concern at the apparent deterioration of the British race. (The women's suffrage movement and the majority of feminists pointed out the special contribution made by mothers to society, and indeed the future of the race. This was one of the many strands in the argument for the right to vote.)

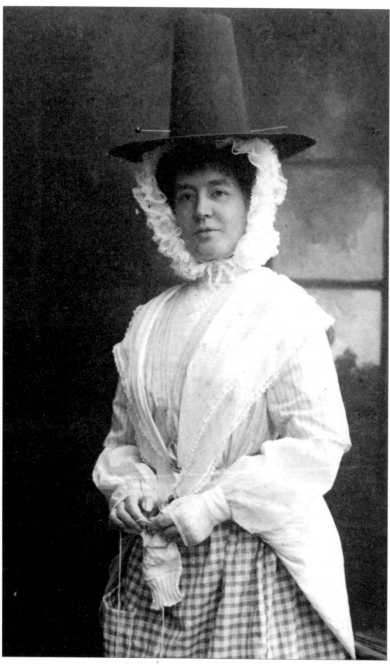

'...Founder of the Forward Cymric Suffrage Union, which has an anti-Government policy, and unites Welsh men and women, their sympathizers and friends, who are working for the enfranchisement of women before any other Cause, and who do not support any political party; was the Organiser of the Welsh contingent in the great "Coronation" Suffrage Procession, 1911;...speaks at numerous meetings in England and Wales.'

EDITH RUTH MANSELL-MOULLIN'S ENTRY IN A.J.R. (ED.), THE SUFFRAGE ANNUAL AND WOMEN'S WHO'S WHO, 1913, PP. 300–1.

Edith Ruth Mansell-Moullin, Welsh suffragette, at the Women's Coronation Procession, 17 June 1911. Edith's husband was an eminent doctor and vice-president of the Royal College of Surgeons, who repeatedly condemned the Government's force-feeding of hunger-striking suffragette prisoners. Edith was present on 'Black Friday', 18 November 1910, when a peaceful deputation to the House of Commons turned into a riot outside Westminster as more than a hundred and fifty suffragettes were assaulted by a police force said to number five thousand. Riots broke out again the following week and Edith was back again, taking part in the Battle of Downing Street. In 1911 she served a month in Holloway Gaol after being arrested while on a deputation led by Emmeline Pethick-Lawrence to the House of Commons.

'It was now the turn of Grace Roe. Ably and courageously she played her part. Gently bred, discerningly amiable, and very young for a responsibility so great, she showed all the judgements, discretion, determination, and organizing power demanded in that contest with a Government of clever men, determined at all costs to defeat us. Her loyalty was complete!'

CHRISTABEL PANKHURST, UNSHACKLED: THE STORY OF HOW WE WON THE VOTE, 1958, P. 249.

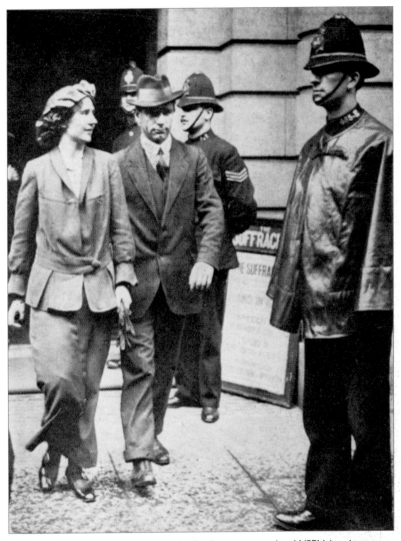

Grace Roe, organizer and deputy-leader, being arrested at WSPU headquarters, 23 May 1914. In 1912 Grace Roe was responsible for organizing the suffragettes' presence at the North West Norfolk by-election, and the Dublin campaign on behalf of three of their members in Mountjoy Prison, charged with 'firing' the Theatre Royal. She ensured that people were made aware of the suffering of the hunger-striking women. During 1913 she organized Emily Wilding Davison's funeral procession in London while she was Annie Kenney's understudy, becoming deputy-leader in the autumn when Kenney was arrested and sent to prison. Here Grace is being escorted from Lincoln's Inn House, charged with conspiracy, after a police raid on a flat in Maida Vale found an arsenal of suffragette window-smashing equipment. No evidence to incriminate her was found and she refused to submit to the trial. She had to be lifted into the dock and shouted throughout the proceedings. While on remand she went on hunger strike and was force-fed. Appearing at Marylebone Police Court six days later, drugged to reduce her resistance to force-feeding, she struggled to describe the torture of her force-feeding experiences. The case was adjourned because of a lack of witnesses.

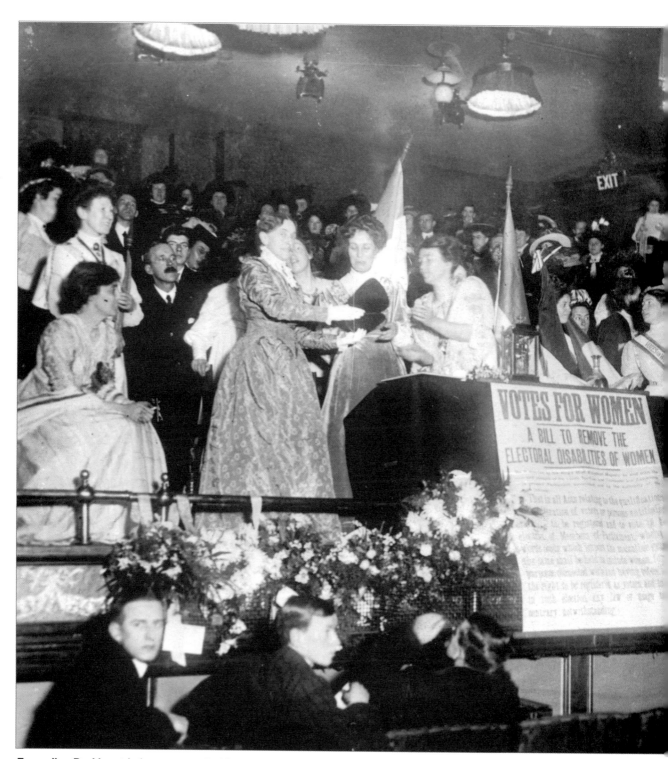

Emmeline Pankhurst being presented with an amethyst, pearl and emerald necklace at the Queen's Hall, Langham Place, London, 14 January 1909. Left to right: Mabel Tuke (seated); Clara Mordan (standing), who made the presentations, 'a pioneer in the higher education of women'; Emmeline Pankhurst (standing); Emmeline Pethick-Lawrence (standing); Christabel Pankhurst (seated); and Annie Kenney (seated). While their leader was in prison, Mabel Tuke had asked WSPU members, through the pages of *Votes for Women*, to contribute towards the gift. (On the same evening Mary Leigh was presented with a clock.) The colour scheme was much in evidence, not only in the choice of stones for the necklace, but also the flags, flower arrangements and dress of the audience were a riot of purple, white and green.

'To our revered and beloved leader, Mrs Pankhurst, founder of the Women's Social and Political Union, we present on the occasion of her release from Holloway, the deep devotion of our hearts, although we feel that this devotion can find adequate expression only in a life-time of loyalty to those principles of justice and freedom for which she has already twice suffered imprisonment. We desire her acceptance of a small token of our gratitude and love. This chain of amethysts, pearls and emeralds we ask her to wear for our sake as a symbol of the dignity, purity, and hope which she has wrought into our lives by the power of her great passion for humanity. . . .'

FROM THE INSCRIPTION ALSO PRESENTED TO EMMELINE PANKHURST AND QUOTED IN VOTES FOR WOMEN, 21 JANUARY 1909, P. 276.

BEHIND THE SCENES AT SUFFRAGETTE HEADQUARTERS

Clement's Inn was the centre of operations. From here the plans of the WSPU were turned into direct action. Politicians were to be interrupted and questioned. Liberal MPs were to be challenged and ridiculed during by-election campaigns. The daring 'Pestering the Politicians' campaign, which targeted Cabinet Ministers when they were 'off duty', was arranged. The huge set-piece demonstrations like Women's Sunday of 1908, the Women's Exhibition of 1909, the processions of 1910, the Women's Coronation Procession and Christmas Bazaar of 1911, and deputations to the House of Commons were also planned in detail in these offices.

As well as these major ventures, the less prestigious but equally significant every-day activities of the campaign were coordinated on the premises too. Notices of meetings had to be chalked on pavements, and propaganda material written and sent out for design and production. 'Suffragette scouts' on bicycles were briefed to circulate and 'rouse' the suburbs. Large indoor meetings required tickets, while outdoor meetings had to be arranged and advertised, and summer holiday campaigns planned and supplied with packs of postcards, pamphlets, books and handbills. Most of this dogsbody work was carried out by unpaid volunteers.

The highly successful weekly newspaper *Votes for Women* was written at Clement's Inn. Circulation drives and competitions boosted the readership figures and increased the classified advertising revenue. It was very much the

mouth-piece of the Pankhurst leadership and its editors and underwriters, the Pethick-Lawrences. Surviving copies of the paper provide a vivid week-by-week insight into the running of one of the most brilliantly and imaginatively organized and successful British political campaigns of the twentieth century. Clement's Inn itself no longer exists; it was destroyed by bombs during the Second World War.

'A description of the offices would be incomplete without a reference to the system of electric clocks which go through every room, and which are electronically controlled from a central clock in Miss Kerr's office, thereby ensuring perfect time, and preventing the waste of valuable minutes in catching trains and keeping appointments. Another noteworthy feature is the telegraph system. Three main lines connect the Union with the Exchange, and an "extension" is made to every department in Clement's Inn and to The Woman's Press, which is also separately linked up to the Exchange. In this way any member of staff can be "put through" to any other member on the Exchange without delay, and an immense saving of time is effected. The main telephone instrument is in the outer office, and is a source of great use to the visitors.'

VOTES FOR WOMEN, 1 SEPTEMBER 1911, P. 766.

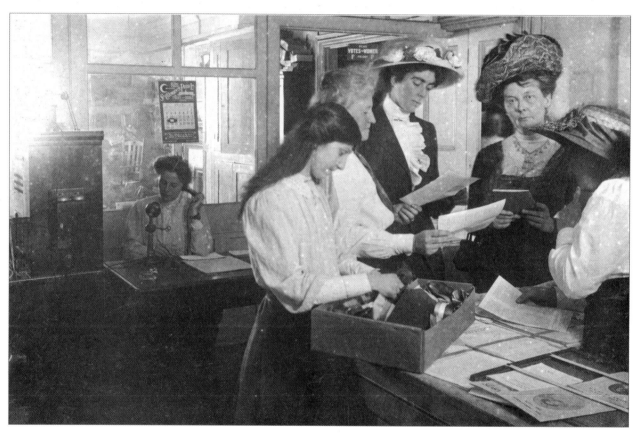

The general offices at the WSPU headquarters, Clement's Inn, September 1911. This room also served as the Visitors' Entrance and telephone exchange, and sold propaganda handbills, pamphlets, and purple, white and green ribbon and badges.

'What won was good organization, stamina, morale, good friendship, loyalty, burning zeal, cooperation, and correlation of ideas in all departments.'
ANNIE KENNEY, MEMORIES OF A MILITANT, 1924, P. 81.

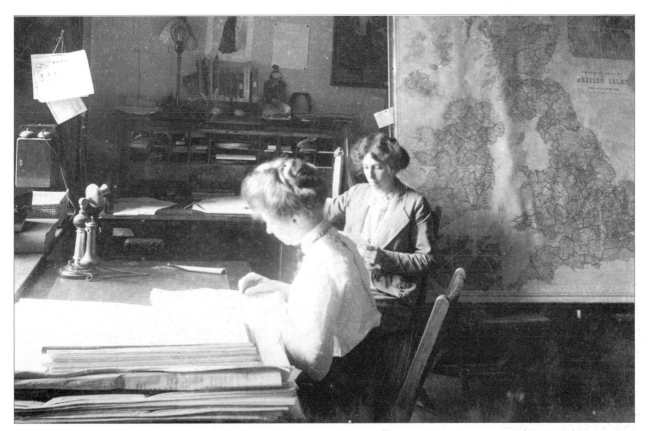

The office of Jessie Kenney (right), Clement's Inn, July 1911. The nationwide scope of the suffragette campaign is evidenced by the map of the United Kingdom on the back wall. By the time this photograph was taken the WSPU had offices in Brighton, Reading, Birmingham, York, Liverpool, Manchester, Newcastle, Bristol, Leicester, Nottingham, Manchester, Leeds, Newport in Wales, and Dundee, Glasgow and Edinburgh in Scotland.

'I made the suggestion to my wife [Emmeline Pethick-Lawrence] that we should start to edit a newspaper devoted to the cause. As up till a few months previously I had been the editor of a London evening newspaper, I thought that this would probably be our most effective contribution to the campaign. . . . There is something organic and individual about a newspaper, and my co-editor and myself looked forward to the birth of our venture with parental anxiety. . . . All the editorial work of the first [monthly] paper was done by my wife and myself, but there were also articles by Christabel Pankhurst and Sylvia Pankhurst, and a speech by Annie Kenney. The circulation of the first number was 2,000 copies, and the paper had no advertisements. The paper ran for five months in the form in which it was started. At the end of April 1908, the pressure on its space had become so great that it was found necessary to publish it every week. At this time the circulation was about 5,000 copies, and a few advertisements had begun to take their place in its columns. . . . Up to this time [mid-1908] my wife and I had regarded the paper as an experiment, and had undertaken all financial liability ourselves, but with the commencement of the year 1909 we decided that the paper was now sufficiently established and handed it over to the Women's Social and Political Union.'

VOTES FOR WOMEN, 14 JULY 1911, PP. 678–9.

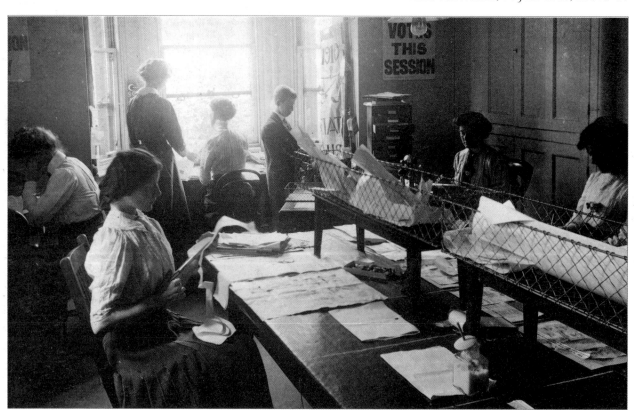

The editorial department, Clement's Inn, September 1911. That week's edition of *Votes for Women* is being cut and pasted by the young woman volunteer at the 'making-up table'. By the summer of 1911 the labour required to produce a weekly issue of the paper had increased sixtyfold from the earliest monthly editions in 1907.

HOW YOU CAN HELP

'1. Canvass with your collecting card. Of all the different methods of raising money, this is the most profitable. Every member should send in a well-filled card.

'2. Send your jewels and other valuables to Headquarters, to be sold for the good of the Movement.

'3. Send goods such as farm produce, home-made cakes, sweets, jams . . . pickles and fancy articles of all kinds to our London and provincial shops.

'4. Arrange any of the following either in your own home or in halls:— teas, soirées, whist drives, cake and candy sales, theatricals, dances, concerts, white-elephant sales . . . bazaars, home-made teas . . . etc.

'5. The following open-air schemes are in hand, help with some of them:— street-selling of flowers . . . violin playing in the street, pavement artists, stalls in country markets, barrows of fruit and flowers to be taken round in the town and country, street collecting.'

WSPU HANDBILL, 1913.

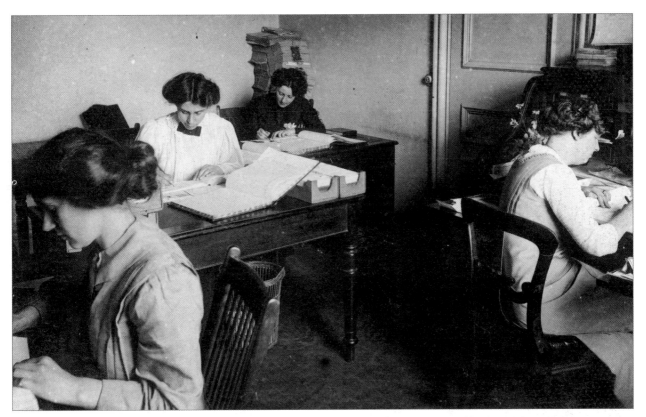

The treasury department, also known as the Financial Secretary's office, Clement's Inn, September 1911. Fund-raising was vital to the success of the WSPU campaign, and here it excelled. Emmeline Pethick-Lawrence helped raise the equivalent of £3 million in just five years. One of their main objectives was to fill 'The War Chest' with monies with which to fight the campaign, or the 'Holy Crusade for Women's Freedom', a term they used frequently.

'Sir, – For man, the physiological psychology of woman is full of difficulties. He is not a little mystified when he encounters in her periodically phases of hypersensitiveness, unreasonableness, and loss of the sense of proportion. . . . These upsettings of her mental equilibrium are the things that a woman has most to fear; and no doctor can ever lose sight of the fact that the mind of woman is always threatened with danger from the reverberations of her physiological emergencies. It is with such thoughts that the doctor lets his eyes rest upon the militant suffragist. He cannot shut them to the fact that there is mixed up with the woman's movement much mental disorder; and he cannot conceal from himself the physiological emergencies which lie behind. The recruiting field for the militant suffragists is the million of our excess female population – that million which had better long ago have gone out to mate with its complement of men beyond the sea.'

SIR A. E. WRIGHT, THE UNEXPURGATED CASE AGAINST WOMAN SUFFRAGE, 1913, PP. 77-8,
REPRINT OF A LETTER TO THE TIMES, 28 MARCH 1912.

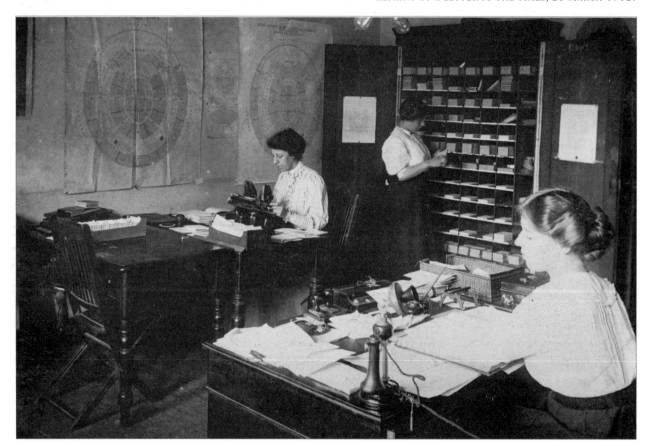

The ticket office, Clement's Inn, September 1911. On the back wall a plan of the Royal Albert Hall, one of the suffragettes' favourite and most prestigious of all venues, is visible. 'Monster meetings' and rallies were held there, when stirring speeches were made, suffragettes told moving accounts of their experiences of force-feeding, and large sums of money were given and pledged for the campaign. Items of jewellery also went into the collecting plate. The Circulation Manager, whose job it was to boost the sales of *Votes for Women*, also worked in the ticket office.

'The failure to recognize that man is the master, and why he is the master, lies at the root of the suffrage movement. By disregarding man's superior physical force, the power of compulsion upon which all government is based is disregarded. By leaving out of account those powers of the mind in which man is the superior, woman falls into the error of thinking that she can really compete with him, and that she belongs to the self-same intellectual caste. Finally, by putting out of sight man's superior money-earning capacity, the power of the purse is ignored.'

SIR A. E. WRIGHT, THE UNEXPURGATED CASE AGAINST WOMAN SUFFRAGE, *1913, PP. 71–2.*

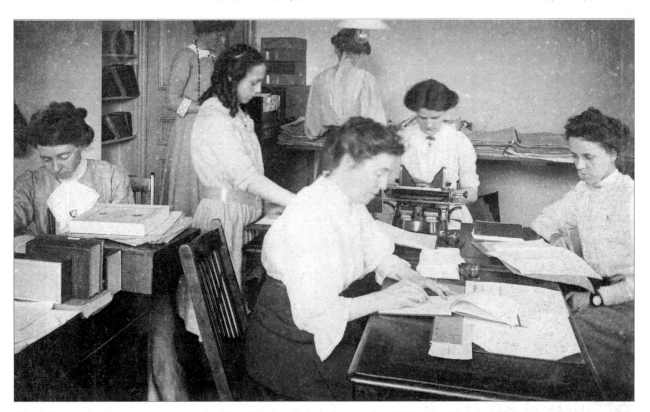

The information bureau and record office, Clement's Inn, September 1911. Also filed and kept in this office were copies of every newspaper report concerning the union's activities. These young women are evidence of the 'white blouse revolution', the feminization of clerical work which started in the 1880s. This was at its height during the Edwardian period, the numbers of women employees in commercial offices increasing from 7,444 in 1881 to 146,133 in 1911, and in the Civil Service from 4,657 to 27,129.

'There were hosts of casual volunteers who came in to address envelopes and wrappers for a few odd hours, the plague of good Miss Kerr, who found it well-nigh impossible to impose upon them her excellent order, and to prevent a distracting babel of talk and laughter arising from their tables.'

SYLVIA PANKHURST, THE SUFFRAGETTE MOVEMENT, 1931, P. 224.

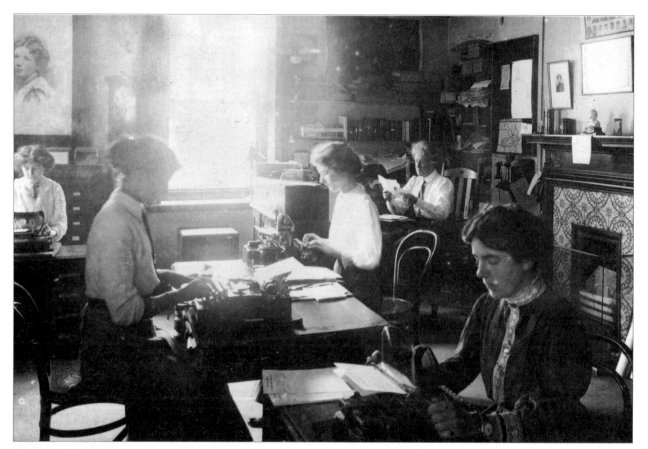

The inner office run by the General Office Manager, Miss Kerr, Clement's Inn, September 1911. Miss Kerr, seen at her desk in the top right-hand corner, had owned a secretarial agency but gave up the business to work for the WSPU. The posters and photographs adorning the office give some clue as to the esteem in which the suffragette leaders were held. On the far left is a poster of Christabel Pankhurst and above the mantelpiece is a framed photograph of Emmeline Pankhurst, below which is a marble bust, also of Emmeline.

'WANTED comfortable homely lodgings near Clement's Inn, for four young suffragettes. Single bedrooms. Joint sitting room. Good attendance suffragette landlady preferred. Box 29 Votes for Women *offices, 4 Clement's Inn.'*

<div align="right">VOTES FOR WOMEN, *1908, PP. 67–8.*</div>

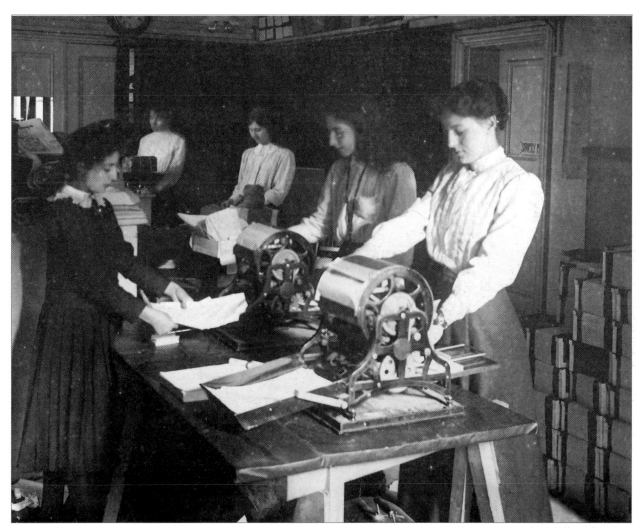

The duplicating office, Clement's Inn, September 1911. Thousands of consciousness-raising propaganda handbills were duplicated in this room and sold cheaply to WSPU members, who then gave them away on the street, outside railway stations, and after football and cricket matches. By the end of 1910, the salaried staff of the WSPU numbered only 110 nationwide, an indication of how the backbone of the army of workers who took part in the campaign were volunteers, like the young women featured in this photograph.

'TO SUFFRAGETTE SPEAKERS — MISS ROSA LEO trains pupils in Voice Production for Public Speaking — Open-air Speaking a speciality. She has had great success with members of the NWSPU. Miss Barbara Ayrton says: "It is entirely owing to Miss Leo's training that I am able to go through by-election campaigns, speaking for hours daily in the open air without suffering any fatigue or loss of voice." For terms apply, 45 Ashworth Mansions, Elgin Ave, W.'

VOTES FOR WOMEN, 3 JUNE 1910, P. 587.

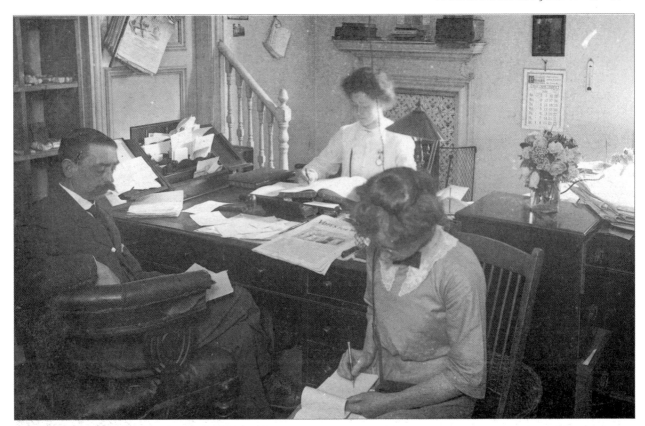

The advertising and book-keeping staff at work in the advertising department, Clement's Inn, September 1911. Editorials in *Votes for Women* urged readers to patronize those firms or individuals who took advertising space in the newspaper. It was anticipated that if advertisers gained business from the suffragettes it would encourage them to take yet more space and thus yield higher revenue for the WSPU, all of which would be vital to 'The War Chest'.

'. . . To the WSPU and even more to its contributors, the paper was an asset, as a paper always is to those who express through it their beliefs and desires. . . . I had a series of articles on the early history of the movement in the first year of the paper, and on the militant movement in the second year. . . . The WSPU and its members made tremendous efforts to extend the circulation of the paper. It was advertised by four-in-hand coaches, women on horse-back, poster and umbrella parades, boats, kites, pavement chalking, and canvassing. Members canvassed shops for advertisements, stood in the gutter to sell it in Piccadilly, Fleet Street, the Strand and anywhere and everywhere of prominence in London and the provinces, and paid for its posters to be exhibited at shops and stations.'

SYLVIA PANKHURST, THE SUFFRAGETTE MOVEMENT, 1931, PP. 268–9.

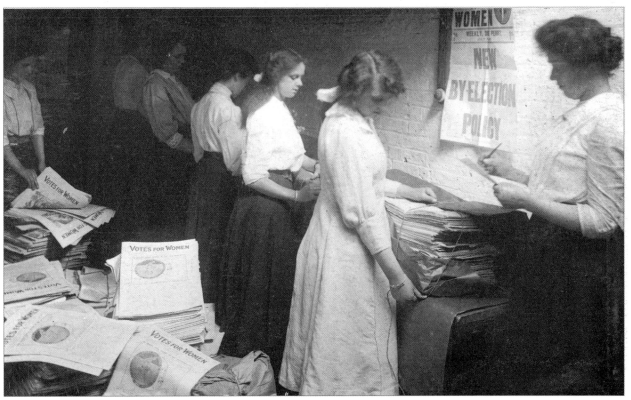

Packing and despatching *Votes for Women* at The Woman's Press, No. 156 Charing Cross Road, September 1911. The newspaper went on sale on Thursdays and wholesalers like W.H. Smith and John Menzies sold it alongside their other dailies and weeklies. For every paper sold the WSPU reckoned it was read by three other people. Regular features included: 'Women in other Lands', about feminism and suffragism all round the world; details of the Union's processions; and fund-raising bazaars and reports of the progress of any legislation going through Parliament which had an impact on women's lives.

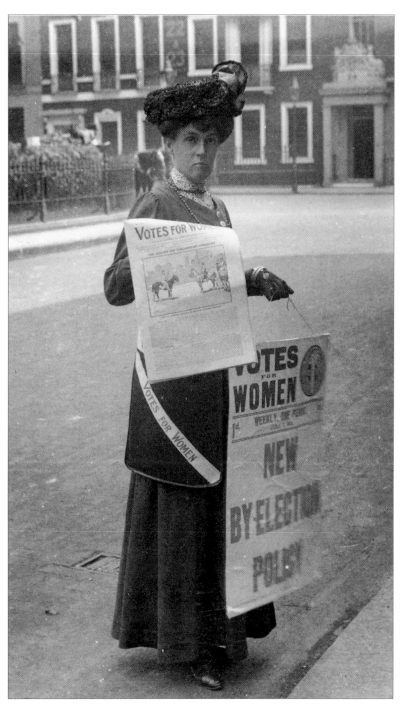

'*Miss Kelly, the captain of the Charing Cross pitch, is representative of all the army of paper sellers up and down the country who by their untiring devotion have brought the paper to its present position. To this splendid army and to the individual members who today are adding new readers one by one to swell the grand total of thousands, every worker for the cause owes that delightful gratitude which comes from fellowship in combined labour.*'

VOTES FOR WOMEN, 14 JULY 1911,
PP. 678–9.

Miss Kelly selling *Votes for Women* in central London, July 1911. She is carrying a purple, white and green canvas satchel, which held forty-eight copies of the newspaper, and slung across her chest is a poster advertising the editorial comment of that issue. The comment in question described the WSPU's new by-election policy which was guaranteed to cause maximum disruption to any Liberal candidate who had to fight for a parliamentary seat. In 1910 a competition had been organized to increase the sales of the newspaper. The two first prizes of suffragette bicycles, painted purple, white and green, went to the two women who sold the most copies and who got the most new subscribers.

HOW TO HELP THE PAPER

'*Ways in which you can help.*

'1. *Get additional readers. Ask them to fill in, or fill in for them, one of the forms enclosed in this issue. Note that wherever possible copies should be ordered through the nearest newsagent.*

'2. *Do not be content with buying a single copy each week, but take in a number of copies and be responsible for selling them. Some readers in this way may take in 100 copies each week, others 50 and a great many a dozen. You will find special opportunities for selling them outside theatres and meetings, at cricket matches and on the river and elsewhere.*

'3. *Offer yourself to Miss Mills at the head office at Clement's Inn or at your local office as one who is willing to take papers out "on sale" in the street.*

'4. *Offer to help with the sale of* Votes for Women *at all meetings of the WSPU. If you are taking the chair at any of the meetings be sure to refer to the paper very particularly and at the close of meetings sell copies of the paper from the platform.*

'5. *Undertake a regular canvass of newsagents in your locality, pointing out the advantage of exhibiting a poster. Before you do you should put yourself in touch with Miss Mills.'*

VOTES FOR WOMEN, 2 JULY 1909, P. 870.

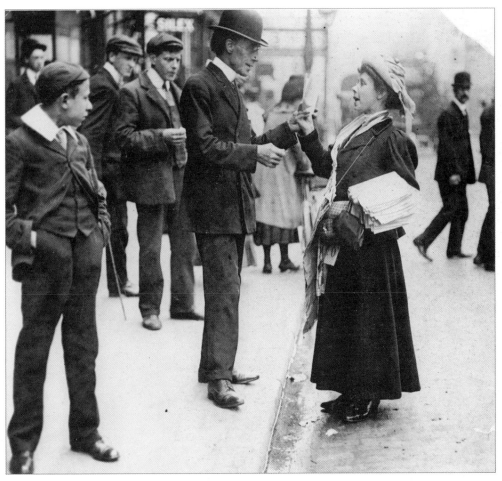

Mary Phillips selling *Votes for Women* in London, October 1907. She stands in the road and not on the pavement, else she would have run the risk of being arrested for obstruction. A poster advertising the issue is tied round her neck with a piece of string. Her customer seems to be holding her hand while he takes the paper from her. The other men in the photograph look on with some curiosity, and one is so interested in the scene that he walks across the road, unconcerned by the traffic. Suffragettes are frequently photographed with men staring at them in amazement.

'In the first were Miss Shepperd (driving) and the Princess Sophia Duleep Singh; in the second the Honorable Mrs Haverfield (driving) and Mrs Robson and in the third Miss Douglas Smith and Lady Constance Lytton . . . at the theatres where matinees were being given a halt was made and Votes for Women sold.'

VOTES FOR WOMEN, 21 JULY 1911, P. 688.

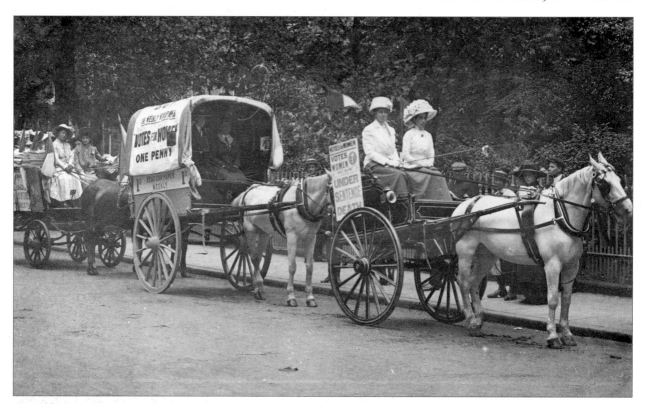

'Press Carts' delivering *Votes for Women* to various pitches in central London, July 1911. Women undertaking such 'unwomanly' and 'unsexing' activities such as this made a strong and often unfavourable impression on passers-by. All the women in this photograph would have been dressed in and carrying accessories of purple, white and green to maximize their impact. The poster advertising this issue refers to a Mrs Napolitano. Members of the public enquired about the woman, and drove off to Clement's Inn to sign a petition for her pardon.

'A novel way of advertising the new issue was adopted . . . when an omnibus covered with notices in the purple, white and green of the Union was driven through the principal streets of the West End by Miss Douglas Smith, while Miss Barbara Ayrton acted as a conductor. . . . People who cheered the women were apparently much struck by the fact that a woman should be capable of driving so ponderous a vehicle safely through the traffic. . . . A trumpeter on the roof drew attention to the omnibus as it went along and as the various pitches were reached, women alighted and left fresh supplies of the paper with the sellers.'
VOTES FOR WOMEN, 8 OCTOBER 1909, P. 29.

Barbara Ayrton on the bottom stair of the *Votes for Women* bus, October 1909. Barbara Ayrton is wearing the suffragette uniform. Publicity stunts such as this were used from the beginning of the campaign and were intended to make the public stop, look, listen and support the suffragettes' demands.

'The Suffragette Punt was a great success. Many papers were sold and much interest aroused. Many thanks to Mr Lowy for lending his punt for the week and to those members who lent cars to take the helpers to and from Henley.'

<div align="right">

THE SUFFRAGETTE, 11 JULY 1913, P. 663.

</div>

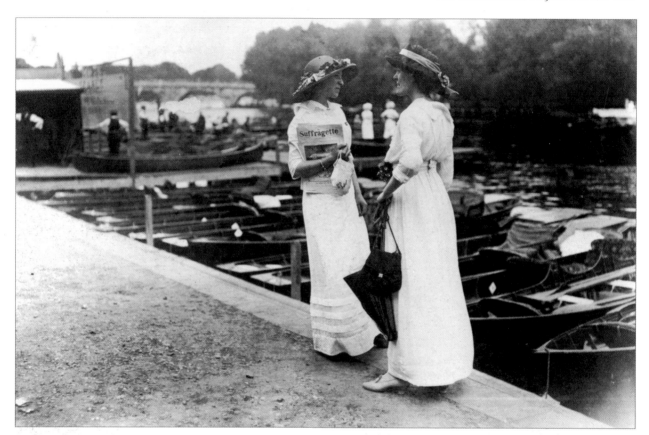

Two suffragettes selling the *Suffragette* at Henley Regatta, July 1913. By this date the newspaper could be bought in Paris, Vienna and New York. Public support, such as it had been, was evaporating during the final two most militant years of the suffragettes' campaign. It was becoming increasingly dangerous to admit to being a suffragette and many were attacked by members of the public who were outraged at the arson attacks and window-smashing raids carried out by the campaigners. These two women were not harmed that day, but certainly did not dare to take the same risk the following year at the same event.

'Yes, the King would not receive Mrs Pankhurst and her companions but he has received Militant Men! . . . Mrs Pankhurst is voteless and the women she represents are voteless. It is because of that difference of political status that Mr John Redmond and other men have been received by the King, and that Mrs Pankhurst and other women were not received but were assaulted and arrested instead. . . . The King did not merely receive them, what is far more significant he invited as well as received men who are militant, men who are committed to the policy of destroying more property, – of destroying life itself. And again, the King did not merely invite and receive these men; he also made a speech to them. And in that speech he condoned militancy. . . . The Militant Women will not forget the moral support of Militancy spoken by the Royal tongue! The cry of Militancy is on the lips of the most responsible and sober-minded of the King's people – on the lips, that is to say, of women who, were they voters as men are, would never have disturbed the peace, broken the law or attacked property.'

THE SUFFRAGETTE, 31 JULY 1914, P. 280.

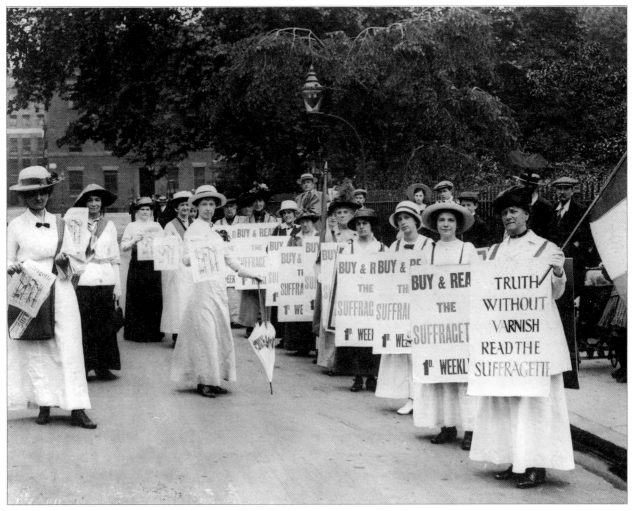

Suffragettes on a 'poster parade' selling the *Suffragette*, 31 July 1914. This would be the last full week of the suffragette campaign before the outbreak of the First World War on 4 August 1914. While there was (some) safety in numbers, it was a brave act to parade their allegiances so openly when suffragettes were regarded as Public Enemies. Here, however, the women proudly carry their newspaper satchels and their flags, and one woman has a purple, white and green parasol (unopened). The front page of the issue they are selling is a gruesome illustration of a suffragette being force-fed. The headline screamed: 'Militant Women Tortured – Militant Men Received by the King', referring to the refusal of King George V to accept a WSPU petition, presented on 21 May 1914, asking him to support their campaign.

PURPLE, WHITE AND GREEN

Colourful Propaganda

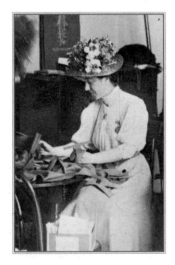

Technological change often precedes social and political change. The suffragette campaign – in particular its use of propaganda – derived enormous benefit from the advent of the new technology of the 1880s, and its members gladly put to use the various new inventions – the telephone, the typewriter, the telegraph system, the improving postal system, as well as the development of photography and printing. Some of the volunteers were young female office workers, part of the revolution that was taking place in the field of employment as women began to take over work which had previously been the preserve of male clerks. Many of them had broken the social conventions of their families and had taken up paid employment in the public domain. They were skilled in this work, and familiar with the technology.

Thousands of propaganda postcards and photographs give a vivid impression of the campaign and graphically document the struggle. By the Edwardian era photography was well established and technically quite sophisticated, hence the many press photographs taken for newspapers, studio portraits, and snapshots. The suffragette movement coincided with the heyday of the picture postcard, and the women took advantage of its popularity. Sympathetic postcard artists and printers produced propaganda material in response to the crude and stereotypical cards of the 'Anti-movement'.

The Edwardian era also saw a boom in the number of newspapers, and the various morning and evening editions all reported on the movement. Though in

the first three years of the campaign there was a marked reluctance among newspaper editors and journalists to write about the suffragettes' activities, once the WSPU relocated its national headquarters in London, it became impossible for them to avoid doing so. The suffragettes were determined headline-grabbers, and were accomplished at staging publicity stunts which could not be ignored. However, by the end of the campaign, when militancy seemed to be spiralling upwards and the public expressed its outrage, newspaper editors and proprietors were delighted to report this aspect. Under screaming banner headlines, they announced that this was what they had predicted would inevitably happen to women who joined this type of organization. While the suffragettes despaired of the prejudices of the press, they viewed all publicity as good publicity for their cause.

The fact that suffragette activities were so well publicized and so frequently reported facilitated the speed with which the public equated the WSPU with its colours and its slogan, 'Votes for Women'. The purple, white and green scheme was heavily marketed and merchandized by the suffragette leadership. No political campaign before or since the WSPU has used a colour scheme so comprehensively and so effectively. Retailers and entrepreneurs identified suffragettes as valuable customers with money to spend, and stocked a wide variety of purple, white and green fashion items. Leading department stores in London and the provinces filled their windows with the WSPU's colours. Even bakers and coal merchants got on to the bandwagon of fashion, politics and economics: in 1910 the wrappers for Allinson's wholemeal bread were printed with a 'Votes for Women' slogan, and a number of coal merchants urged suffragettes to buy their coal for a warm fire after a hard day of campaigning.

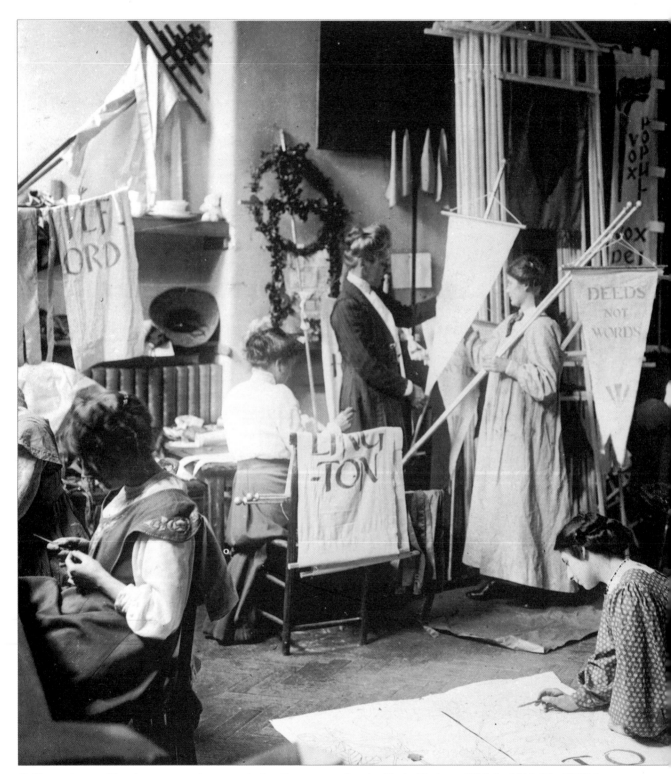

Suffragettes making banners and pennants for the procession to Hyde Park on 23 July 1910. The WSPU's motto
'Deeds Not Words' is the legend on one. The date was chosen because it was the anniversary of the Men's Franchise
Demonstration of 1866 when the railings in Hyde Park were torn down. It was hoped that the public would be reminded that male
suffrage had not been a quiet and peaceful affair. At the time this photograph was taken the Artists' Suffrage League, responsible for
many of the WSPU's banners, had its atelier at No. I Pembroke Cottages, Edwardes Square, Kensington.

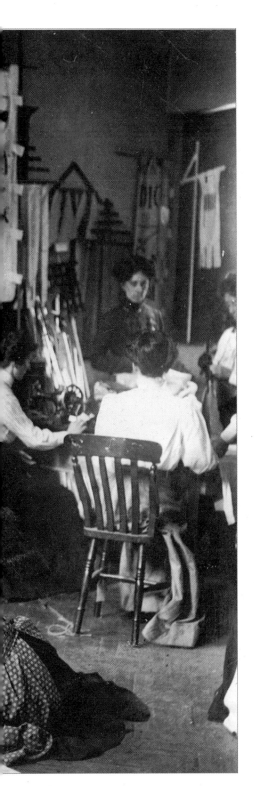

'Great numbers of banners have been seen of late in the streets of London; some beautiful in themselves, many picturesque in effect, and some indifferently ugly and dreary. Banners, however, of one sort and another have evidently been associated with the appearance of women in public. . . . In all ages it has been women's part to make banners, if not to carry them. . . . A little must now be said on the subject of material. Never use anything ugly because it is expensive or because it is cheap. Do not use the wrong colour or the wrong tone because you have a piece of something 'over' which would 'just do'. If it is not exactly right it won't do at all.

'Can we make the banner ourselves? is a question often asked by the inexperienced. I would reply to it with another inquiry. If you want a new pair of winter curtains for your dining-room, can you make them yourself, so that they shall hang straight and true and the linings be not puckered? If you can, I think you can make the banner. If such a task is beyond you, there are many women competent to undertake it, and you must call in the more experienced worker.'

MARY LOWNDES, ON BANNERS AND BANNER-MAKING, 1909, PP. 1–5.

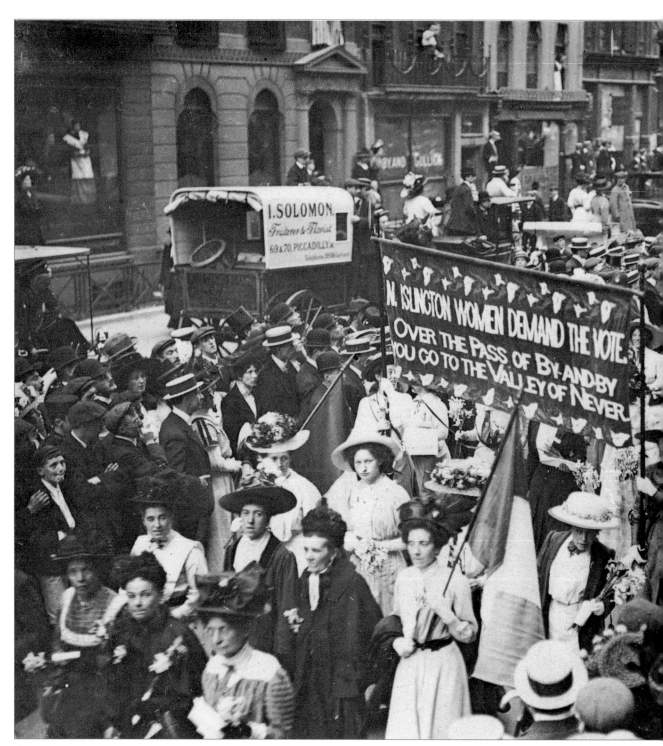

Suffragettes en route to Women's Sunday, held in Hyde Park, 21 June 1908. Although there was no local WSPU branch, the women of North Islington were well represented on this procession, with three banners. They had 'formed up' as part of the Euston Road contingent, one of seven such contingents which converged on Hyde Park that day. Six brass and silver bands accompanied the women, playing stirring marching music and suffragette songs.

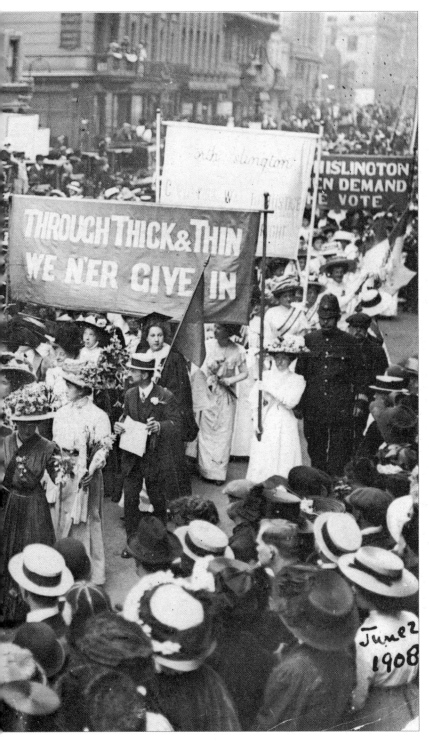

CERTAIN PRACTICAL SUGGESTIONS

'Perhaps the best size for a single-pole banner is three feet two inches broad by four feet six inches long. The Artists' Suffrage League has invented a double hook, made on the lines of those used for church banners which is fixed to the upright pole at about one foot from the top, and which prevents the banner from swinging round when carried; it may be obtained from the Secretary, price six pence.

'A good size for a double-pole banner is fifty inches broad by six feet long. This is the size of most of the banners made under the directions of the Artists' Suffrage League, though some are a little larger. It will be found that banners four feet six inches wide by six feet six inches long are as long as women bearers can carry should there be any wind. A very good screw-hook, proved to be the simplest and most secure method of mounting the double-pole banner, is to be had from the Artists' Suffrage League, price four pence each. These were invented for Suffrage use, and are forged by a Chelsea smith. . .'

MARY LOWNDES, ON BANNERS
AND BANNER-MAKING, 1909, P. 5.

'It may be laid down as a broad general rule that only two classes of men have the cause of women's suffrage really at heart. The first is the crank who, as soon as he thinks he has discerned a moral principle, immediately gets into the saddle, and then rides hell for leather, reckless of all considerations of public expediency. The second is that very curious type of man, who when it is suggested in his hearing that the species woman, is, measured by certain intellectual and moral standards, the inferior of the species man, solemnly draws himself up and asks, "Are you, Sir, aware that you are insulting my wife?"'

SIR A. E. WRIGHT, THE UNEXPURGATED CASE AGAINST WOMAN SUFFRAGE, 1913, P. 2.

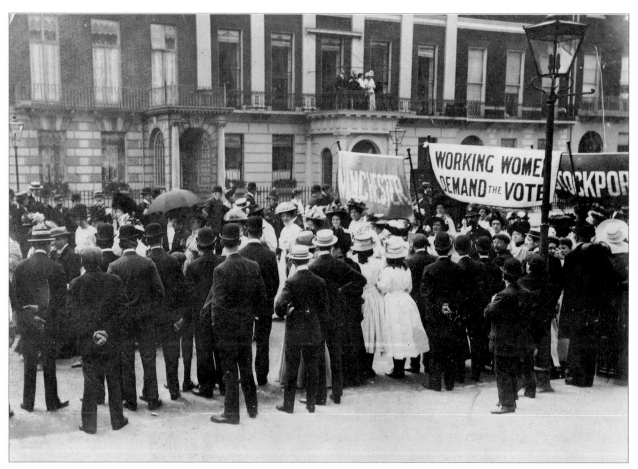

A small crowd watches the Women's Sunday procession as it passes Portland Place, 21 June 1908. The protesters are almost at the end of their walk to Hyde Park.

'A banner is a thing to float in the wind, to flicker in the breeze, to flirt its colours for your pleasure, to half-show and half-conceal a device you long to unravel; you do not want to read it, you want to worship it.'

MARY LOWNDES, ON BANNERS AND BANNER-MAKING, 1909, P. 3.

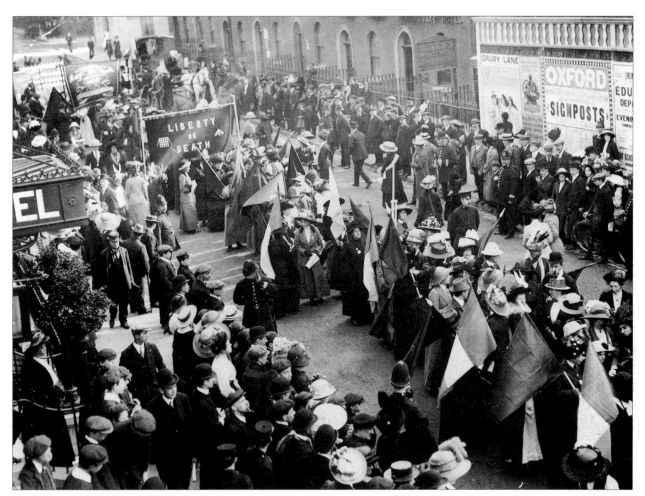

Suffragettes marching from King's Cross to Tower Hill to show their support for Mary Leigh and Gladys Evans, who were on hunger strike in Mountjoy Gaol, Dublin, 20 September 1912. The majority of flags taken on this procession were black, reflecting the suffering their two comrades were enduring while being force-fed. The WSPU presented the situation starkly on the large black banner (left): 'Liberty or Death'.

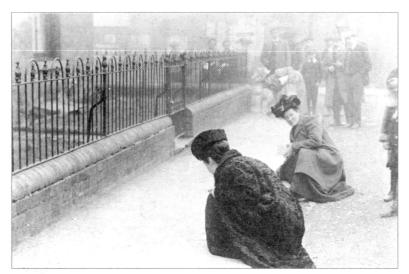

'Volunteers are needed for pavement chalking. This is one of the most effective means of advertisement, as invariably an interested crowd assembles to watch the announcement . . . develop under the hand of the chalker.'

VOTES FOR WOMEN, 11 JUNE 1908,
p. 234.

Emma Sproson (left) and a friend chalking the pavement, 1907. Suffragettes who went on 'chalking parties' had to be careful, they were advised to go in twos or threes, never alone. Purple, white and green chalk was used. Sproson, who was from Wolverhampton, left the WSPU following the departure of Charlotte Despard, Edith How-Martyn and Teresa Billington-Greig to form the Women's Freedom League. She had twice been arrested, serving six weeks in Holloway Gaol and three months in Stafford Gaol, and had a reputation as a 'mob orator'.

'Today in the House of Commons Mr Geoffrey Howard is introducing his Bill for the extension of the franchise. As a Woman Suffrage measure it has already been repudiated by every responsible Woman Suffrage society, and the result of the Second Reading discussion upon which it is a matter of no little importance to women. It has, however, served an excellent purpose in making it clear to the people of this country the exact nature of the demand which women are putting forward for the enfranchisement of their sex.'

VOTES FOR WOMEN, 19 MARCH 1909,
p. 443.

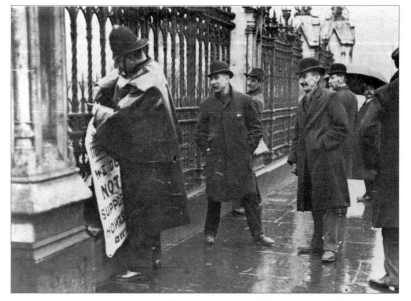

A policeman removes a suffragette poster from the railings in the vicinity of the House of Commons, 19 March 1909. Plastering important places with its propaganda was a favourite WSPU tactic. The onlookers are evidently pleased with the policeman's actions. The poster concerns a Private Member's Bill not favoured by the WSPU, which did not pass its Second Reading in the House of Commons.

'A flash of humour was provided just then, thanks to a Post Office regulation permitting the posting and transmission of human letters. Two suffragettes were duly posted as human letters, at the regulation charge, addressed to the Prime Minister at 10 Downing Street, and were led by a telegraph boy to their destination, where, however, acceptance was refused. "You must be returned: you are dead letters", said Mr Asquith's butler.'

CHRISTABEL PANKHURST, UNSHACKLED: THE STORY OF HOW WE WON THE VOTE, 1959, P. 123.

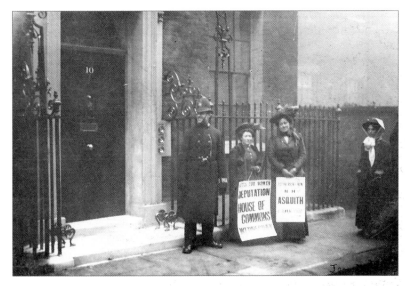

'Human Letters to Downing Street'; two suffragettes outside No. 10 attempt to speak to the Prime Minister, 23 January 1909. Daisy Soloman is on the left and Elspeth McLelland stands next to her. Soloman's mother was a leading figure in the WSPU, and was badly injured on a deputation to the House of Commons at a later date. McLelland had been the only woman among 600 male students at the Polytechnic Architectural School in London, and became the first woman to practice as an architect.

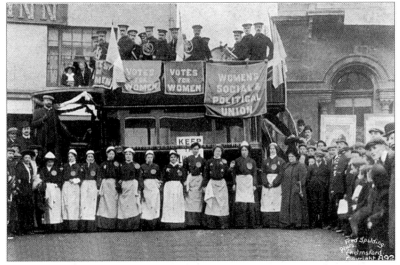

Suffragette prisoners in replica prison clothing campaigning at the Chelmsford by-election, December 1908. The demonstration was organized and led by Flora Drummond (standing at the end of the row on the far right), and was accompanied by a male brass band. The by-election results pleased the WSPU: the Liberal MP polled 2,565 fewer votes than the Conservative candidate, who took the seat. Although it was impossible to prove, the suffragettes always said that they and their campaign were the cause of the loss of Liberal votes.

'The special feature of the week was the demonstration which was held on Saturday last, when the local party, under Mrs Drummond, joined forces with four motor-bus loads of suffragettes coming down specially into the constituency from London. Mrs Drummond has had charge of the general election arrangements, and divided the constituency in two halves. . . . Each centre was supplied with a motor-car. . . . Everywhere the women have been received with the utmost consideration and kindness, and the most hearty support has been given by the local people, who have come to their assistance in all kinds of ways. The shops have displayed the Union colours, and have exhibited for sale many articles in the familiar colours of purple, white and green.'

VOTES FOR WOMEN, 3 DECEMBER 1908, PP. 164–5.

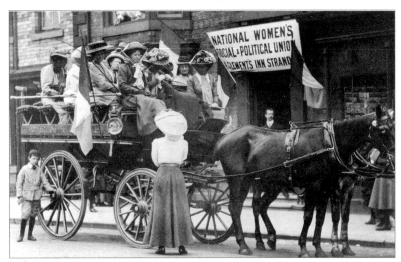

Suffragettes campaigning at the Cleveland by-election, July 1909. The WSPU committee rooms at No. 27 Station Road, Redcar, can be seen in the background. Polling day was 9 July and the sitting Liberal MP, Herbert Samuel, saw his majority slashed by the Conservatives.

'The campaign of the Women's Social and Political Union in Cleveland is being carried out with the utmost vigour and determination. Already the whole district is being covered by a network of centres in which members of the Union are taking up their residence, and from which meetings are being organized to take place in every part of the constituency. . . . Especial attention is being directed to the Liberal strongholds of Redcar (where are the central Committee rooms of the Women's Social and Political Union), Sketton, Guisborough, Ayton, Eston, and Grangetown. Among the active workers who are already on the spot or who are expected shortly are Mrs Drummond, Miss Adela Pankhurst, Miss Elsa Gye, Mrs Taylor, and Miss Rona Robinson at Redcar, Miss New and Miss Benson at Eston, Miss March and Miss Ryland at Sketton, and Miss Cameron and Miss Dora Marsden at Guisborough.'

VOTES FOR WOMEN, 2 JULY 1909, P. 871.

'The woman Suffragists have made a favourable impression upon the electorate, and the miners especially appear to have been thoroughly converted by the new propaganda. Mr Samuel [the sitting Liberal MP], who declines to say that he is in favour of woman suffrage and leaves it to be presumed that he is not, may lose some support on this account. Some miners with whom I have talked would even vote for the candidate who was in favour of woman suffrage without respect to his opinions upon other subjects. To put it more emphatically, a woman suffrage candidate pure and simple as a third candidate would probably have endangered Mr Samuel's re-election quite as much as a candidate of the Labour party. It is the first by-election in which I have seen the electors really aroused in a practical interest in the grievance of a score or two of eloquent women.'

THE TIMES QUOTED IN VOTES FOR WOMEN,
9 JULY 1909, P. 913.

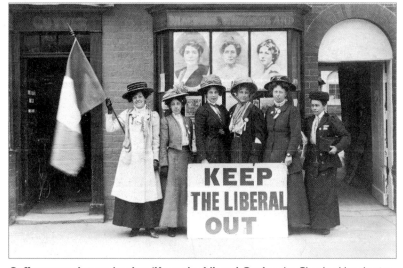

Suffragettes determined to 'Keep the Liberal Out' at the Cleveland by-election, 1909. The window of the temporary premises they rented for the by-election is decorated with posters of the three leading women of the WSPU, from left to right: Emmeline Pethick-Lawrence, Emmeline Pankhurst and Christabel Pankhurst. 'Hit squads' of suffragettes would arrive in a constituency, hire the best public rooms and go to work immediately to try and keep the Liberals out of the House of Commons.

'On Thursday morning a novel form of advertisement, designed by Mrs Marshall, paraded the constituency [South St Pancras]. Special twelve foot green poles were carried on the shoulders of the women. In the centre was affixed a large placard: "KEEP THE LIBERAL OUT", while on either side were suspended the WSPU posters, backed with others advertising the meeting to be addressed by Mrs Pethick-Lawrence, the placards being kept in position by loops of purple ribbon. The bearers wore flowers in the colours, and the whole formed a charming and dainty procession, evoking much admiration from the passers-by. Supplementary workers delivered election addresses and other literature and sold Votes for Women. To judge by the attitude of the onlookers one concluded that South St Pancras desired nothing better than to "Keep the Liberal Out". Everywhere were smiling faces; men driving huge, high-laden lorries towards King's Cross lifted their caps; friendly greetings were exchanged.'

VOTES FOR WOMEN, 21 JANUARY 1910, P. 267.

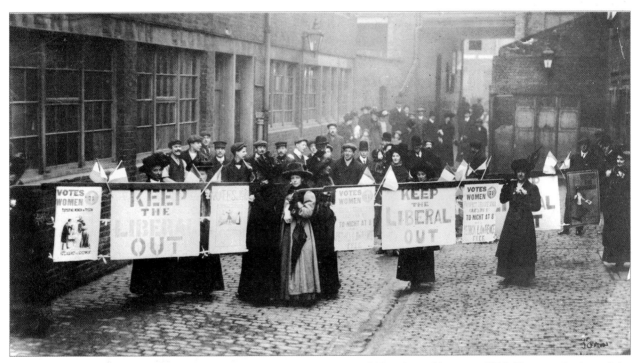

Suffragettes campaigning in South St Pancras during the General Election of January 1910. This was the first of the two general elections of 1910. The candidates on this occasion were the Liberal MP P. W. Wilson, and Captain H. Jessel, the Conservative, who won. The artist Hilda Dallas was in charge of the campaign at the committee rooms at No. 7 St Andrews Mansions, Newman Street.

'The general plan is that several Unions shall cooperate in each demonstration, but as Ealing was somewhat isolated from any other, that gallant little Union bravely assayed to organize its demonstration single-handed, and decided not merely to shoulder the whole responsibility of its effort, but to lead the way for others. . . . All the way there on the train on Saturday I kept catching glimpses of the poster announcing the Ealing and Wimbledon meetings. . . . Outside the station [Ealing] I found a band of our Ealing comrades wearing the purple, white and green sandwich posters announcing the afternoon demonstration. They had been zealously parading their neighbourhood for weeks past, and proudly told me that last week their Ealing parades had numbered nearly twice as many women as those in the City.'

VOTES FOR WOMEN, 7 JUNE 1912, P. 581.

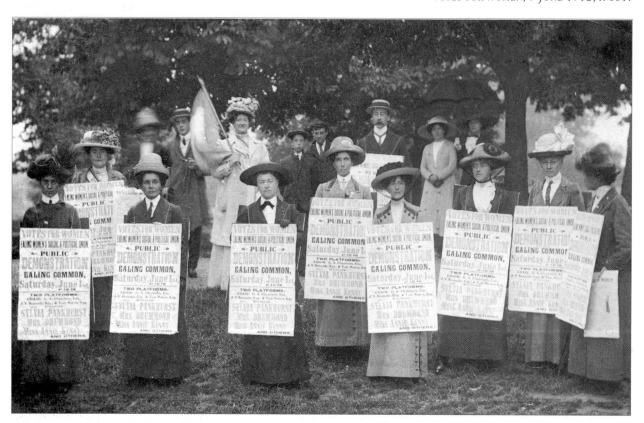

A 'poster parade' of Ealing suffragettes advertising a meeting to be held on Ealing Common on 1 June 1912.
This was one in a series of weekly demonstrations designed to prove there was a popular demand for women's suffrage. As well as the advertised speakers, three local men also took the platform. The Ealing WSPU's branch was at No. 35 Warwick Road.

PREPARE FOR THE SUFFRAGE CAMPAIGN OF 1911

'*You have to meet prejudice with sound argument, opposition with hard facts, and indifference with telling points on the present status of the women. Whatever your work in the coming campaign, whether speaking, organizing, or quietly converting friend and foe, you must be ready with the right thing at the right moment.*'

VOTES FOR WOMEN, 6 JUNE 1911, P. 236.

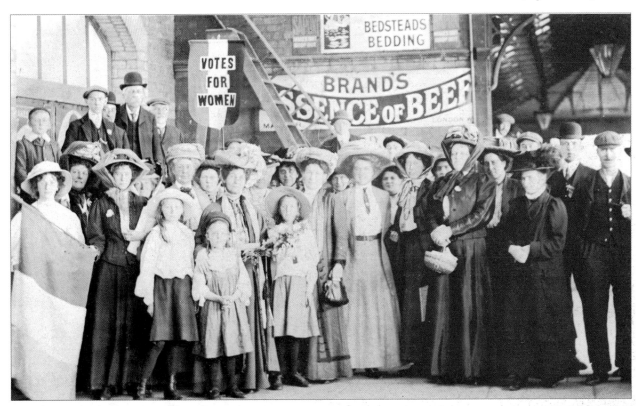

Emmeline Pankhurst at a railway station on a campaign tour of the country, 1911. A large box of propaganda material would have accompanied her, including books entitled *Rebel Woman, Woman's Secret* and *The Wakening of Women*, pamphlets such as *Prison Faces* and *The Brawling Brotherhood*, and leaflets including *What Women Demand, The Suffragettes and their Unruly Methods* and *What Woman Suffrage Means in New Zealand*.

'Audiences are strange things to handle. We were taught never to lose our tempers; to always get the best of a joke, and to join in the laughter with the audience even if the joke was against us. This training made most of the Suffragettes quick-witted, good at repartee, and speakers that an audience took a delight in listening to, even though they did not agree with them, were able to make an audience laugh.'

ANNIE KENNEY, MEMORIES OF A MILITANT, 1924, P. 104.

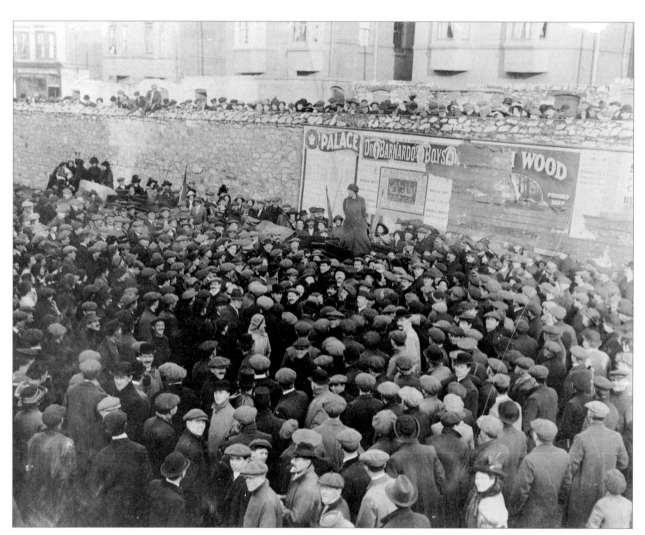

A suffragette addressing a crowd, c. 1908. It took a certain amount of courage to address large gatherings like this, which could turn hostile. Women often had to put up with being pelted with rotting fruit and vegetables and sometimes even dead cats or dogs.

'In the early days I thought nothing of having a hard morning's work sending out handbills and chalking pavements, of speaking at a factory gate at 12 o'clock, of speaking at the docks at 1.30, of holding a women's meeting at 3 and a large open-air one at 7, and when it was over I would address envelopes for letters which I sent out to the sympathizers or members in the district.'

ANNIE KENNEY, *MEMORIES OF A MILITANT*, 1924, P. 126.

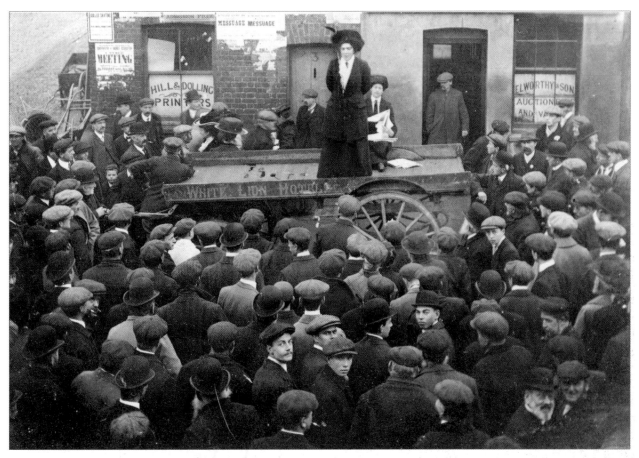

Isabel Seymour addressing a crowd of men and boys from a tradesman's cart, 1908. Seymour worked in the office and Clement's Inn, and was a close friend of the Pethick-Lawrences.

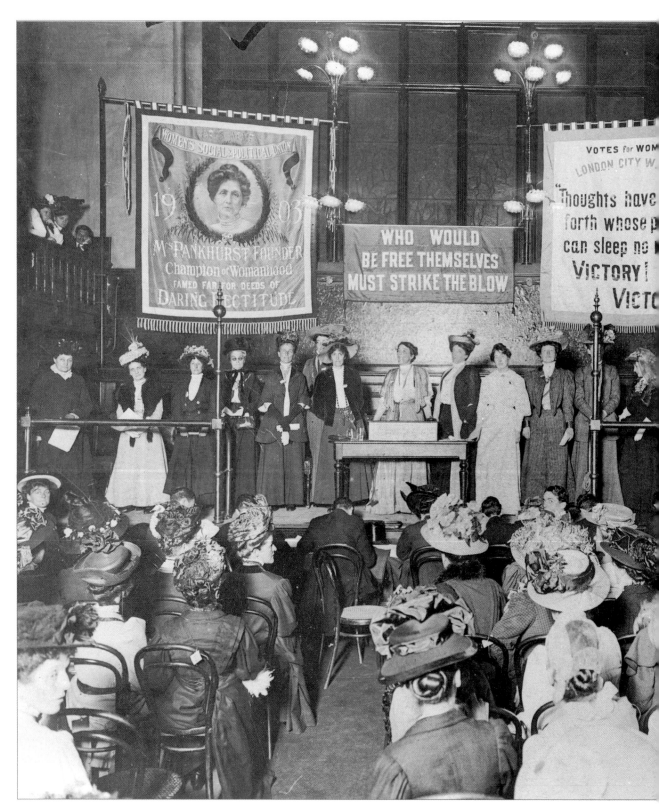

Senior WSPU figures addressing the meeting at Caxton Hall prior to the 'Rush the House of Commons' demonstration on 13 October 1908. At the desk are Mabel Tuke and Emmeline Pethick-Lawrence (left), and Sylvia Pankhurst (right). Emmeline and Christabel Pankhurst and 'General' Drummond were arrested and charged with conspiracy to incite the crowd to 'rush the House of Commons'.

'On the 12th instant Parliament meets to continue the work of legislation. . . . The Bill of Enfranchisement of Women, which earlier in the year passed its Second Reading by a great majority, finds no place in the Government programme, although every effort has been made by women and their friends to convince the Cabinet that it is expedient, as well as just, that the disability of sex should be removed without further delay. . . . On the 13th we meet in the Caxton Hall, and we have asked those who support our demands to assemble in Parliament Square.

'From our meeting in Caxton Hall will be chosen a deputation to go again as deputations have gone before to the House of Commons, to enter the House, and, if possible, the Chamber itself, and lay our claim to the vote before the Government and Parliament.'

VOTES FOR WOMEN, 8 OCTOBER 1908, P. 24.

'One would wish that the educators of the rising generation of women should, basing themselves upon these foundations, point out to every girl how great is woman's debt to civilization; in other words, how much is under civilization done for woman by man.

'And we would wish that, in a world which is rendered unwholesome by feminism, every girl's eyes were opened to comprehend the great outstanding fact of the world; the fact that, turn where you will, you find individual man is showering upon individual woman – one man in tribute to her enchantment, another out of a sense of gratitude, and another just because she is something that is his – every good thing which, suffrage or no suffrage, she could never have procured for herself.'

SIR A.E. WRIGHT, THE UNEXPURGATED CASE AGAINST WOMAN SUFFRAGE, 1913, P. 74.

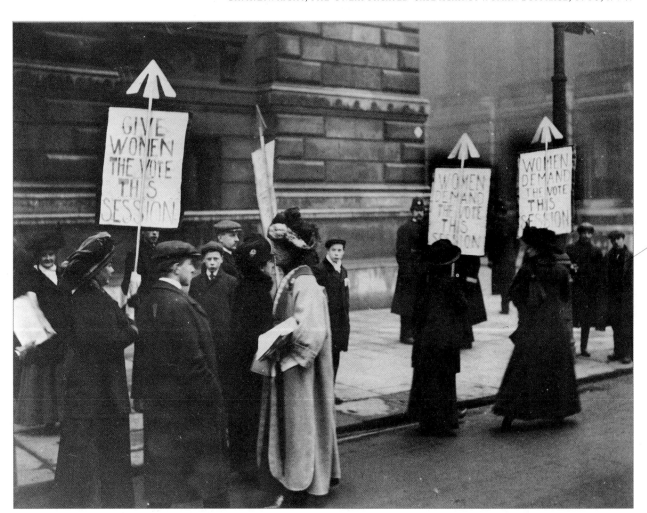

Suffragettes demonstrating at the end of Downing Street, several carrying placards decorated with the convict's arrow, c. 1912. This symbol told passers-by that women, often those carrying the placards at that moment, had been imprisoned for their involvement in the campaign.

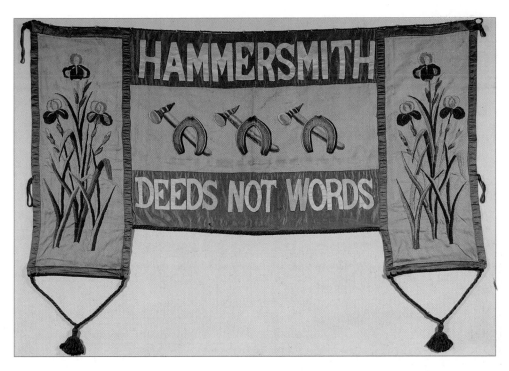

1. The Hammersmith banner. Made of purple, white and green cotton damask, velvet and satinette, this banner was first seen at the Women's Coronation Procession, 17 June 1911. The hammers and horse-shoes represent 'Hammer Smith'. To ensure maximum reversibility, the irises were appliquéd on one side and embroidered on the other. In 1910 Hammersmith WSPU had an office and shop at No. 100 Hammersmith Road; in 1912 it moved to No. 95 The Grove.

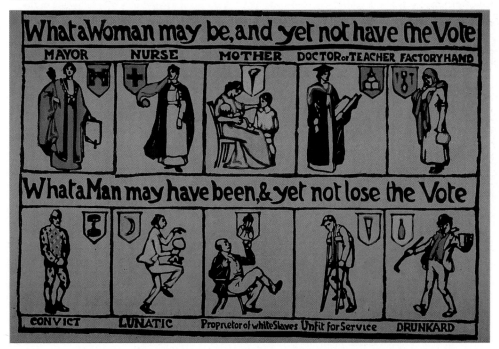

2. 'What a woman may be, and yet not have the Vote', c. 1912. This popular poster was also produced as a postcard. It was published by the Suffrage Atelier, an organization founded in London in February 1909, whose aim was: 'to encourage Artists to forward the Women's Movement, and particularly the Enfranchisement of Women, by means of pictorial publications.' By depicting images of worthy females over their unworthy male counterparts, the poster highlighted the absurdity of women not being able to vote, and of their being forced or even expected to take an inferior position in society.

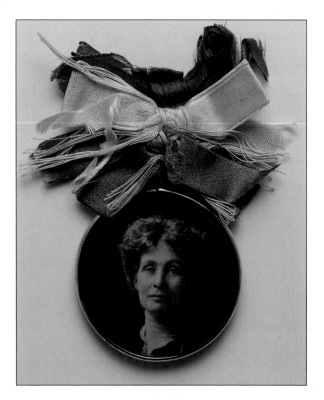

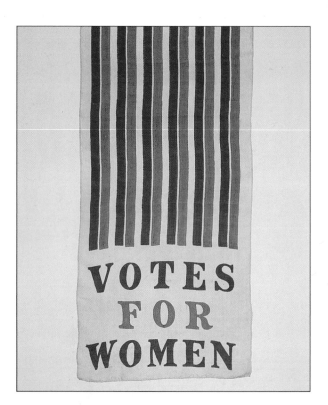

3. A silver and glass badge with a medallion portrait of Emmeline Pankhurst, c. 1908. The ribbons are in the familiar purple, white and green. This was one of many badges, brooches and statuettes of the leader on sale from the earliest years.

4. A purple, white and green striped silk scarf, 1908. The slogan 'Votes for Women' was printed at both ends. This was one of the earliest items of suffragette merchandise, and because of its versatility it became one of the most successful. It could be worn as a scarf, as a stole, as a 'motor-veil' to keep hats in place, as a sash, and as a trimming for a straw-boater.

5. China manufactured for the Women's Exhibition of 1909. Sylvia's angel symbol, first used in 1908, was used on this and other items. The tea-sets were made by Williamsons of Longton, Staffordshire.

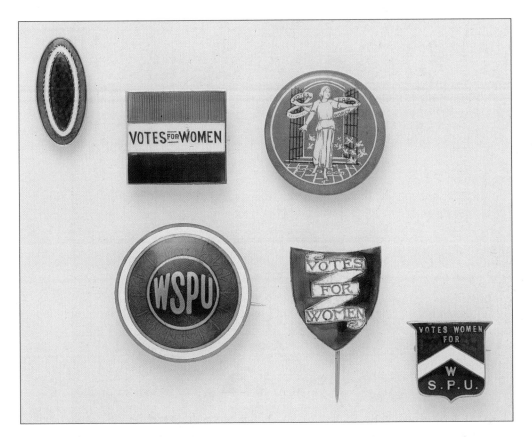

6. A selection of purple, white and green badges and brooches, dating from 1907–12. Top row, left to right: oval and silver enamel brooch; square silver and enamel 'Votes for Women' badge; circular tin badge bearing a design by Sylvia Pankhurst. Bottom row: circular enamel WSPU badge; shield-shaped silver and enamel pin; shield-shaped enamel badge.

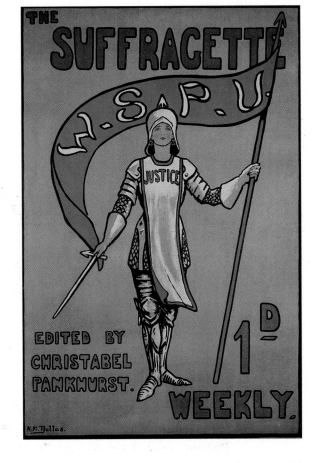

7. A poster advertising the *Suffragette* newspaper, 1912. Designed by Hilda Dallas, the poster shows a suffragette dressed as Joan of Arc, who was the patron saint of the suffragettes. The increasingly militant tone of the latter stages of the campaign is illustrated by the use of this image.

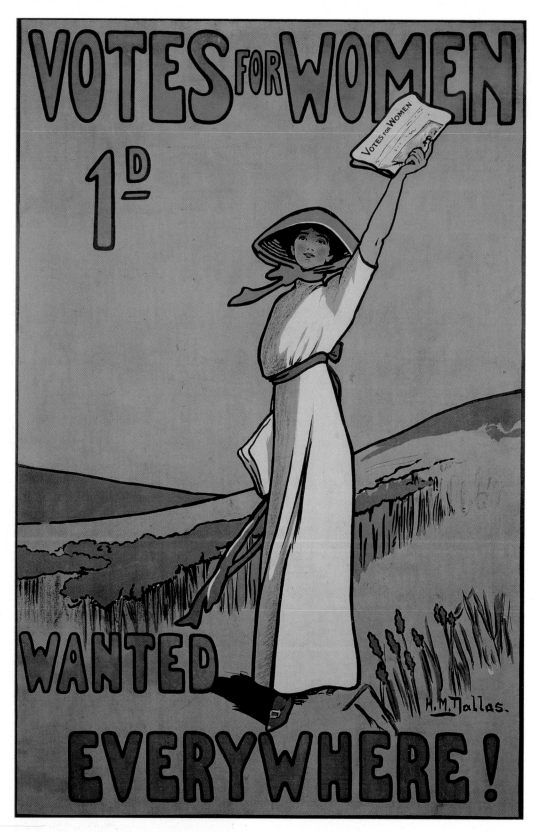

8. A poster advertising the newspaper *Votes for Women*, 1909. The poster was designed by Hilda Dallas (1878–1958), who was a member of the WSPU. She studied at the Slade for the year 1910 to 1911, in the middle of the campaign, and was responsible for a number of suffragette designs.

9. A purple, white and green poster to welcome Christabel to Manchester in December 1908. Mary Gawthorpe was in charge of all the arrangements and chaired the meeting at the Free Trade Hall on 19 January 1909. These tricolour posters were used throughout the campaign.

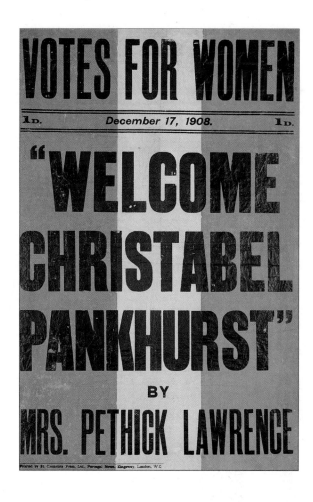

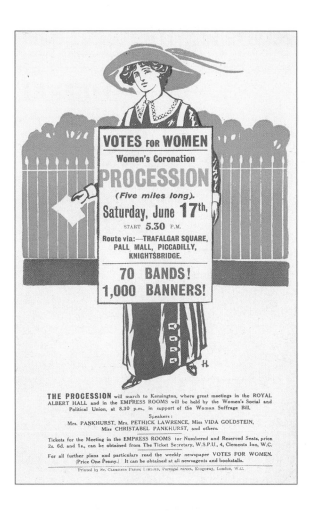

10. A purple, white and green handbill advertising the Women's Coronation Procession on Saturday 17 June 1911. The design shows a suffragette taking part in a 'poster parade'. Her sandwich board is advertising the procession and the handbill gives details of the 'monster' rally to be held afterwards.

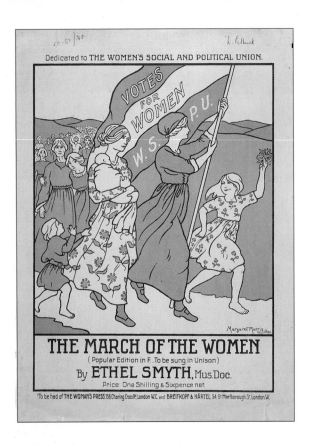

11. Songsheet of *The March of the Women.* This anthem was written by Ethel Smyth (later Dame Ethel Smyth) in 1911 and was dedicated to Emmeline Pankhurst. The three-colour illustration is by Margaret Morris.

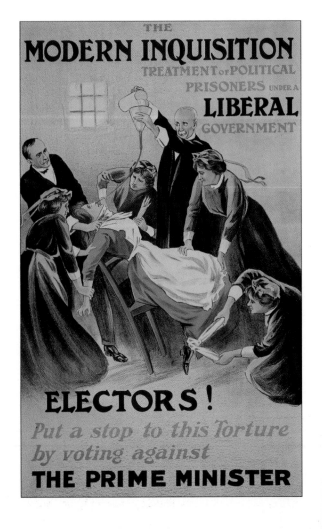

12. A poster by 'A Patriot', showing a suffragette prisoner being force-fed, 1910. Drawn specially for the WSPU's propaganda campaign for the General Election of January 1910 by Alfred Pearse (1856–1933), the poster shows four hatchet-faced wardresses holding down the woman, who is being fed by nasal tube. The flyposting of the poster and the high sales of the matching postcard were part of the WSPU's strategy to encourage the public to vote against a prime minister and government who would sanction the torture of women.

13. A suffragette Christmas card for 1910. The drummer girl is modelled on a young member of the Junior Band attached to the Women's Band.

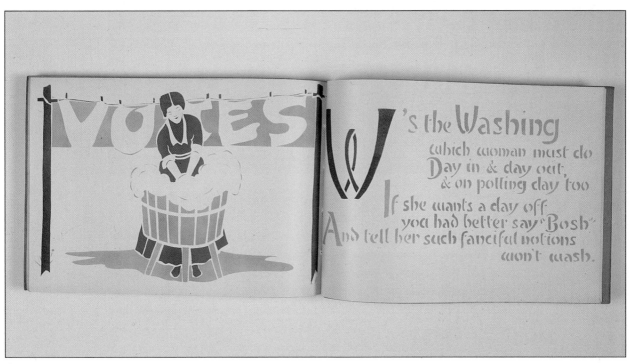

14. An Anti-Suffrage Alphabet, 1911. Written and published by Laurence Housman, the cartoon-type drawings and accompanying verse lampooned the opponents of women's suffrage. The stencils were by Alice B. Woodward, Pamela C. Smith, Ada P. Riley and others. It was edited by Leonora Tyson, who was the organizer of Lambeth/Southwark WSPU.

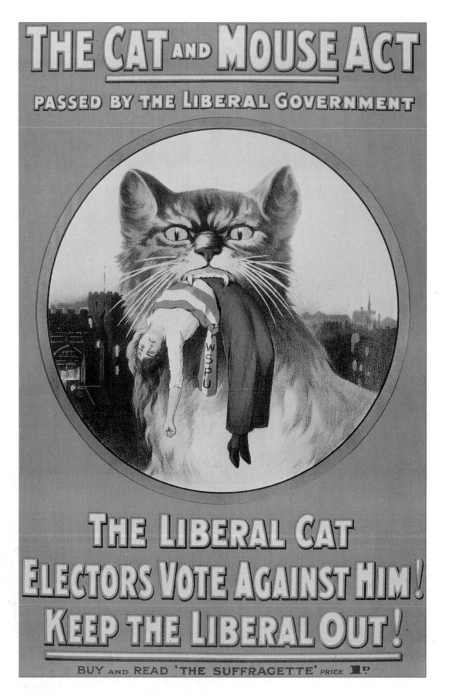

THE CAT AND MOUSE ACT

PASSED BY THE LIBERAL GOVERNMENT

WSPU

THE LIBERAL CAT
ELECTORS VOTE AGAINST HIM!
KEEP THE LIBERAL OUT!

BUY AND READ 'THE SUFFRAGETTE' PRICE 1D.

15. The Cat and Mouse Act, 1914. This suffragette poster graphically depicts the workings of the Prisoner's Temporary Discharge for Ill-Health Act, known by the WSPU as the Cat and Mouse Act. For much of 1913 and part of 1914, the force-feeding of suffragettes who had staged hunger strikes stopped. Instead, the weakened campaigners were released from prison on a special licence. However, they were liable to be rearrested when their health improved and returned to prison to complete their sentences. The large and bloody-toothed cat represents the police, the prison authorities and the Home Secretary, Reginald McKenna, who was responsible for the Act. The 'mouse' is a small and injured suffragette. Intended to wear down the morale and resolve of the suffragettes, the Cat and Mouse Act failed in both theory and practice: when suffragettes were released they were nursed in suffragette nursing homes and then went into hiding, from where many of them continued to commit yet more militant 'outrages'.

'On Saturday one of the most impressive demonstrations ever organized by the NWSPU was carried out. During the day twelve of the women who have undergone various terms of imprisonment for the part they have taken in the agitation for the vote, put on prison dress and drove through some of the principal streets of the West End to advertise the fact that a procession would march from Kingsway to Holloway at 6 o'clock. The dress worn was the winter prison garb of green serge, decorated with the broad arrow in white, a check apron, a small white linen cap, and a cardboard number.

'The object of the procession was to enter a protest against the Government's action in imprisoning Mrs Pankhurst, Christabel Pankhurst, and other women now in the second division. . . . The procession, accompanied by thousands of men and women, circled twice round the prison, the [two brass] bands playing and the crowds cheering. . . . Mrs Drummond said: "Let us raise our voices in indignation against the treatment of our friends inside those walls." Then a "Good-night cheer" was given to the prisoners inside the building, and the procession, accompanied by the crowd, returned to Clement's Inn.'

VOTES FOR WOMEN, 7 NOVEMBER 1908, P. 109.

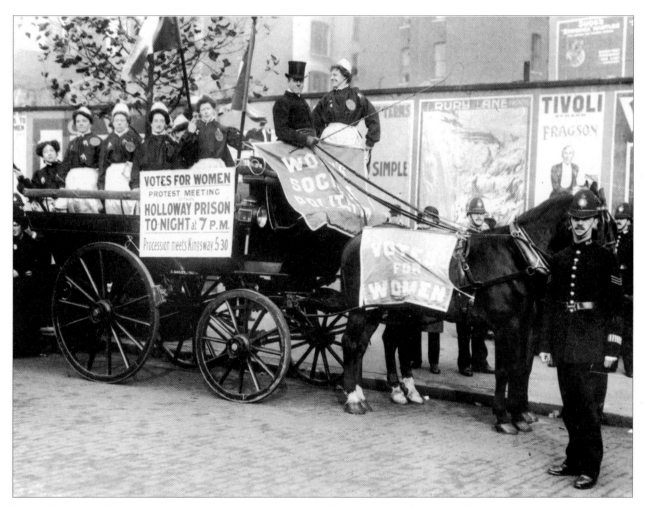

Ex-suffragette prisoners, wearing replica prison clothing, advertise a 'protest meeting' to be held outside Holloway Gaol, 7 November 1908. The women were particularly worried about Emmeline Pankhurst, who was reported to be in the hospital wing at the gaol. Wherever suffragettes were in prison, local (N)WSPU members and sympathizers would regularly stand outside the prison walls and sing suffragette songs to try and keep up the morale of their imprisoned sisters, and to remind them they had not been forgotten.

'Long before 8 o'clock, the hour of their release, a number of members and friends of the NWSPU had gathered wearing the colours of the Union. . . .

'A few minutes after 8 o'clock Mrs Leigh and Miss New were seen to pass through the small door, and a cheer went up from the crowd. They were affectionately welcomed by Mrs Pethick-Lawrence, Christabel Pankhurst, and other members of the Union. Bouquets in purple, white and green were presented to them, and they were conducted to a waiting landau. The band meanwhile struck up, and the crowd thickened round the carriage. Great interest was caused by the waving of prison loaves which the two women had managed to secure to bring away with them.'

<div align="right">

VOTES FOR WOMEN, 27 AUGUST 1908, PP. 404–5.

</div>

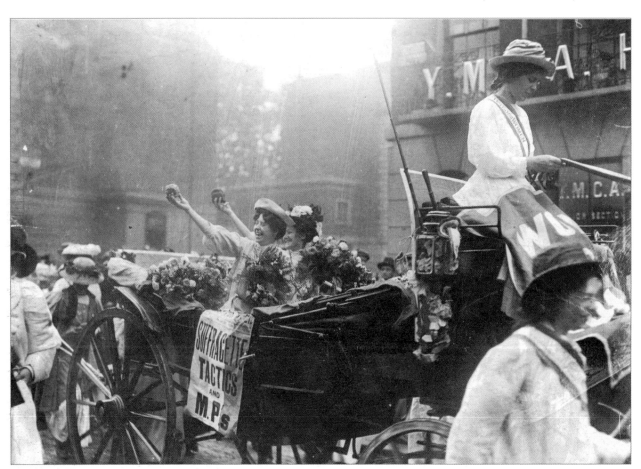

Mary Leigh (left) and Edith New (right) on their release from Holloway Gaol on 22 August 1908. The two women, who had both given up their teaching careers to become involved in the campaign, had carried out the first window-smashing attack. On 30 June they had broken windows at No. 10 Downing Street in protest at the way fellow demonstrators had been treated by the police in Parliament Square, and had served nearly two months in prison.

'At about half past seven a large crowd began to gather outside the prison, among them being French, Swiss, and Norwegian sympathizers, some of whom were holiday-making in this country, and had been caught in the vortex of the movement. A number of ladies wearing Scotch tartans and glengarry caps presently appeared and took stock of the wagonette intended for the use of the released prisoner and her parents, which was a mass of purple heather and immense Scotch thistles. Miss Vera Wentworth, who was released two days ago, mounted the box-seat and gathered together the Scottish team, numbering twelve, all wearing different tartans, and watched for the approach of the heroine. The skirl of four bagpipes, played by pipers in full Highland costume, and a great waving of colours and cheering, marked the advent of the lady, who had delayed to don her glengarry and plaidie of Forbes tartan outside the walls, where she was met by a small contingent of Suffragists and her father and mother. A policeman made an avenue for her through the crowd, which had grown to a troublesome size, and was supplemented by some rough looking customers, who also may not have been unacquainted with life on the other side of the gate.'

DAILY TELEGRAPH QUOTED IN VOTES FOR WOMEN, 24 SEPTEMBER 1908, PP. 470–1.

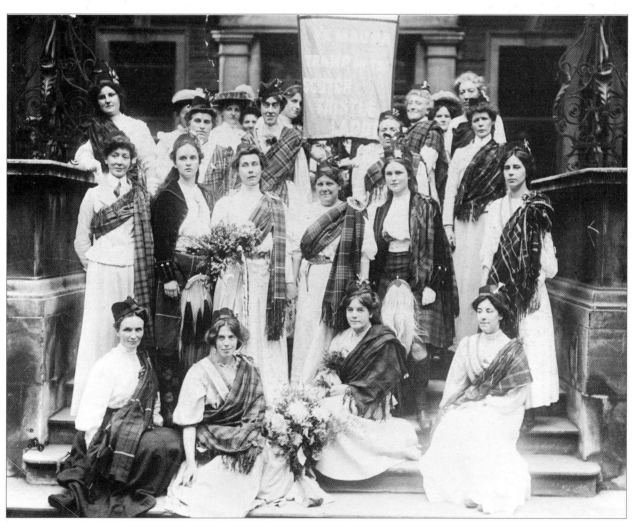

Scottish suffragettes welcoming Mary Phillips (standing third from left) on her release from Holloway Gaol on 23 August 1908. Mary Phillips had been sent to prison for obstructing the police in Parliament Square on 30 June. 'General' Drummond stands next to her in the centre of the photograph.

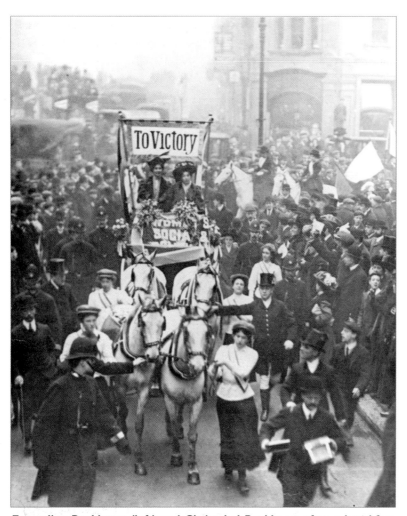

'*Mother and I were drawn in a procession from Holloway to a gathering of welcome. One of the happiest days in the whole movement was this. Confidence, unity, enthusiasm were complete. A great year had ended. The beloved WSPU had winged its way through storm and stress, further and higher towards its great aim. Each woman in our army of justice had done, had given, had been her best. All had known the pure delight of a self-regardless service and self-transcending purpose.*'

CHRISTABEL PANKHURST, UNSHACKLED: THE STORY OF HOW WE WON THE VOTE, 1959, P. 118.

Emmeline Pankhurst (left) and Christabel Pankhurst after a breakfast party at the Inns of Court Hotel, 22 December 1908. The party was to welcome them on their release from Holloway Gaol; they had been imprisoned for inciting the crowd to 'rush' the House of Commons. The WSPU often used members who were horsewomen to lead out processions, or to escort newly released prisoners.

'*Unheard of precautions had been taken to exclude from Mr Asquith's meeting in Leeds women who might ask him about the vote. Mrs Baines . . . her deep, powerful voice made her one of our finest open-air speakers, and it served her well that day. She challenged the Prime Minister as he descended from the train – as he issued from the railway station. The crowd supported her by a great cheer and then followed her to the Coliseum where another dense crowd was assembled to support the women.*

'*Mounting an improvized platform, Mrs Baines announced that she would attempt to fight her way into his meeting. "If they will not give us a hearing, we shall get inside the hall and make them."*'

CHRISTABEL PANKHURST, UNSHACKLED: THE STORY OF HOW WE WON THE VOTE, 1959, PP. 113–14.

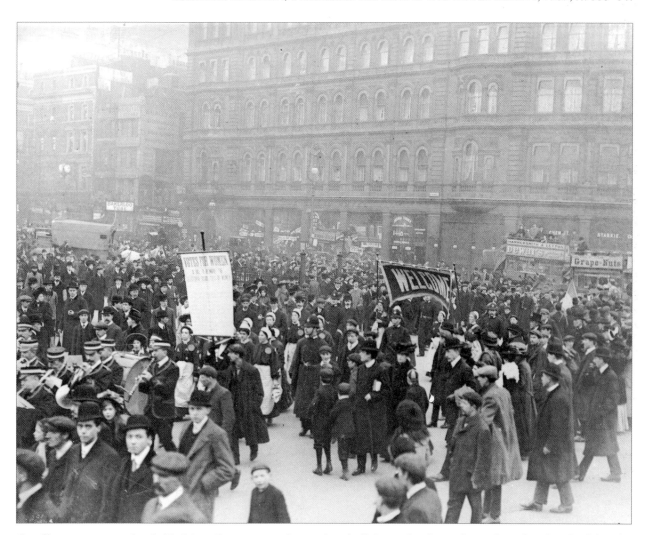

A suffragette procession in Trafalgar Square to welcome Jennie Baines after her release from Armley Gaol, Leeds, 12 December 1909. Jennie Baines was born in Birmingham into a working-class background, and as a young girl had been active in temperance reform, and was a missionary in Bolton. She joined the WSPU when Christabel Pankhurst was arrested after the first militant protest at the Free Trade Hall in Manchester in 1905.

'The great feature of Self-Denial Week was the barrel organ. . . . One member had a stall on the Downs, where home-made cakes and sweets were on sale, and another feature was the sale of choice flowers in the town, the flowers being the gifts of members. One member's husband did a five days' hunger-strike, and gave the money to his wife's Self-Denial card, performing his daily occupation as usual.'

<div align="right">

VOTES FOR WOMEN, 13 MAY 1910, P. 539.

</div>

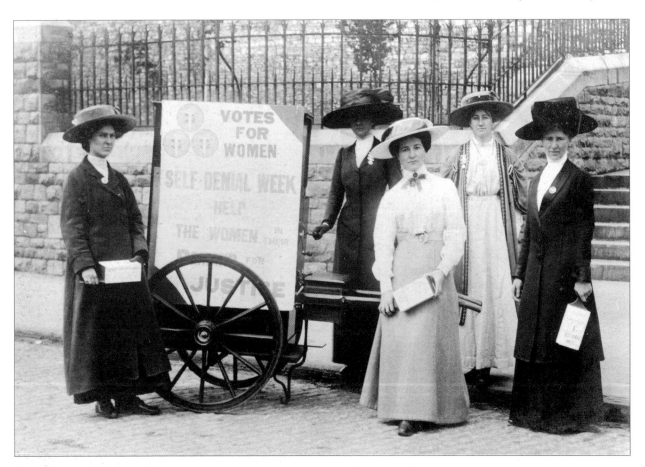

Bristol suffragettes raising money during Self-Denial Week, 1910. Whist drives, door-to-door and street collections, making marmalade and donating jewels were some of the ways in which WSPU members raised funds for 'The War Chest' (the campaign fund). From left to right: Edith West, Mary Allen, Miss Staniland, Elsie Howey and Mrs Dove-Willcox.

'We shall draw the attention of the business world and the holiday world to our colours and extend their popularity. Purple, white and green must be the prevailing colours of the summer of 1909. . . . Our exhibition must also prove so original, so interesting, and so effective from the picturesque point of view as to be yet another revelation of the resource and capacity that is in the WSPU. It must be so successful as to be the talk of the town.'

<div align="right">VOTES FOR WOMEN, APRIL 1909, P. 296.</div>

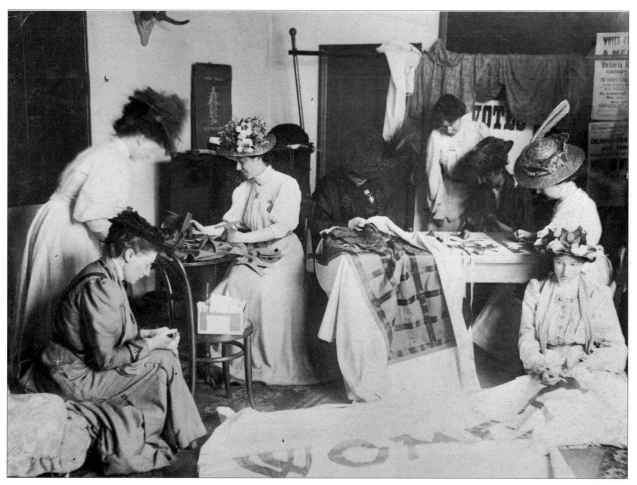

Suffragettes making banners for the Women's Exhibition, held at Princes' Skating Rink, Knightsbridge, May 1909. As well as being a means of raising funds, this event was another opportunity to promote the colour scheme. Traditionalists enjoyed images of women engaged in 'womanly' pursuits like sewing, but were often dismayed to see women walking around the streets carrying the banners they had made.

'The colours have now become to those who belong to this Movement a new language of which the words are so simple that their meaning can be understood by the most uninstructed and most idle of passers-by. Again and again we have seen how the colours arrest attention and evoke enthusiasm; how they bring an element of beauty into the field of political contest at the by-elections, and call forth a response from the work-weary faces of men and women in the crowded ways of great cities.'

PROGRAMME FOR THE WOMEN'S EXHIBITION, 1909, P. 13.

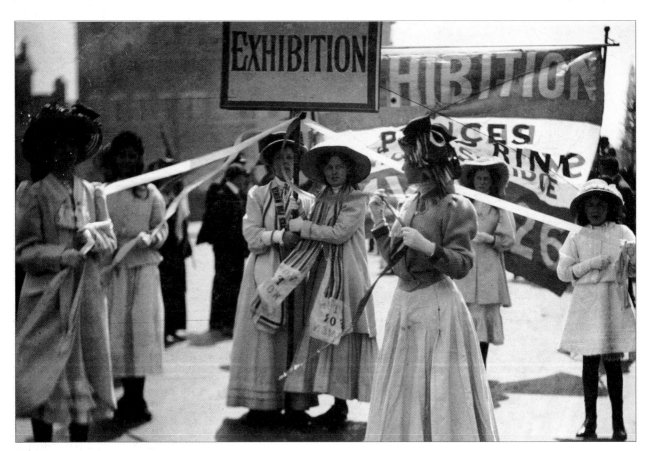

Young suffragettes advertising the Women's Exhibition at Princes' Skating Rink, May 1909. Purple, white and green silk scarves and ribbons are everywhere in this maypole procession.

'All the bandswomen were attired in the special uniforms, the colours of the material representing the Union colours. This is said to be the first amazon drum and fife band which has ever existed. . . . The strange sight of a feminine band attracted the attention of a considerable number of passers-by and in some of the busier streets the crowds became so dense that the traffic had to be temporarily held up.'

NEWS OF THE WORLD QUOTED IN VOTES FOR WOMEN, MAY 1909, P. 693.

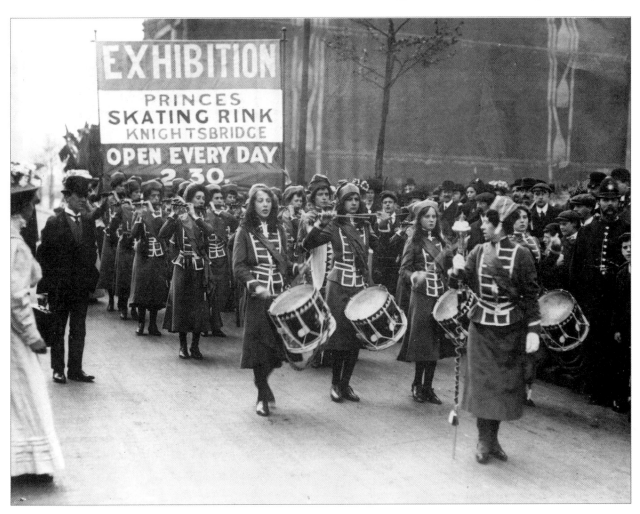

The Women's Drum and Fife Band, led by Drum Major Mary Leigh, advertising the Women's Exhibition, May 1909.
It was a noisy, martial and colourful procession which amused some of the onlookers, and surprised others.

'Every day, from 13 May to 26 May, a stream of people found their way through the large entrance doors to the many and varied attractions within. Of these some were strangers to the militant cause, and it is to be hoped that what they saw and heard, both in the opening speeches of the eminent women who attended on the first days and in the conversational opportunities that occurred from time to time, will have induced many others to become active supporters of the WSPU.

'It is encouraging to be able to report that at the membership stall over two hundred new members were enrolled, while a very large number of signatures were entered in the Visitors' Book.'

VOTES FOR WOMEN, 28 MAY 1909, P. 722.

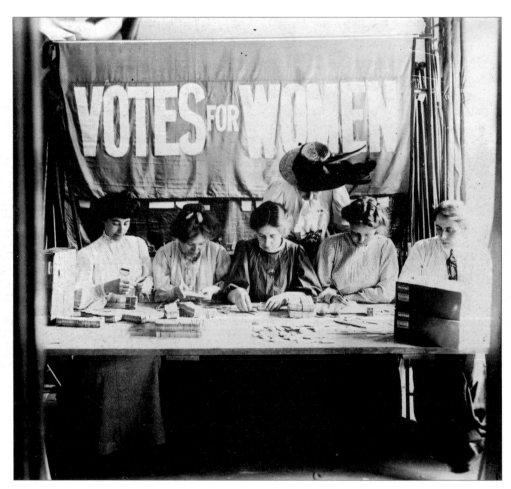

A ticket stall at the Women's Exhibition, May 1909. The exhibition was open from 13 to 24 May, excluding Sundays, and was well attended, raising £240,000 (in modern terms) for 'The War Chest'.

'Everyone concerned – Exhibition Secretaries, stall-holders, sales women, and workers in all departments – put into the Women's Exhibition of their very best, and as a result the Exhibition was a brilliant success. It was impossible to pass down Knightsbridge without one's eye being attracted by the brave show of purple, white and green flags and festoons which almost smothered Princes' Skating Rink.'

VOTES FOR WOMEN, 28 MAY 1909, P. 722.

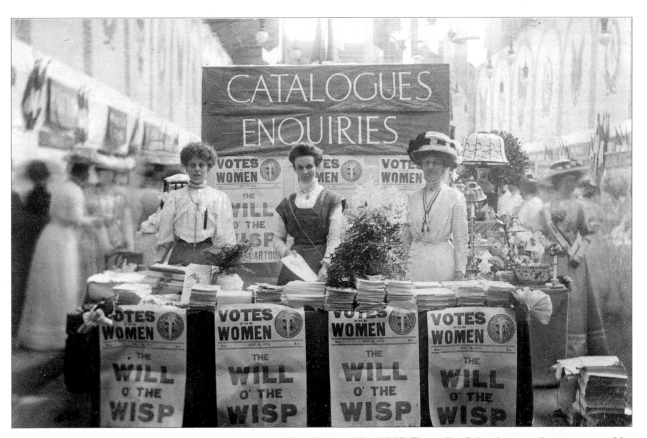

The catalogue and enquiries stall at the Women's Exhibition, May 1909. The walls of the skating rink were covered by Sylvia Pankhurst's symbolic mural, which was painted on wood and was later taken down and used again at another event.

'The Women's Exhibition is evidence, if any were needed of the ingenuity and determination which characterize the members of that body. There has been arranged a skilful display of women's work which combines artistic interest and satire at the expense of the enemy — the Government — and political propaganda. The decoration of the hall is a striking tribute to the talent of Miss Sylvia Pankhurst.... Then there are scores of stalls laden with miscellaneous articles from picture postcards to charming art and needlework, flowers and farm produce.'

MORNING POST QUOTED IN VOTES FOR WOMEN, MAY 1909, PP. 690–1.

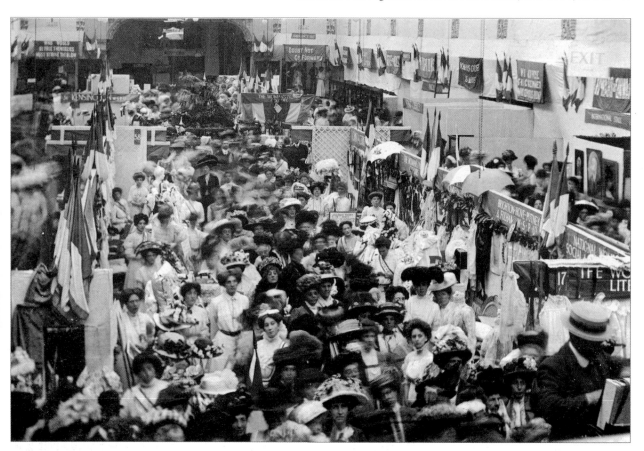

The Women's Exhibition, May 1909. Everyone is standing quietly listening to a speech made by one of the different women who opened the exhibition every day. One day it was Her Highness the Ranee of Sarawak, Malaysia.

'Will members please remember that their contributions to our two Exhibition stalls must be sent in or before 6 May. Hats, veils, or scarves suitable for the millinery stall must be sent to Mrs Reginald Potts, 8 Victoria Rd, Kensington; and all contributors to the general stall to Mrs Harry Silver, care of Lawrence Housman, 1 Pembroke Cottages, Edwardes Square. . . . Mrs Hartley Withers is kindly donating a drawing-room meeting on Friday afternoon, 7 May at which Mrs Pankhurst has promised to speak. A few invitations are available, preferably for unconventional friends or "wobblers". A purple, white and green awning is much wanted for our shop; who will provide the necessary money?'

<div align="right">VOTES FOR WOMEN, 30 APRIL 1909, P. 612.</div>

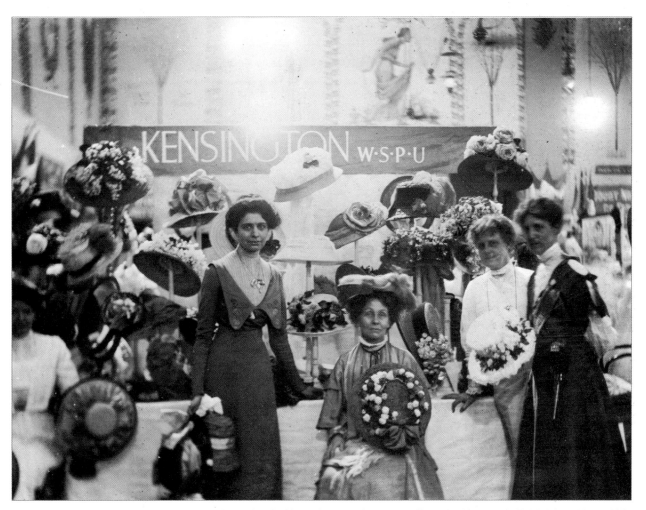

Emmeline Pankhurst (seated) and Mabel Tuke (left) at the Kensington stall at the Women's Exhibition, May 1909.
Leading London stores Liberty, Derry and Toms, and Peter Robinson had donated some of the hats. Milliners like Elizabeth of South Molton Street and Rose of Bond Street also contributed.

'It would be quite impossible to speak severally of the various stalls . . . the various campaign centres all over the country supplied an immense amount of miscellaneous work, as did local WSPUs and the private individuals who made themselves responsible for the whole or part of a stall. Many women clever with the needle had spent months in preparation for the great Exhibition; others talented in different directions — as the actresses, artists, writers, palmists, and last, but not least, those clever in persuading prospective buyers to become purchasers — all deserve special commendation.'

<div align="right">

VOTES FOR WOMEN, 28 MAY 1909, P. 722.

</div>

The joint stall of the Brighton and Hove, Putney and Fulham branches at the Women's Exhibition, May 1909.
Brighton and Hove sold 'plain and fancy needlework, artistic jewellery, books and hand-painted fancy goods', and Putney and Fulham sold household linen, baby clothes and 'miscellaneous' articles. The stall stood between the Christabel Pankhurst stall and the Lewisham, Brixton and Camberwell stall.

'Those who were fortunate enough to be present at the opening on Monday afternoon will not soon forget the impression of gaiety and light-heartedness, beautiful colouring, and pretty costumes, all seen against a background of exquisite mural designs from the clever brush of Miss Sylvia Pankhurst. The Portman Rooms are transformed into a Village Market Hall; painted signs hang over each of the stalls denoting the wares for sale, and every available corner is occupied by side-shows and other attractions. . . . The general aspect of the Fair is proof positive that the militant woman can be just as feminine as anybody else, for on the many stalls the goods are the product of distinctive feminine arts.'

VOTES FOR WOMEN, 8 DECEMBER 1911, P. 155.

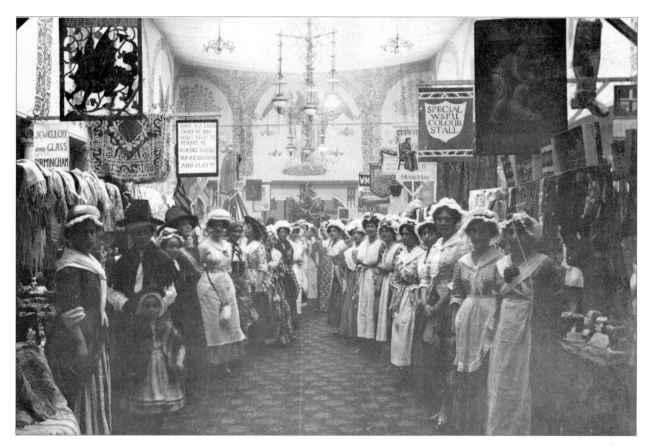

The Christmas Bazaar, Portman Rooms, Baker Street, 1911. The bazaar was open from 4 December to 9 December, with a theme of 'the eighteenth century'. There was a Welsh stall (left), jewellery and glass from Birmingham (left), and a special colour stall (right); all the stall-holders wore eighteenth-century costume.

'Mrs Lamartine Yates heartily thanks Mrs Ayrton for her box full of surprises for the Nursery Stall; Princess Sophia Duleep Singh for her gift of children's clothes; Miss Skeate for the little boys' hats; Miss Stoakley, Mrs Belmont and others for fine lace and trimming; Mrs Jones for charming little hand-knitted jackets; Miss Loxwood King for a child model; Mrs Boord for a number of thermometers of her own invention, and other appliances. . . . Who will supply wool for volunteer knitters, powder boxes and puffs? A very large doll is wanted at once. Who will supply it?

<div align="right">VOTES FOR WOMEN, 10 NOVEMBER 1911, P. 90.</div>

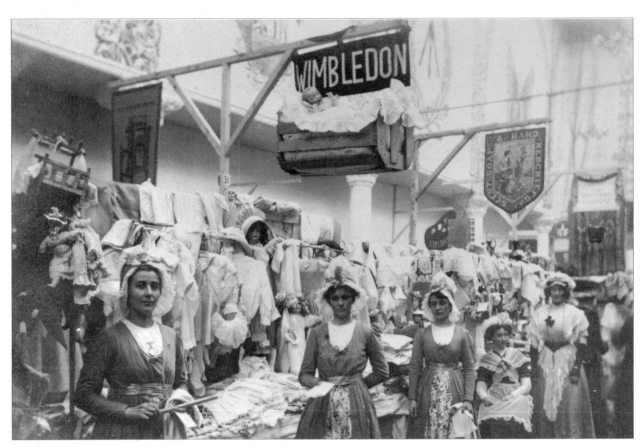

Wimbledon WSPU's stall at the Christmas Bazaar, Portman Rooms, 1911. Rose Lamartine Yates was the Secretary of the stall, which specialized in children's clothes (notice the symbol for the stall, below the Wimbledon sign). The Wimbledon office and shop were at No. 9 Victoria Crescent, Broadway.

VOTES FOR WOMEN BAGS

'Specially designed for the use of Votes for Women *sellers. It is made of strong green material, with a strap of adaptable length to go over the shoulder and across the front is a white band on which the words Votes for Women are stamped.'*

VOTES FOR WOMEN, 16 JUNE 1911, P. 606.

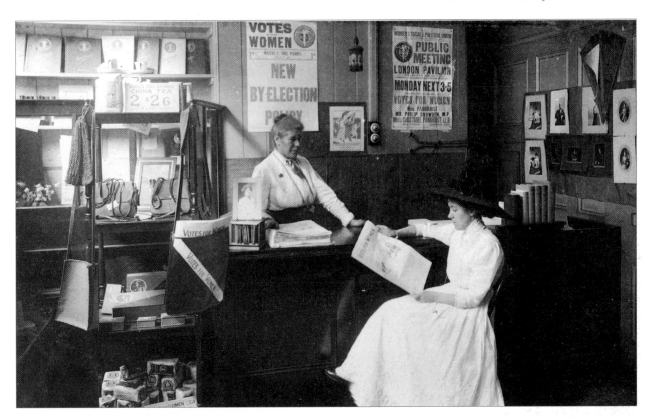

The interior of The Woman's Press shop, No. 156 Charing Cross Road, September 1911. Mrs Knight, who was responsible for sales of the colours, is behind the counter. From 1907 up to the time this photograph was taken the Woman's Press turnover was £480,000 (in modern terms). Note the postcard albums (top left), the Votes for Women tea (bottom left), and the purple, white and green kite (right).

'The Woman's Press is showing some beautiful motor and other scarves in various shades of purple, as well as white muslin summer blouses, and among the almost unending variety of bags, belts etc are noticeable "The Emmeline" and "The Christabel" bags and "The Pethick" tobacco pouch. In addition to books, pamphlets, and leaflets, stationery, games, blotters, playing cards, and indeed almost everything that can be produced in purple, white and green, or a combination of all three, is to be found here.'

VOTES FOR WOMEN, 1 JULY 1910, P. 651.

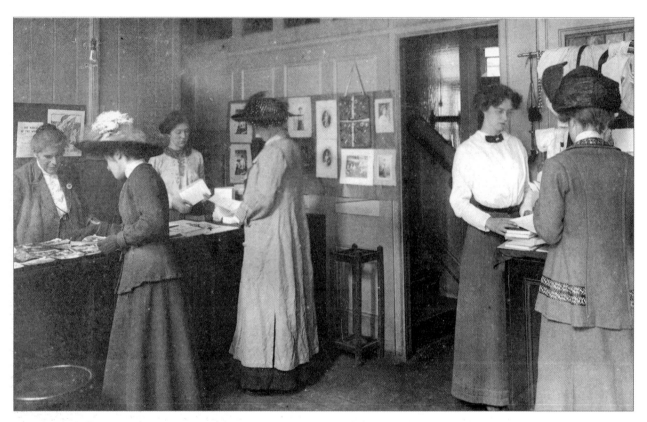

Another view of the interior of The Woman's Press shop, September 1911. As well as the goods on sale here, many items were sold through the various advertisements in the pages of *Votes for Women*. For instance Roberta Mills of Brixton designed and sold leather goods with suffragettes in mind; Clara Strong was a Suffragette Milliner; Dorothy Eckford sold purple, white and green sweet pea seeds by mail order; and Mrs Courtenay Wallis sold tricolour hatpins. Votes for Women cigarettes, chocolate, soap and marmalade were also available.

'The "shop warming" held last Friday to inaugurate the opening of the new office attracted a very large amount of interest. Between 60 and 70 people were present . . . the local interest was very great, and a policeman was on duty all day, keeping watch on the very friendly crowd gathered round the window. . . . To meet the heavy expenses, the organizer will be glad to receive home-made articles for sale in the new shop, as well as contributions towards the jumble sale.'

VOTES FOR WOMEN, 18 FEBRUARY 1910, PP. 327–8.

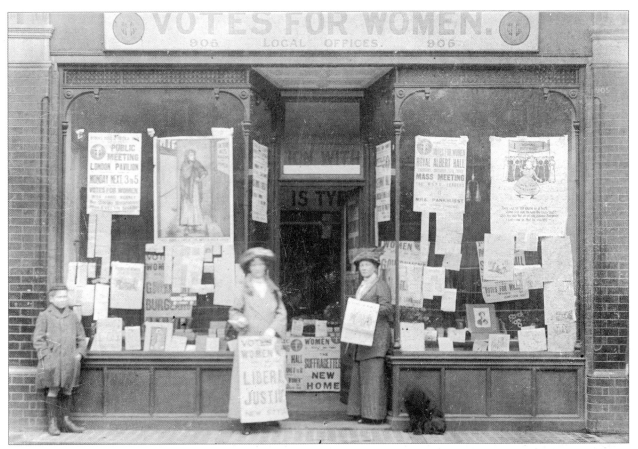

The Fulham and Putney WSPU shop, No. 905 Fulham Road, 1910. Newspaper cuttings of suffragette activities are displayed in the window alongside propaganda materials for sale. Members were encouraged to buy posters like these and put them up wherever they could. The poster on the left was designed by Emily Ford, and refers to the fact that women factory workers had long been the subject of legislation and had played no part in the framing of the laws which affected their working lives.

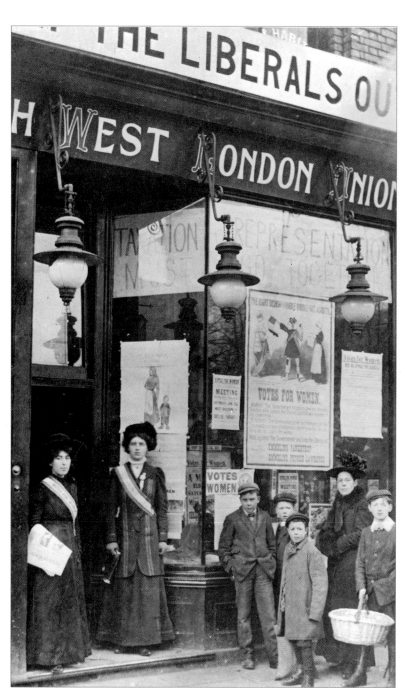

The North West London WSPU shop, No. 215 High Road, Kilburn, 1909. Local suffragettes who wanted to avoid taking part in the Census of 1911 were able to spend the night here at the shop. Extraordinarily, two hundred could be accommodated.

'The opening of our shop, 215 High Road, Kilburn, on 1 November has created quite a sensation in the neighbourhood. Members are kept busy answering questions and selling the various articles. . . . On Saturday, a full band paraded the main streets and attracted considerable attention. The band was followed by a dozen sandwich bearers advertising the meeting on the 9th at Brondesbury Hall, where Mrs Pethick-Lawrence spoke, and also several "hunger-strikers".'

VOTES FOR WOMEN, 12 NOVEMBER 1909, P. 110.

SUFFRAGETTE SPECTACULARS

Set-piece Demonstrations

The purple, white and green colour scheme was launched at the WSPU's first set-piece demonstration, Women's Sunday on 21 June 1908. Advertised in *Votes for Women* as a 'monster meeting', it brought thousands of suffragettes from all over the country in specially chartered trains. Seven processions marched through the capital to the rally in Hyde Park, where they heard over seventy speakers at the twenty platforms.

The leadership anticipated press criticism of the Union's members, and so urged them to wear their colours in as fetching, charming and ladylike a manner as possible. This advice paid off, as reports paid tribute not only to the organization and stage management of the day, but especially to the appearance and unmistakable 'womanliness' of the marchers. Some of the reports intimated that the suffragettes had even set the hearts of some of the reporters fluttering.

The next major set-piece demonstration, the Women's Coronation Procession, took place three summers later, on 17 June 1911. It was a bigger and even more noisy and colourful affair. After the march a rally took place in the Royal Albert Hall; such was the demand for tickets that the Empress Rooms in Kensington had to be hired for an 'overflow meeting'. The event was held during a WSPU truce, which had been called to enable the Conciliation Bill of 1911 to be debated in a calm atmosphere. The organizers of the procession, which marched a week before the coronation of the new king, George V, hoped it would help to enlist his support in getting the Bill through Parliament. In this

they were disappointed – the new king made it quite clear that he had no sympathy for their demands.

The diversity of women's support for the vote was demonstrated on these processions too. Indian women, Welsh, Scottish and Irish women took part in 1911. Many different occupational groups marched under their own banners. The solidarity of the women's suffrage movement was palpable on these occasions, as was its international nature.

These brilliantly organized demonstrations and processions kept the suffragettes and their campaign in the public eye, and went some way to ameliorate hostile views about the women involved. The embroidered and appliquéd banners that the campaigners carried helped to remind curious onlookers that these were feminine women, accomplished in traditional female skills of sewing and needlework. Their own marching songs and bands had a jaunty foot-tapping style, which must have encouraged passers-by to stop and listen, and even join in. The drab images of the suffragettes commissioned by the 'Anti-movement', depicting the women as mewing kittens, crying babies, and badly dressed butch women with a lot of facial hair, had to be reappraised in the light of the purposefully engaging and ladylike image that the suffragettes presented at such public events. Many of the photographs in this chapter show WSPU campaigners to be attractive, fashionably dressed women, and not the ugly harridans their opponents said they were.

'The following ways of helping are suggested to those who find it more convenient to work independently. . . . By distribution of handbills at Tube and Metropolitan stations, and in trams, trains, and buses. By bringing one of the processions to the notice of shop assistants, waitresses, and others. By chalking announcements of one of the processions on the pavement. By making the processions known in schools, hospitals, clubs, houses of residence and the like. By getting window bills displayed in shops.'

VOTES FOR WOMEN, 18 JUNE 1908, P. 242.

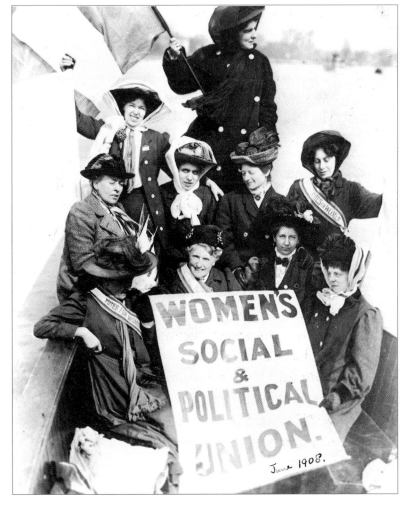

Ten suffragettes advertising the Women's Social and Political Union, from a boat on the Thames, June 1908. Other posters advertised Women's Sunday, to be held on 21 June. The women are wearing 'Votes for Women' sashes and hats held in place with 'Votes for Women' silk scarves.

RAID BY WATER

'The House of Commons on Thursday last, 18th, received a surprise visit from members of the NWSPU. As it is so difficult to approach them by land, it was decided to make the attempt by water.

'A few minutes before 4 o'clock M.Ps and lady friends who were settling down to afternoon tea on the terrace were attracted by the sound of music from an approaching steamer. Presently its purpose became clear. The little steamer, with a white painted funnel, was gay with bunting, and the three conspicuous banners proclaimed its mission to all beholders. . . . Several members at once rushed into the House to spread the news. . . . The steamer having come as near to the terrace as possible, Mrs Drummond began her address, delivered as a morning paper says, "in a loud, clear and pleasant voice". She formally invited all members of Parliament – Liberals, Conservatives, and Labour men, without any distinction – to take part in the Hyde Park Demonstration, especially inviting Cabinet Ministers. . . .

'Mrs Drummond aroused roars of laughter by saying "I am very glad you have got lady waiters: but are you not afraid that some of them might be suffragettes?". . . Meanwhile the presence of the demonstrators had been communicated to the Thames police, and a party of constables arrived in their launch, amidst laughter and cheers.'

VOTES FOR WOMEN, 25 JUNE 1908, P. 270.

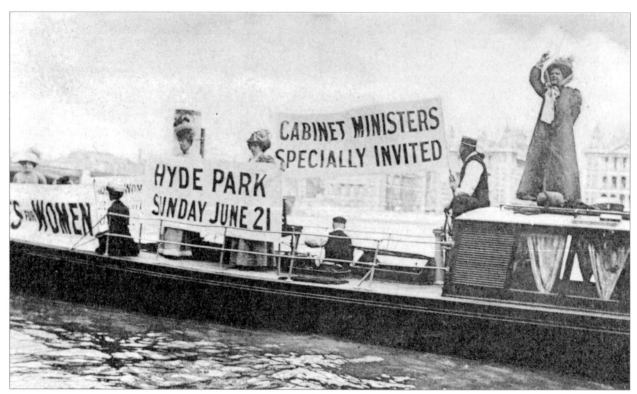

'General' Mrs Drummond (far right) in a decorated boat opposite the terrace of the House of Commons, addressing MPs and inviting them to Women's Sunday in Hyde Park on 21 June 1908.

UNFURLING OF BANNERS

'Wednesday afternoon, 17 June, Queen's Hall, 3 o'clock. Enter it carefully in the diary. Note the date, the time, and the place. For this is one of the red letter days in the Votes for Women movement. There will be a great meeting. Mrs Pankhurst will preside.

'The seven beautiful banners that are to head the seven processions will be unfurled and formally presented to the Unions by the privileged donors. The Bradford Union, the London City Union, and the Kensington Union will also unfurl their magnificent silk banners. Hundreds of standards will be shown.

'It will be a scene of great interest and enthusiasm. And member and friend of the Union should make a point of being with us. Shilling tickets and sixpenny tickets of admission can be obtained from the Ticket Secretary, 4 Clement's Inn, W.C.'

VOTES FOR WOMEN, 11 JUNE 1908, P. 234.

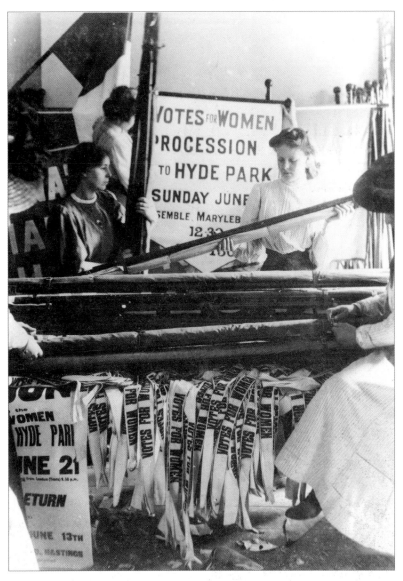

Preparing banners for Women's Sunday, 21 June 1908. The procession referred to on the banner at the back was 'Procession G', which was to assemble at Marylebone Road. It would include three brass bands and a silver band, suffragettes from Nottingham, Sheffield, Huddersfield, Leicester and Loughborough, women teachers and working women.

'Be guided by the colours in your choice of dress . . . we have seven hundred banners in purple, white and green. The effect will be very much lost unless the colours are carried out in the dress of every woman in the ranks. White or cream tussore should if possible be the dominant colour, the purple or green should be introduced where other colour is necessary. . . . You may think that this is a small and trivial matter but there is no service that can be considered as small or trivial in this movement. I wish I could impress upon every mind as deeply as I feel myself the importance of popularizing the colours in every way open to us. If every individual woman in this union would do her part, the colours would become the reigning fashion. And strange as it may seem, nothing would so help to popularize the WSPU . . . now everyone has simply got to see to it that everywhere our colours may be in evidence.'

VOTES FOR WOMEN, 18 JUNE 1908, P. 249.

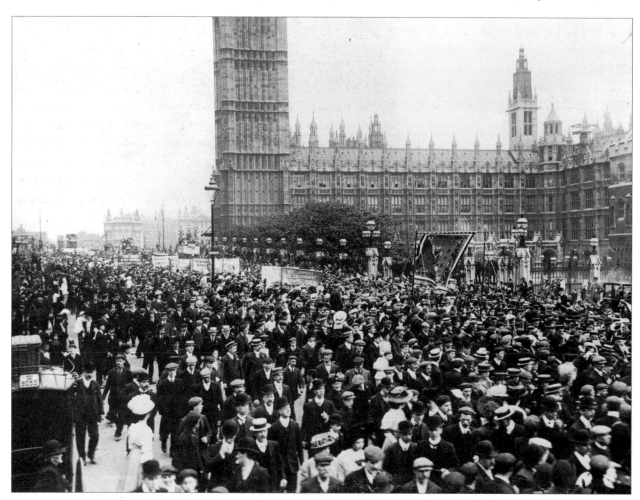

Crowds passing the Houses of Parliament en route to Women's Sunday, 21 June 1908.

THE COLOUR SCHEME

'One of the remarkable features of the whole demonstration was the unity of the colour scheme, displayed not only in the banners, but in the dresses and decorations of the women who were taking part. We are informed that in the various drapers' establishments in which the special votes for women scarves were displayed, several thousand in all were disposed of, and that the whole stock was sold out before the demonstration took place. Fresh orders were given by the Union at the end, but could not be executed in time for the day itself, though a few are now obtainable at Clement's Inn.'

VOTES FOR WOMEN, 25 JUNE 1908, P. 258.

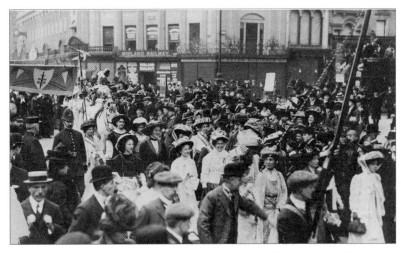

The Euston Road procession en route to Hyde Park, 21 June 1908. The procession is led by Emmeline Pankhurst (left), Christabel Pankhurst (centre) and Annie Kenney (right). Emmeline Pankhurst, who chaired Platform 5, walks behind a huge banner which bears her portrait and describes her as 'Famed for Deeds of Daring Rectitude'. Elsie Howey, dressed as Joan of Arc and riding a white horse, is on her way to speak at Platform 6. Six bands accompanied this procession of mostly 'Lancashire Lassies'.

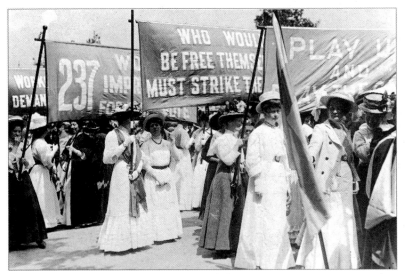

Suffragettes on the Euston Road procession carrying banners to Women's Sunday, 21 June 1908. This group of marchers is included in the photograph on pp. 106–7. Some of the same banners can just be made out in the background.

'The depth and extent of the public interest was at once made apparent by the great crowds that gathered to watch the assembling of the demonstrators. . . . At the head of each procession was carried a flag of purple, white, and green — the colours of the National Women's Social and Political Union — and after that "the regimental colours", so to speak — a beautiful silk banner, also in purple, white, and green, with artistic embroidery and symbolical devices. Each group marched under a banner of its own, and every woman walking in the procession wore purple, white, and green, either in favours pinned to the breast, or in the trimmings of the hat, in belt ribbons, or in shoulder sashes. . . . From noon until half past one the peaceful Sunday streets of the West End resounded to the beat of the drum, the call of the bugle, and the tramp of marching feet, as detachment after detachment hurried to its appointed rendez vous.'

THE TIMES QUOTED IN VOTES FOR WOMEN, 25 JUNE 1908, P. 260.

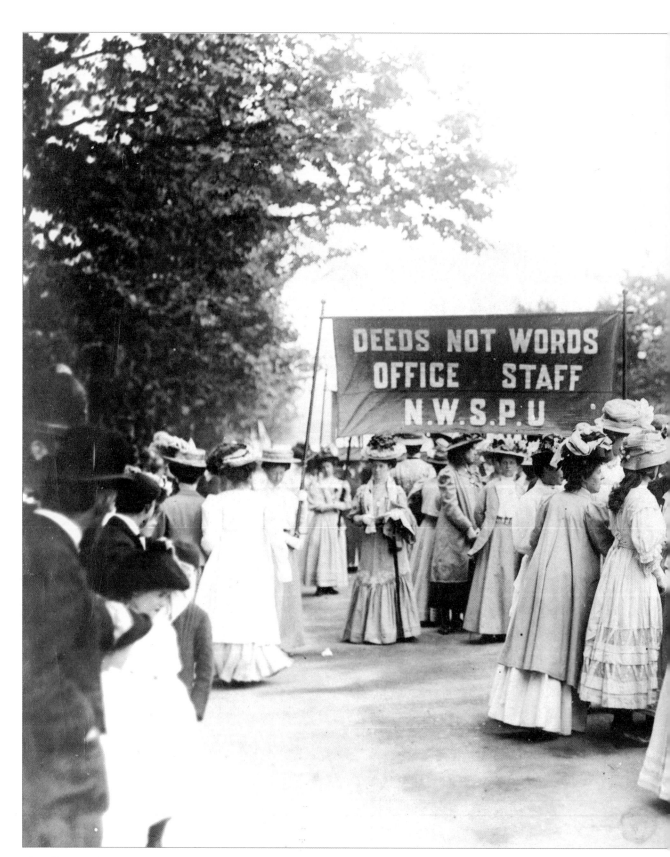

The Clement's Inn office staff carrying their own banner in Hyde Park, 21 June 1908.

'I am sure a great many people never realized until yesterday how young and dainty and elegant and charming most leaders of the movement are. And how well they spoke — with what free and graceful gestures; never at a loss for a word or an apt reply to an interruption; calm and collected; forcible, yet, so far as I heard, not violent; earnest, but happily humourous as well!'

DAILY MAIL QUOTED IN VOTES FOR WOMEN,
25 JUNE 1908, P. 261.

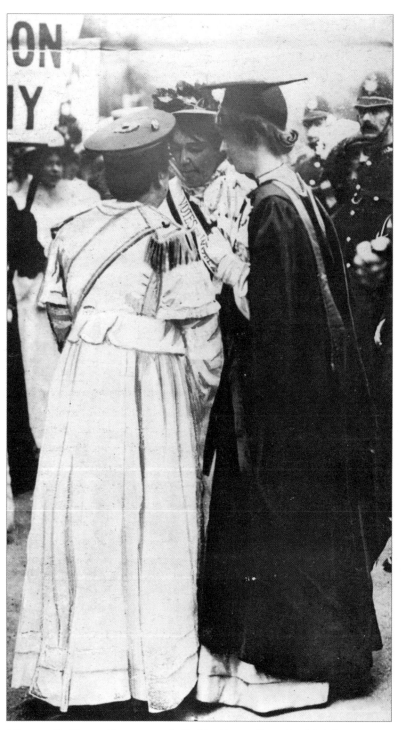

'In general the control of all the processions will be the well-known general, Mrs Drummond, who has superintended the operations of the NWSPU on so many occasions previously. She will be in constant touch with every one of the processions, and will make it her business to see that every one of them is in marching order, and that all the arrangements are complete and satisfactory.'

VOTES FOR WOMEN, 18 JUNE 1908, P. 243.

'General' Flora Drummond (left), Emmeline Pethick-Lawrence (centre), and Christabel Pankhurst (right), on Women's Sunday, 21 June 1908. Emmeline Pethick-Lawrence chaired Platform 4, at which Jessie Kenney spoke, and Christabel Pankhurst chaired Platform 8, at which Joan Dugdale spoke.

'The dignity, the grace, the beauty, the courage of the processionists carried conviction everywhere. Scoffers were converted. Some who had evidently come to jeer stayed to cheer. The good-humoured London crowd was not without its banter here and there; but the genuine outbursts of cheering, the waving of handkerchiefs, the crying out of words of encouragement, must have been very gratifying to those among the processionists who have withstood harshness and insults.'

DAILY NEWS QUOTED IN VOTES FOR WOMEN, 25 JUNE 1908, P. 261.

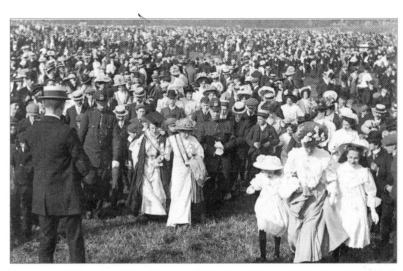

Crowds in Hyde Park on Women's Sunday, 21 June 1908. Annie Kenney, in the centre of the photograph, is about to take up her place chairing Platform 3, one of whose speakers included Dorothy Pethick, the sister of Emmeline Pethick-Lawrence.

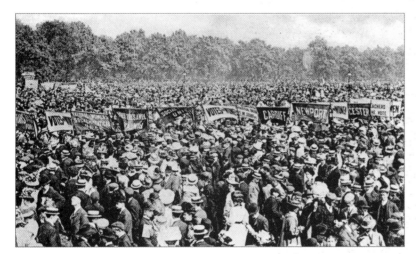

Women's Sunday, Hyde Park, Sunday 21 June 1908. Banners from all over the country were taken to this 'monster' rally. Prominent in this photograph are banners from WSPU branches in Newport, Cardiff and Leicester.

'The great demonstration of militant suffragists, so long talked of and so elaborately organized, culminated in an extraordinary scene in Hyde Park yesterday afternoon. Never, in the estimation of the most experienced observers, has so vast a throng gathered in London to witness a parade of political forces; and the crowd in the park passed computation. There must have been over 300,000 people of all classes present, and the majority of them no doubt were drawn by curiosity, as well as by interest in the remarkable personalities of the movement which has excited so much controversy in the last few years.'

DAILY CHRONICLE QUOTED IN VOTES FOR WOMEN, 25 JUNE 1908, P. 262.

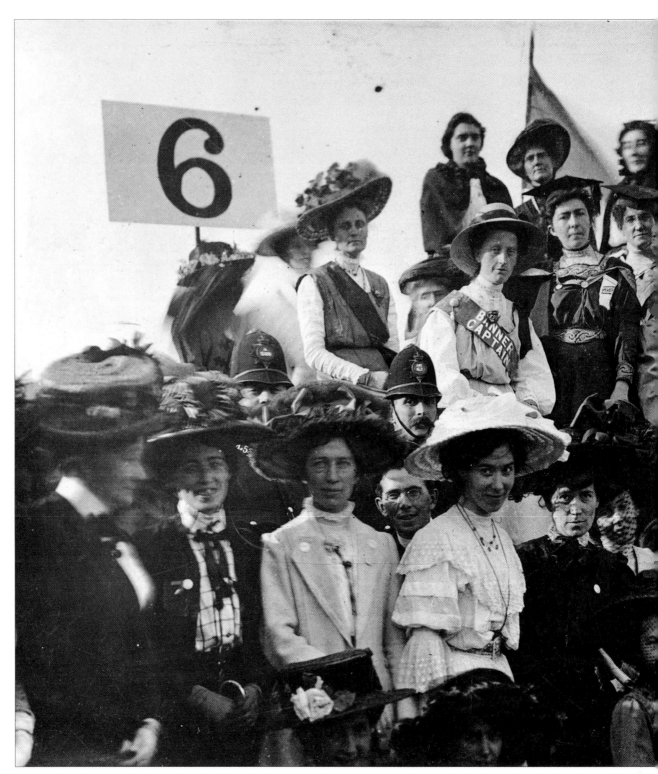

Platform 6 in Hyde Park on Sunday 21 June 1908. The Banner Captain (centre) was in charge of all the banners for this particular procession.

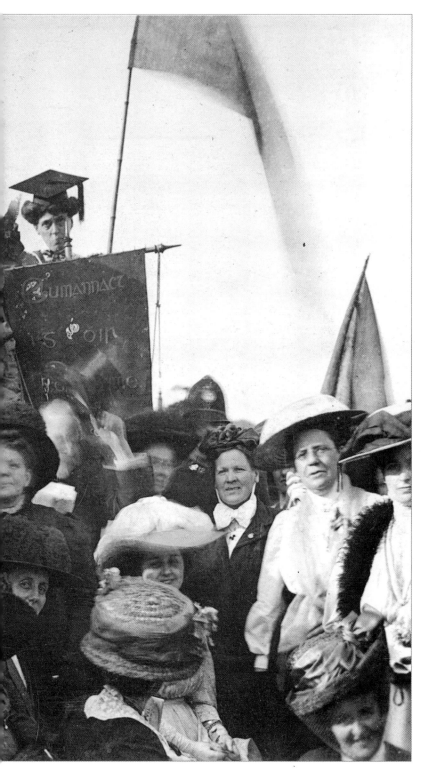

THE GREAT SHOUT

'One of the features of the great demonstration will be the shout that will go up from 200,000 voices – the shout, "Votes for Women". At 5 minutes to 5 the bugle will sound; at each platform the speaker will conclude, and the chairman will rise and make the final announcements. At 5 o'clock the bugle will sound again, and the chairman will put the resolution. Then once again the bugle will be heard, and then every voice will take up the cry. "One, Two, Three, VOTES FOR WOMEN, VOTES FOR WOMEN, VOTES FOR WOMEN".'

VOTES FOR WOMEN, 18 JUNE 1908, P. 242.

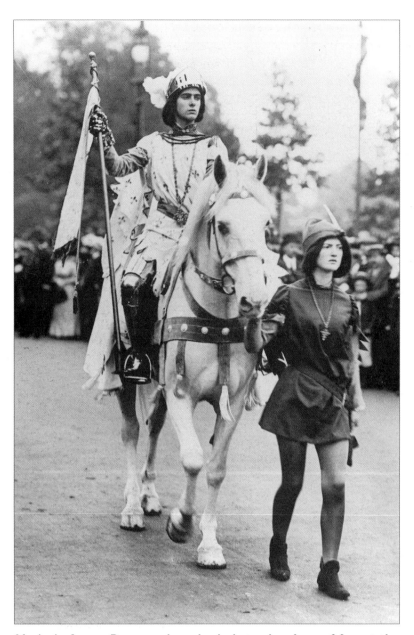

'Joan of Arc is the militant women's ideal. They feel the closest kinship with her and in every word and in every act of hers they recognize the same spirit as that which strengthens them to risk their liberty and endure torture for the sake of freedom.'

THE SUFFRAGETTE, 9 MAY 1913, P. 501.

Marjorie Annan Bryce on horseback dressed as Joan of Arc at the Women's Coronation Procession, 17 June 1911. Ahead of her, leading the procession, was 'General' Drummond, who was followed by Charlotte Marsh, the colour-bearer. The WSPU leadership followed behind Annan Bryce: Emmeline and Christabel Pankhurst, Emmeline Pethick-Lawrence and Mabel Tuke.

'No Suffragette procession has ever approached this in picturesqueness, variety, size, and significance. The views of Londoners about votes for women may or may not have changed, but it is certain that their attitudes towards the women who demand the franchise has undergone attention.'

VOTES FOR WOMEN, 23 JUNE 1911, P. 624.

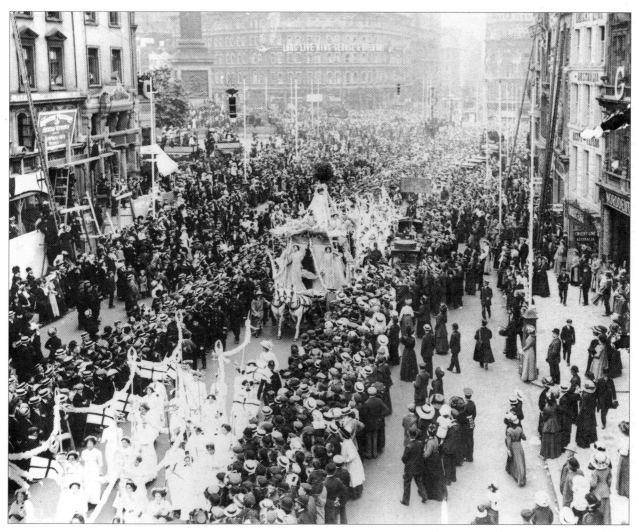

The 'Car of Empire' on the Women's Coronation Procession, 17 June 1911. Ahead of it was the Scottish contingent (not visible in this photograph) which included women pipers in Highland dress and Scottish suffragettes carrying the lion rampant, the emblem of Scotland, and national flags.

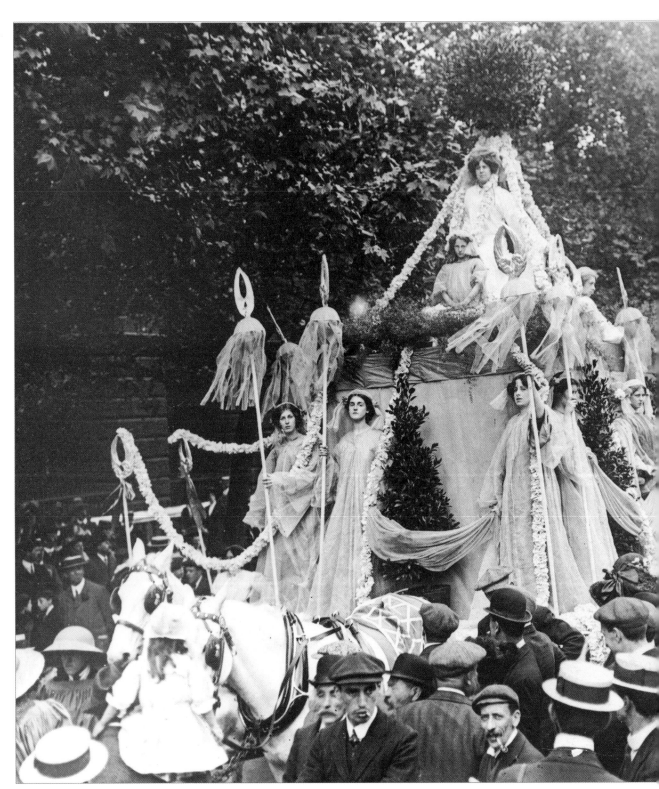

The 'Car of Empire' on the Women's Coronation Procession, 17 June 1911. This float was 'the symbol of the unity of the British Empire'. At the top of the car were two figures (only one is visible here) representing East and West, and on the lowest tier were women depicting 'the King's dominions overseas'. Suffragettes from Croydon accompanied the float, which was preceded and followed by young women carrying garlands of red roses, the emblem of England.

'Saturday, 17 June 1911, will be a historic date in the annals of this country. For on this day a procession of women greater and more representative than ever before will march through the streets of London to demand the enfranchisement of their sex. . . .

'But the procession of women on 17 June 1911, will be the greatest ever witnessed in the history of the world. It will be four miles long and will stretch from the Houses of Parliament . . . to the Bank of England. The significance of the Demonstration will be world-wide, for the procession will not only be National in its character, but also Imperial and International.'

VOTES FOR WOMEN, 5 MAY 1911, PP. 508–9.

'The Historical Pageant of Women . . . will not only be a wonderful sight from an artistic point of view, it will also be instructive: it will seize the imagination and suggest many trains of thought.'

VOTES FOR WOMEN, 23 JUNE 1911, P. 623.

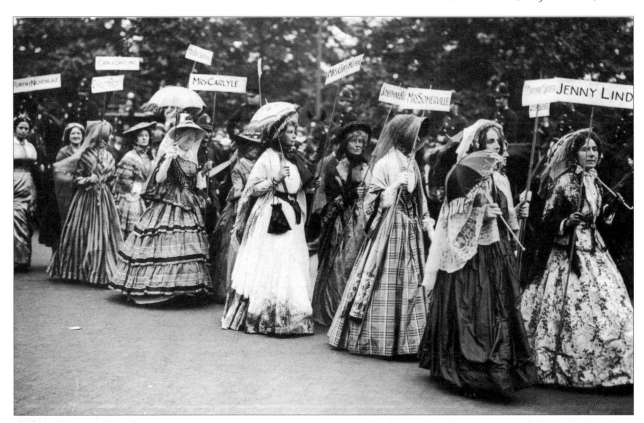

The 'Famous Women' Pageant of the Women's Coronation Procession, 17 June 1911. These suffragettes, dressed as notable women from the past, joined in the march and the rally in the Royal Albert Hall. The characters included: Jenny Lind (1820–87), the most celebrated soprano of her day; Grace Darling (1815–42), a heroine who rescued survivors from a boat wrecked off the Farne Islands; and Mrs Somerville (1780–1872), a science writer and advocate of higher education for women and women's suffrage, after whom Somerville College, Oxford, is named.

'This section will be particularly striking with the beautiful dresses of the Indian women who will carry their emblem, a charmingly designed model of an elephant. The banner is now being prepared and subscriptions will be gratefully received.'

VOTES FOR WOMEN, 2 JUNE 1911, P. 583.

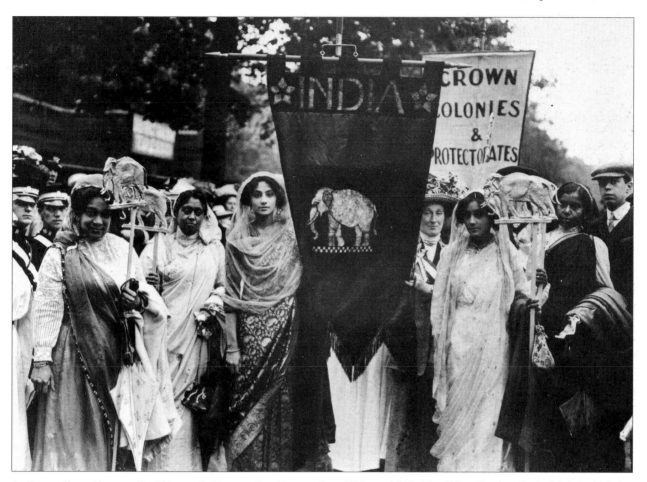

Indian suffragettes on the Women's Coronation Procession, 17 June 1911. Mrs Fisher Unwin, who had links with India, was in charge of this contingent, which was part of the Empire Pageant.

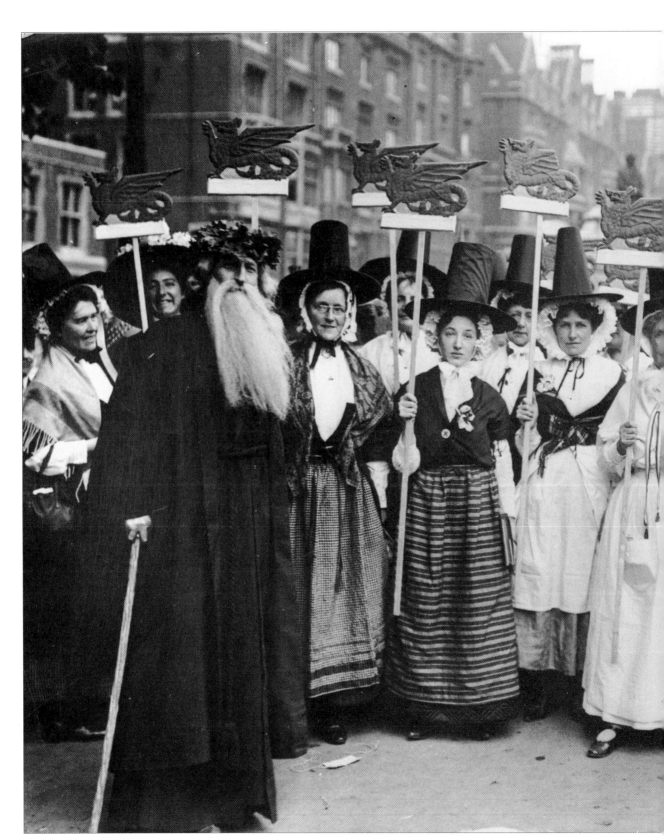

Welsh suffragettes in traditional costume on the Women's Coronation Procession, 17 June 1911. The Welsh women marched between contingents of Scottish and Irish suffragettes.

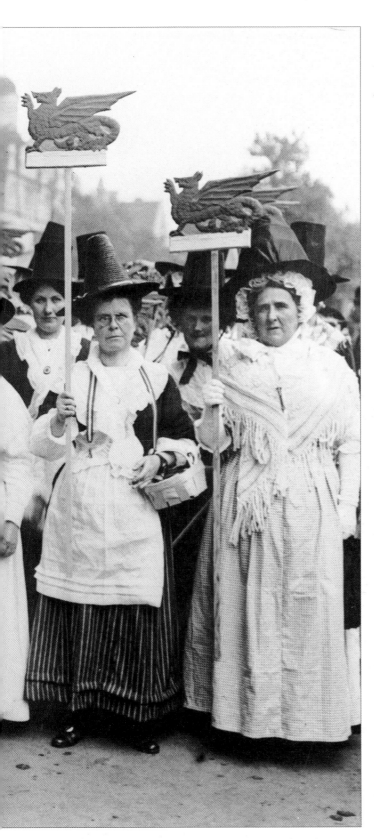

'Reverend Evan Douglas of Llandrillo offers a goat and wants some kind friend to write immediately saying she or he will meet the goat at Paddington station on the 16th and will stable and feed it and lead it in the procession. . . . The last request is for a Welsh bard, will some kind friend offer to wear the picturesque costume and walk in front of the choir?'

VOTES FOR WOMEN, 9 JUNE 1911, P. 598.

'DO *wear white if possible with a gay display of the colours.*

 wear a gown that clears the ground.

 wear a small hat.

 be punctual.

 bring some provisions lest you suffer from want of food.

 leave a space several yards on the march in front and behind every large banner or standard.

 march eyes front like a soldier in the ranks.

 march with the left foot first.

 remember when turning corners the first person marks time til the last one gets round.'

VOTES FOR WOMEN, 9 JUNE 1911, P. 593.

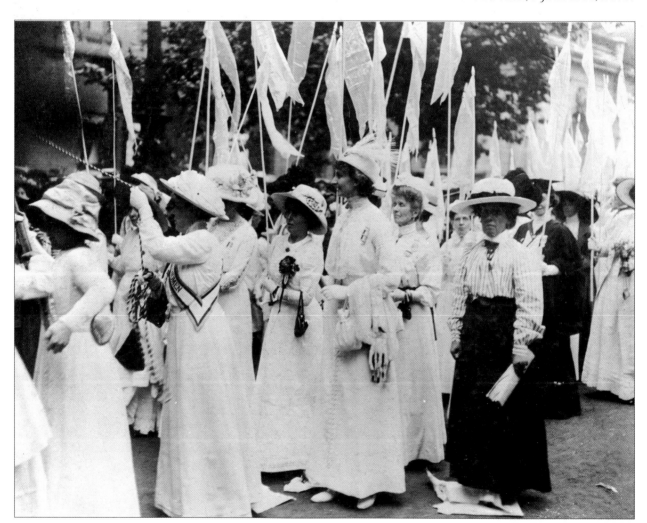

Suffragettes 'forming up' in the Prisoners' Pageant of the Women's Coronation Procession, 17 June 1911. Included in this group are Annie Kenney (centre, wearing a dark rosette), Constance Lytton (carrying a shawl) and Dr Ethel Smyth (wearing a striped blouse). By 1911, seven hundred suffragettes had been to prison for their involvement in the militant campaign.

'Preparations for the Procession occupy all thoughts now, and a very good contingent is expected. Many actresses are hurrying from their matinee to the Embankment, walking to the Albert Hall, and hastening back to the fatigues of an evening performance. One member writes: "I am playing two shows at a Music Hall both afternoon and evening, but will employ the interval in walking with you, and will carry a banner. . . ." Miss Lillah Macarthy, Miss Lena Ashwell, Miss Gertrude Elliott, Miss Anna Stannard, Miss Sarah Brooke, and many more leading actresses will join the ranks. The Musicians' Section will be particularly numerous. Dr. Ethel Smyth will lead their ranks, and a new banner, designed by Mrs Jopling Rowe, will be carried.'

VOTES FOR WOMEN, 9 JUNE 1911, P. 592.

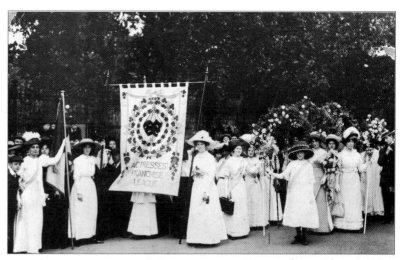

Members of the Actresses' Franchise League and their banner at the Women's Coronation Procession, 17 June 1911. Founded in 1908, the League's members included the leading actresses of the day. They would have been heavily accessorized in their own colours, pink, white and green.

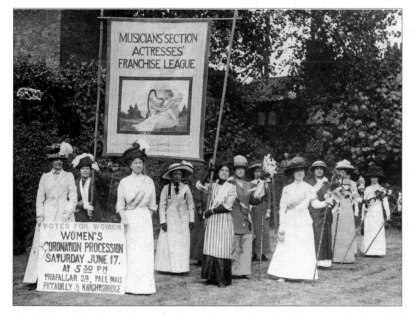

The Musicians' Section of the Actresses' Franchise League at the Women's Coronation Procession, 17 June 1911. They marched behind the actresses, and in front of the Artists' Suffrage League.

'As this contingent is to have the honour of being led by the composer of the "March of the Women", which is to be sung on the march, all those who do not yet know the song by heart should make a special effort to learn it before Saturday.'

VOTES FOR WOMEN, 16 JUNE 1911, P. 616.

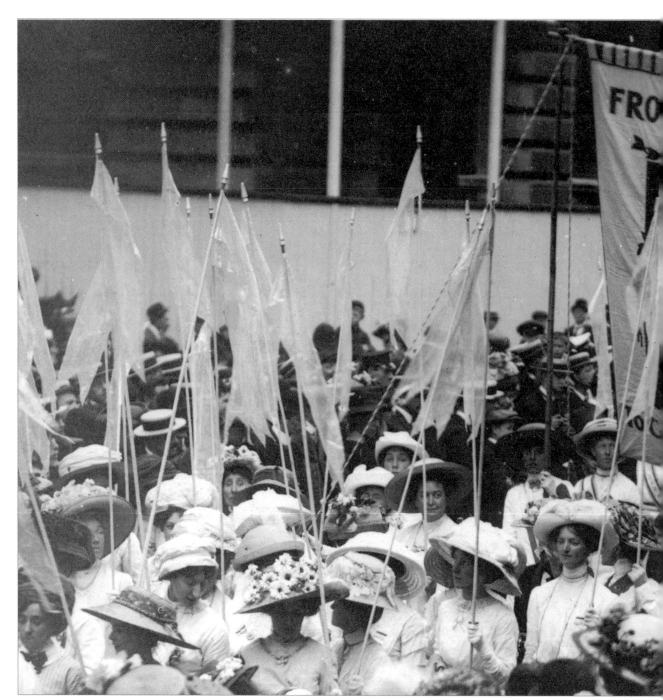

The 'From Prison to Citizenship' banner on the Women's Coronation Procession, 17 June 1911. Lawrence Housman designed this banner for the Kensington WSPU in 1908. The Prisoners' Pageant marched immediately behind the suffragette leaders and in front of the historical pageant of women.

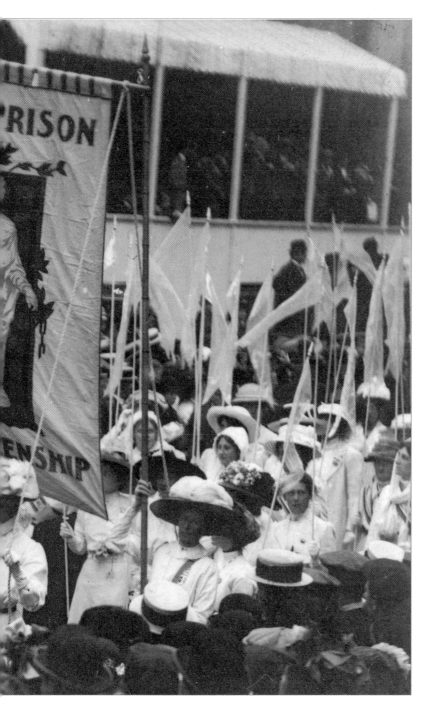

'Nothing in my mind could have made a finer opening for the Procession than the battalion of prisoners, seven hundred strong who followed behind the leaders with silver pennants fluttering in the sun and wind of cool June weather.'

VOTES FOR WOMEN, 23 JUNE 1911, P. 624.

RISE UP WOMEN
The Growth of Militancy

From the beginning, the suffragette campaign brought its members into contact with the police. Hundreds of women were imprisoned and many went on hunger strikes and were fed by force, either by nasal or stomach tubes. This was the ultimate test of a suffragette's commitment to the cause. To stage a hunger strike was an individual decision that each woman had to make on her own – they were not instructed to take this course by the leaders. Incredibly, some women took this action during every one of their prison sentences. Kitty Marion, a well-known actress, music-hall artiste, and ardent suffragette, was fed by force over two hundred times in one year alone. The prison medical records of her experiences, and those of others, make harrowing reading. Many suffragettes suffered long-term health problems as a result of their time in prison.

The sight of a solitary woman lost in thought pacing the exercise yard, and another of four suffragette prisoners, remind us of the lengths that many WSPU members went to for women's suffrage. They made personal, social and financial sacrifices for their belief in the cause; every WSPU member who had been to prison could identify with their patron saint, Joan of Arc. Their militant actions were awarded with medals, like military medals, which were worn and never left in their presentation box and put away in a drawer.

Their time spent in prison gave the women a high profile among other members of the WSPU. The tales of prison experiences made a big impact on those who had not been arrested and sentenced. The WSPU used breakfast parties like modern press conferences to welcome released prisoners. Hearing harrowing descriptions of force-feeding certainly incited

some women to take yet more militant action, and stiffened the resolve of others, who could not make this sacrifice, to work even harder for the campaign. If we were able to interview suffragettes who had become serious career militants they would say that they had been spurred on to take increasingly militant action because of their rough handling by the police and prison warders.

Holloway Gaol in 1910, the place of imprisonment where hundreds of suffragettes were incarcerated between 1906 and 1914. It was built in 1852 as the City House of Correction for men and women sentenced to short terms of imprisonment. From 1902 it was used exclusively for women. In 1970 it was demolished and a new prison was built on the site.

'...

11. The following offences committed by prisoners will render them liable to punishment:— . . .

 4. Being absent without leave from the Divine Service, or prayers, or school instruction.

 6. Swearing, cursing or using any abusive, insolent, threatening, or other improper language.

 7. Being indecent in language, act or gesture. . . .

 10. Singing, whistling, or making any unnecessary noise, or giving any unnecessary trouble. . . .

 13. Committing any nuisance. . . .

 20. Wilfully or wantonly breaking the Prison windows, or otherwise destroying the Prison property. . . .'

ABSTRACT OF THE REGULATIONS RELATING TO THE TREATMENT AND CONDUCT OF CONVICTED PRISONERS

'The idea was to get the Lancashire and Yorkshire factory women to come to London in clogs and shawls and march on Parliament. Adela Pankhurst and I were set off as recruiting sergeants. . . .

'We had arranged that a number of women from the Lancashire and Yorkshire cotton factories should make an effort to approach in a wagonette, pretending to be sight-seers, but, alas!, on reaching the Strangers' Entrance they were suspected by the police on duty and were beaten back with the rest of the crowd.

'The struggle went on during the whole afternoon and evening. Extra policemen were called up and the fight soon became a very grave one. Many of the women were seriously injured and arrests were far more numerous than on previous occasions.'

ANNIE KENNEY, MEMORIES OF A MILITANT, 1924, PP. 113–14, 116.

'Prisoners were held down by force, flung on the floor, tied to chair and iron bedsteads . . . while the tube was forced up the nostrils.

'After each feeding the nasal pain gets worse, so that it becomes the refinement of torture to have the tube forced through.

'The wardress endeavoured to make the prisoner open her mouth by sawing the edge of the cup along the gums . . . the broken edge caused the laceration and severe pain.

'Food in the lung of one unresisting prisoner immediately caused severe choking, vomiting . . . persistent coughing. She was hurriedly released next day suffering from pneumonia and pleurisy. We cannot believe that any of our colleagues will agree that this form of prison treatment is justly described in Mr McKenna's [the Home Secretary] words as "necessary medical treatment" or "ordinary medical practice".'

ABSTRACT OF THE PRELIMINARY REPORT BY THE BRITISH MEDICAL JOURNAL, 1912.

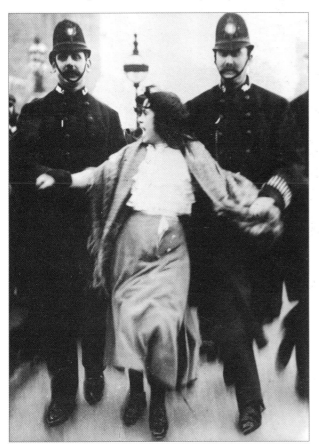

A 'Lancashire Lassie' being 'escorted' through the Palace Yard, Westminster, 20 March 1907. The defeat of Mr Willoughby Dickinson's Private Member's Bill, which would have given the vote to some women, was the catalyst for this demonstration. Forty Lancashire mill girls and Annie Kenney joined hundreds of suffragettes trying to get into the Lobby of the House of Commons. Many were arrested and charged with disorderly conduct and resisting the police. Sixty-five of them were sent to Holloway for sentences ranging from two to four weeks.

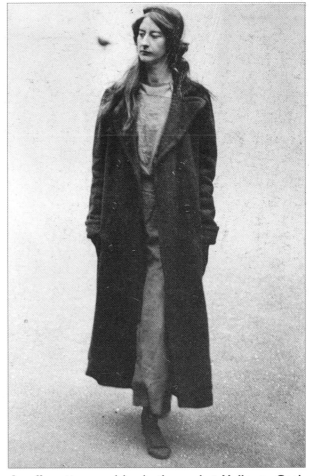

A suffragette exercising in the yard at Holloway Gaol, c. 1912. The woman is wearing her own clothing, suggesting that she is a recent arrival and still on remand. Once sentenced, she would have had to wear the prison uniform.

'Mr Churchill was questioned on leaving the train, at the door of his hotel, on leaving for the Assembly Rooms, on arrival at the reception held there. As he entered "votes for women" greeted him. "Will votes for women be in the King's Speech?" was asked again and again. . . . At the Chamber of Commerce banquet, he was met by more questioning women. The feast was at its height when Suffragettes entered the large banqueting hall, and, with the aid of a megaphone, urged their demand.'

CHRISTABEL PANKHURST, UNSHACKLED: THE STORY OF HOW WE WON THE VOTE, 1959, P. 122.

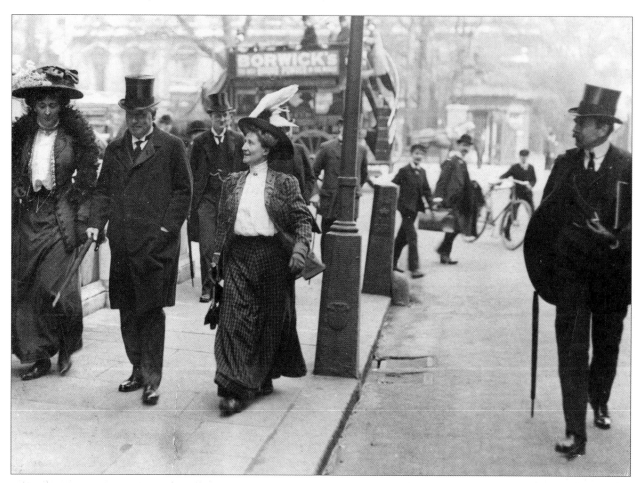

Olive Fergus (left) and Mrs Frank Corbet (right) attempting to speak to the Prime Minister, Henry Asquith, in Downing Street, 1908. On the far right walks the Secretary of State for Foreign Affairs, Sir Edward Grey. 'Pestering the Politicians' was a favourite tactic of the suffragettes. Often yielding newsworthy results, the practice reminds us how extremely accessible senior Edwardian politicians were, and how they did not have the kind of close police protection given to their present-day counterparts.

'Window-breaking, when Englishmen do it, is regarded as honest expression of political opinion. Window-breaking, when Englishwomen do it, is treated as a crime. In sentencing Mrs Leigh and Miss New to two months . . . the magistrate used very severe language, and declared that such a thing must never happen again. Of course the women assured him it would happen again. Said Mrs Leigh: "We have no other course but to rebel against oppression, and if necessary to resort to stronger measures. This fight is going on."'

EMMELINE PANKHURST, MY OWN STORY, 1914, p. 119.

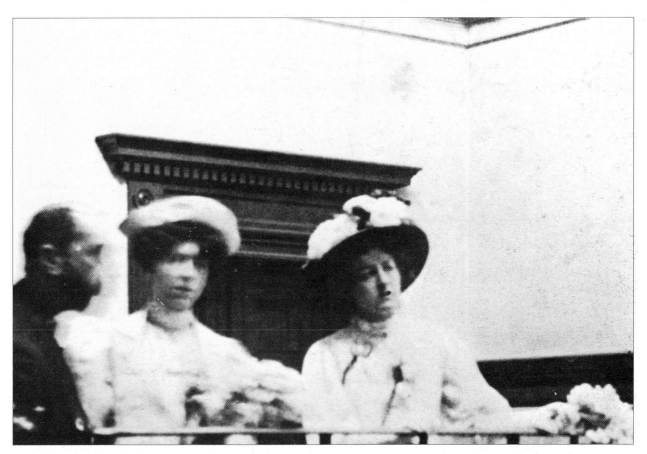

The first window-smashers, Mary Leigh (left) and Edith New (right) in the dock at Bow Street Magistrates Court, 1 July 1908. Frustrated and angered by the way members of the WSPU were being treated by the police during a demonstration in Parliament Square on 30 June, they broke windows at No. 10 Downing Street. Twenty-seven suffragettes were charged with obstruction and went to Holloway Gaol, where Leigh and New joined them.

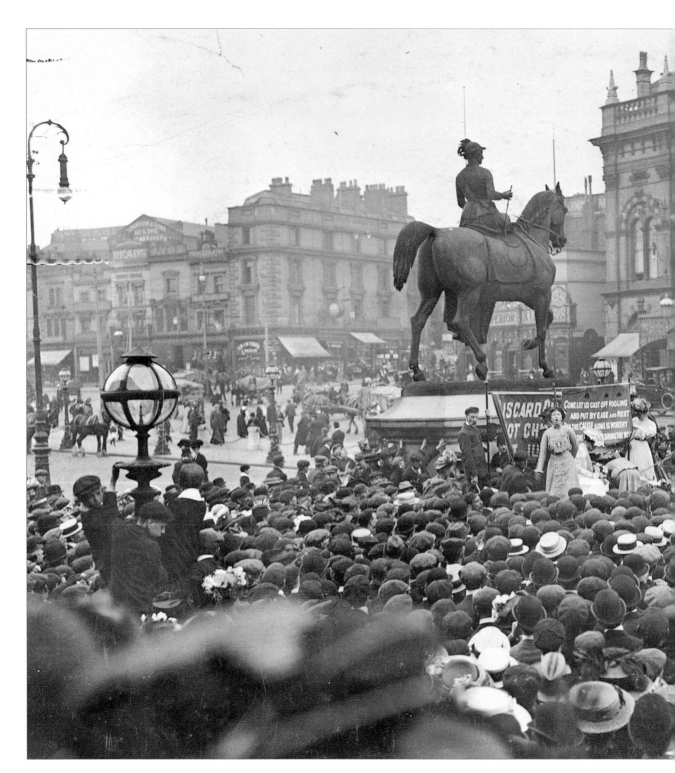

Four suffragettes speaking opposite the Empire Theatre, Liverpool, 1908. Patricia Woodlock, standing in front of the Liscard WSPU banner, was described by the *Liverpool Courier* as a 'Liverpool girl, refined, tender-hearted and heroic'. That summer, Bessie K. Morris, who was the Secretary of the Liverpool WSPU, organized 'At Homes' and meetings on the sands in Southport. The Men's League for Women's Suffrage also had a branch in Liverpool.

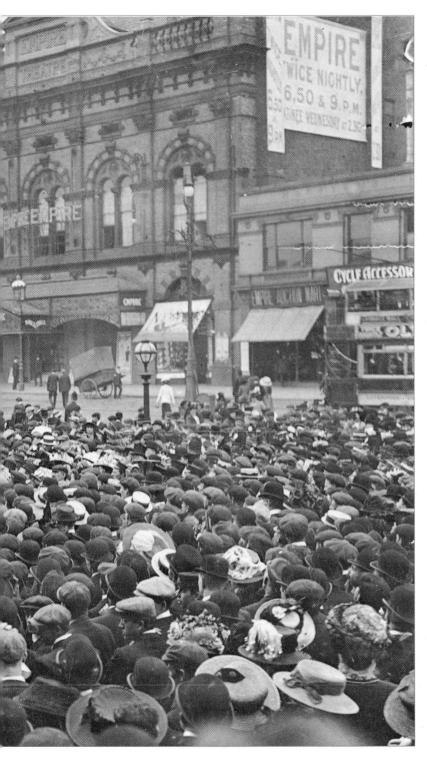

'Miss Woodlock has been three times in prison. When she came out after her second term she was only free for two or three days before she was again arrested, and sentenced this time to one month's imprisonment without the option of a fine. She has been a great trial to Cabinet Ministers.'

VOTES FOR WOMEN, 18 JUNE 1908, P. 252.

RAILING CHAINERS

'It tells the whole world that women are not prepared to submit tamely and without protest to political tyranny. It has just the same effect, neither more or less, than if we were men, and used the weapon of "murder". It is the announcement of a mental and moral revolt against oppression. It arrests attention and arouses thought and quickens perception of a wrong hitherto ignored or slothfully accepted.'

VOTES FOR WOMEN, MARCH 1908, P. 81.

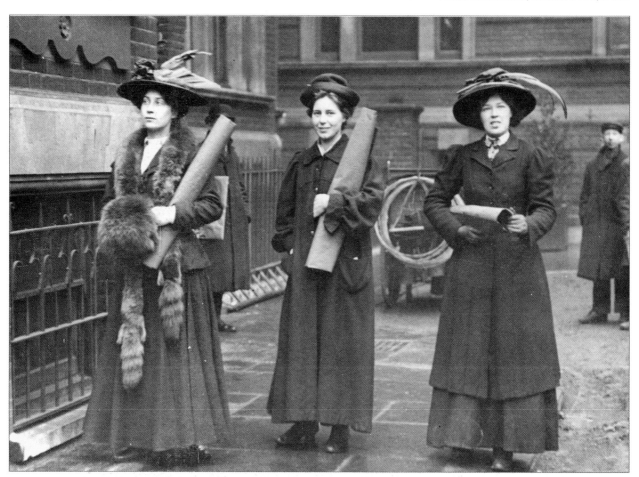

Three suffragettes prepare to chain themselves to the railings, 1909. Vera Holme, the WSPU chauffeur, is on the right. Padlocking themselves to the railings of important Government buildings afforded the suffragettes the opportunity of making lengthy political speeches. The women had as long as it took the police to cut them out of their padlocks and chains. Otherwise they would have been arrested immediately and bundled to the nearest police station.

TWO GREAT PROCESSIONS

'The West Procession will form up at 3 pm on the north side of Holland Park, and will stretch from Notting Hill Gate station to Shepherd's Bush tube station. The East Procession will form up at 3 pm on Westminster Embankment, and will stretch from Westminster Bridge to Blackfriars.

'The West Procession will start at 4 pm and, lining up on the south side of the road, march straight along the Bayswater Road until it reaches the Marble Arch, at which point it will enter Hyde Park and proceed to the space allotted to the demonstration. The East Procession will also start at 4 pm, and march up Northumberland Avenue via Cockspur Street, Pall Mall, St James's Street, Piccadilly to Hyde Park Corner, where it will enter the Park.'

THE OFFICIAL PROGRAMME FOR THE MARCH TO HYDE PARK ON SATURDAY, 23 JULY 1910, PP. 2–3.

A WSPU rally in Hyde Park in support of the Conciliation Bill, 23 July 1910. This group of male supporters, carrying their banner, is making its way to one of the four platforms for men's groups, where associations such as the Men's Committee for Justice and the Men's League for Women's Suffrage would be speaking that day. The Conciliation Bill of 1910 was the work of the Conciliation Committee, an all-party group of MPs who had devised the bill which would have given the vote to women who occupied premises for which they were responsible. Single women would have been the greatest beneficiaries of the bill if it had become law.

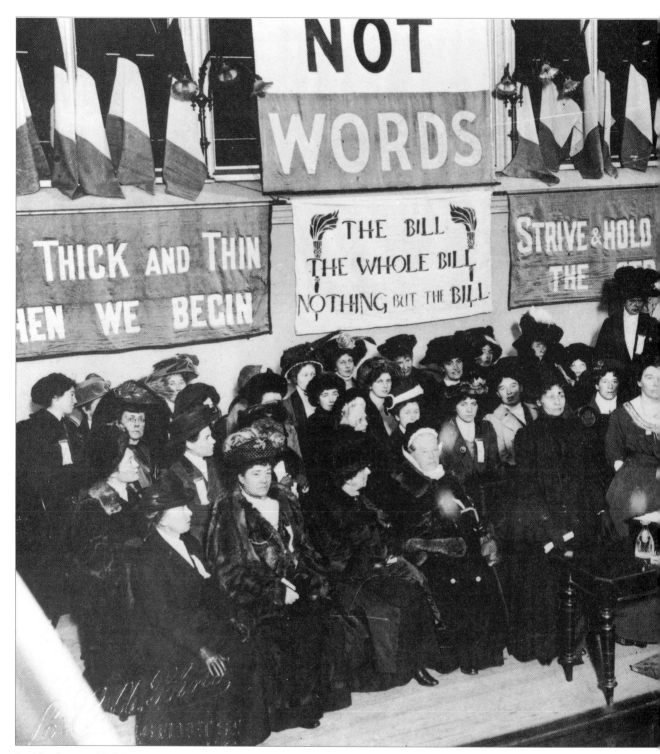

Inside Caxton Hall, Westminster, 18 November 1910. The four women in the centre of the photograph are, from left to right: Elizabeth Garrett Anderson (seated), Emmeline Pankhurst (standing), Emmeline Pethick-Lawrence (standing), and Christabel Pankhurst (standing). This day quickly became known as 'Black Friday' and was remembered as a special date in the suffragette calendar. Furious at Prime Minister Asquith and the Cabinet's political machinations in delaying the 1910 Conciliation Bill, the women marched to the House of Commons and a riot broke out. Two other riots broke out the following week, signalling the end to the truce called by the WSPU earlier in the summer in order to allow time to debate the bill in a calm and peaceful atmosphere.

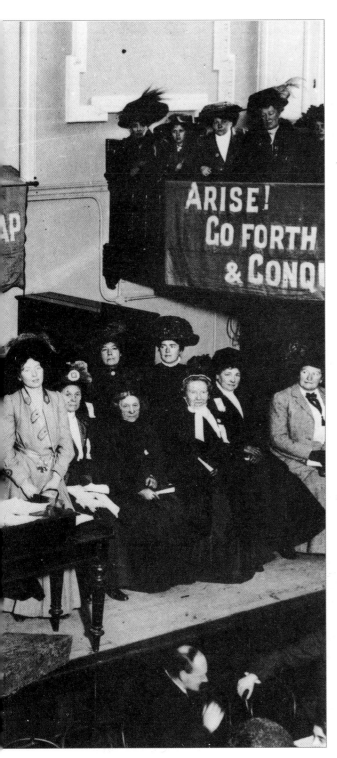

'On Friday [18 November 1910] Mr Asquith made a statement in the House of Commons omitting all reference to Woman Suffrage but announcing the Dissolution [of Parliament] for Monday 28 November. While this statement was being made in the House of Commons the Women's Social and Political Union was sitting in conference in the Caxton Hall, and on learning that Mr Asquith had definitely decided to shelve the Conciliation Bill it was determined to send a deputation to him forthwith. This deputation consisted of over three hundred women, but was divided into detachments of twelve each. At the head were Mrs Pankhurst, the founder of the WSPU, and Mrs Garrett Anderson, twice mayor of Aldeburgh, who is one of the pioneer women doctors and the sister of Mrs Fawcett [the leader of the moderates, the National Union of Women's Suffrage Societies]. Among other well-known women were Mrs Hertha Ayrton, distinguished scientist; Mrs Cobden Sanderson; Mrs Saul Solomon; Miss Neligan, who is eighteen years of age; the Honourable Mrs Haverfield; and the Princess Sophia Duleep Singh.

'The treatment which this deputation received was the worst that has been meted out to any deputation since the conflict between women and the Government began. The orders of the Home Secretary were, apparently, that the police were to be present both in uniform and also in plain clothes among the crowd and that the women were to be thrown from one to the other. In consequence of these instructions many of the women were severely hurt and several were knocked down and bruised. But altogether undaunted by these tactics the women passed on, determined to enter the House of Commons and interview the Premier. Finally one hundred and fifteen women and four men were taken into custody.'

VOTES FOR WOMEN, 25 NOVEMBER 1910, P. 117.

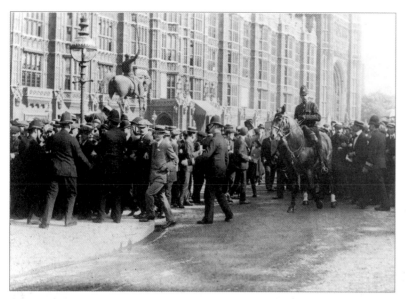

The large police presence at the House of Commons on 'Black Friday', 18 November 1910. The Conciliation Committee produced a report which examined police conduct. Sworn statements made by independent witnesses confirmed the truth of more than a hundred and fifty statements made by the suffragettes.

'For hours I was beaten about the body, thrown backwards and forwards from one to another, until one felt dazed with the horror of it. . . . Often seized by the coat collar, dragged out of the crowd, only to be pushed helplessly along in front of one's tormentor into a side street . . . while he beat one up and down one's spine until cramp seized one's legs, when he would then release one with a vicious shove, and with insulting speeches, such as "I will teach you a lesson. I will teach you not to come back any more. I will punish you, you ——, you ——." . . . Once I was thrown with my jaw against a lamp-post with such force that two of my front teeth were loosened. . . . What I complain of on behalf of us all is the long-drawn-out agony of the delayed arrest, and the continuous beating and pinching.'

TREATMENT OF THE WOMEN'S DEPUTATIONS
OF 18, 22 AND 23 NOVEMBER 1910
BY THE POLICE, P. 6.

ACTS OF INDECENCY

'The intention of terrorizing and intimidating the women was carried out by many of the police beyond mere violence. Twenty-nine of these statements complain of more or less aggravated acts of indecency. . . . The following experience is one of the worst, but is not without parallels. The victim is a young woman:–

Several times constables and plain-clothes men who were in the crowds passed their arms round me from the back and clutched hold of my breasts in as public a manner as was possible, and men in the crowd followed their example. I was also pummelled on the chest, and my breast was clutched by one constable from the front. . . . I was also very badly treated by PC ——. . . . My skirt was lifted up as high as possible, and the constable attempted to lift me off the ground by raising his knee. This he could not do, so he threw me into the crowd and incited the men to treat me as they wished.'

TREATMENT OF THE WOMEN'S DEPUTATIONS
OF 18, 22 AND 23 NOVEMBER 1910
BY THE POLICE, PP. 11–12.

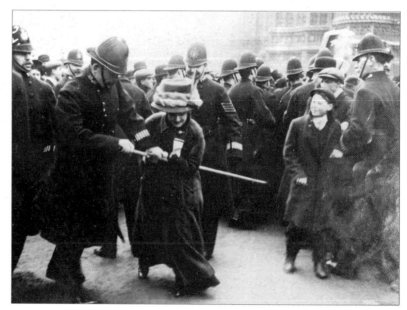

A suffragette struggling with a policeman on 'Black Friday', 18 November 1910. The WSPU quickly learned the lessons of that day and a policy decision was made to pursue their campaign using different tactics. Large deputations were considered to be too dangerous and from this moment the suffragettes went underground and waged 'guerrilla warfare' (their phrase) against the Liberal Government.

'The smashing of windows is a time-honoured method of showing displeasure in a political situation.'

EMMELINE PANKHURST, MY OWN STORY, 1914, P. 119.

'On Friday [1 March] evening, shortly before six o'clock a band of women carried out such a window breaking campaign in the principal streets of the West End as London has never known. For a quarter of an hour or twenty minutes nothing was heard in the Strand, Cockspur Street, Downing Street, Whitehall, Piccadilly, Bond Street, Oxford Street, but the fall of shattered glass and the angry exclamations of shopkeepers.'

DAILY TELEGRAPH QUOTED IN VOTES FOR WOMEN, 8 MARCH 1912, P. 352.

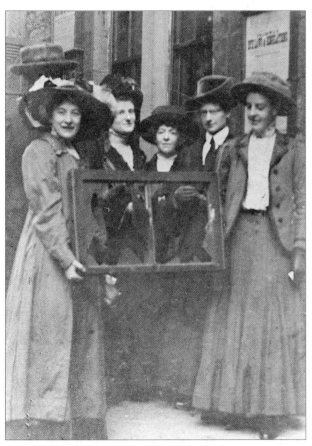

Five suffragettes holding a broken window in its frame, 1912. Adela Pankhurst is on the far left. From 1911, window smashing as executed by Mary Leigh and Edith New in 1908 was taken up with a vengeance and caused tremendous damage all over the country. The women who took part in this campaign were quickly arrested and therefore were not exposed to violent and traumatic struggles with the police as on 'Black Friday'.

Broken windows at an Aerated Bread Company (ABC) tea-shop, 1 March 1912. Two of the ABC's shops had their windows smashed that day, one in The Strand, the other in Bond Street. The first shop in this chain of tea-shops had opened in 1861 in The Strand.

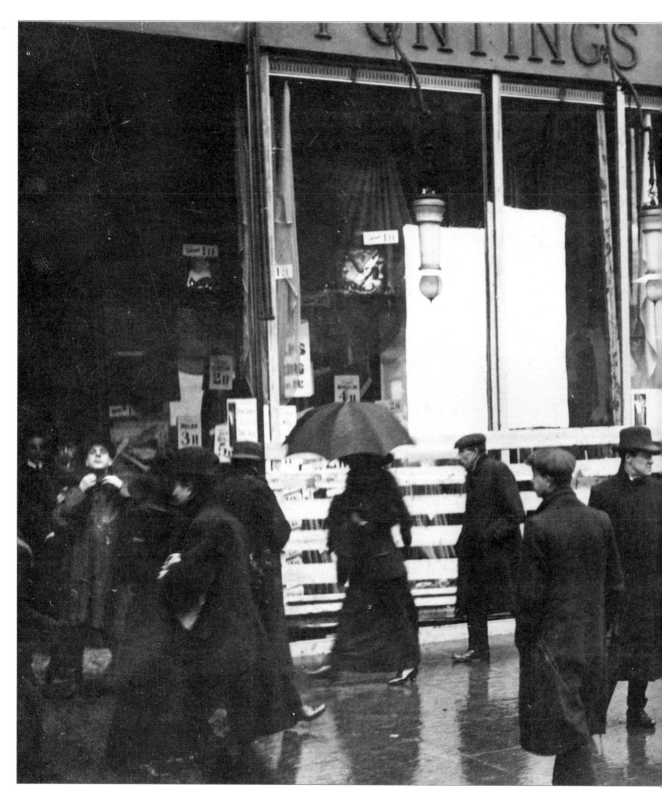

Broken windows at Pontings of 123 to 127 Kensington High Street, 4 March 1912. Tom Ponting of Gloucester opened a 'fancy draper's' shop in Westbourne Grove in 1863. Soon after, his brothers Sidney, John and William bought No. 125 Kensington High Street, then Nos. 123 and 127, quickly establishing their fancy goods and silks business which included a needlework school. Kensington WSPU bought materials and trimmings for their banners from Pontings.

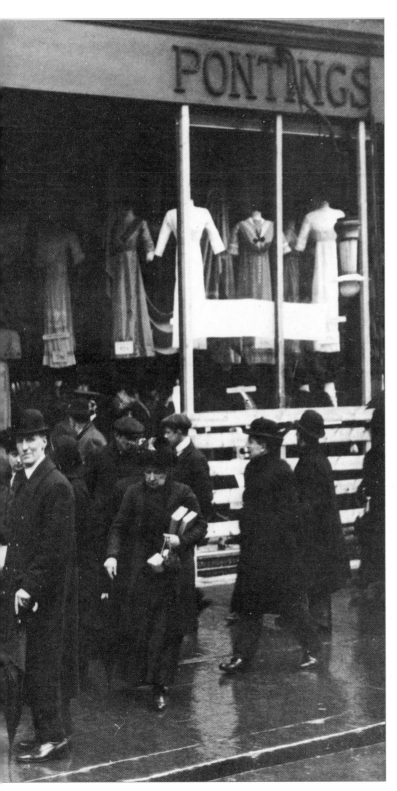

MRS PANKHURST'S MAENADS

'No one surely can have imagined destruction on this scale in London as the work of a few unbalanced women whose only grievance lies in an insignificant point of Parliamentary procedure affecting a measure they have at heart. For whatever may be the thought of the suffragist agitation its immediate grievance is simply infantile. Until recently its militant section have at least been able to urge that only violent methods would secure from Parliament the immediate facilities which they desired. But now not even that excuse remains. . . . There is indeed, only one explanation for this crowning folly, which is not merely folly but crime — that the obvious movement of public opinion from indifference to hostility has reduced them to despair. . . . Rational observers may perhaps feel that a demonstration which so utterly condemns its cause needs nothing but the passing pity which we give to the insane; but the tradesmen whose property has been destroyed will hardly take that now. So calculated, although foolish, is the outrage that it will we trust be visited upon its perpetrators with the utmost vigour of the law.'

THE TIMES QUOTED IN VOTES FOR WOMEN,
22 MARCH 1912, P. 354.

Salmon and Gluckstein's windows, broken on 1 March 1912. J. Lyons' tea-shops were established by the tobacconists Salmon and Gluckstein in 1894 – Joseph Lyons was a friend of theirs. Four months before this attack, on 21 November 1911, the windows of the tobacconists' branch in The Strand had been attacked by suffragettes.

THE ARGUMENT OF THE BROKEN PANE

'It is perhaps one of the strangest things of our civilization that it should be necessary to say that; to think that women in the twentieth century are in a world where they are forced to say that an appeal to justice, that an appeal to reason, that evidence of their fitness for citizenship should be of less value than the breaking of panes of glass. And yet there is no doubt that it is true. . . . "Deeds Not Words" is the motto of this movement, and we are going to prove our love and gratitude to our comrades by continuing the use of the stone as an argument in the further protests that we have to make. . . . Most important of all . . . does not the breaking of glass produce more effect upon the Government? . . .We only go as far as we are obliged to go in order to win, and we are going on the next protest demonstration in full faith that this plan of campaign initiated by our friends whom we honour will on this next occasion prove effective.'

VOTES FOR WOMEN, *23 FEBRUARY 1912, P. 319.*

'Peace will come again. It will come when woman ceases to believe and to teach all manner of evil of man despitefully. It will come when she ceases to impute to him as a crime her own natural disabilities, when she ceases to resent the fact that man cannot and does not wish to work side by side with her. And peace will return when every woman for whom there is no room in England seeks 'rest' beyond the sea, 'each one in the house of her husband', and when the woman who remains in England comes to recognize that she can, without sacrifice of dignity, give a willing subordination to the husband or father, who, when all is said and done, earns and lays up money for her.'

SIR A. E. WRIGHT, *THE UNEXPURGATED CASE AGAINST WOMAN SUFFRAGE, 1913, P. 86.*

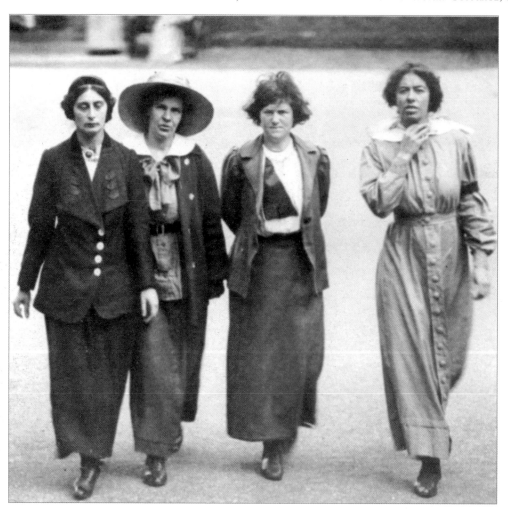

Four suffragettes exercising in the yard at Holloway Gaol, c. 1912. The woman on the right wears a black armband suggesting she may have been recently bereaved. This group of women may have been arrested on a window-smashing raid in London in early March 1912.

'Nuns in a convent were not watched over more and supervised more strictly than were the organizers and members of the Militant Movement. . . . It was an unwritten rule that there must be no concerts, no theatre, no smoking; work and sleep to prepare us for more work, was the unwritten order of the day.'

ANNIE KENNEY, MEMORIES OF A MILITANT, 1924, P. 110.

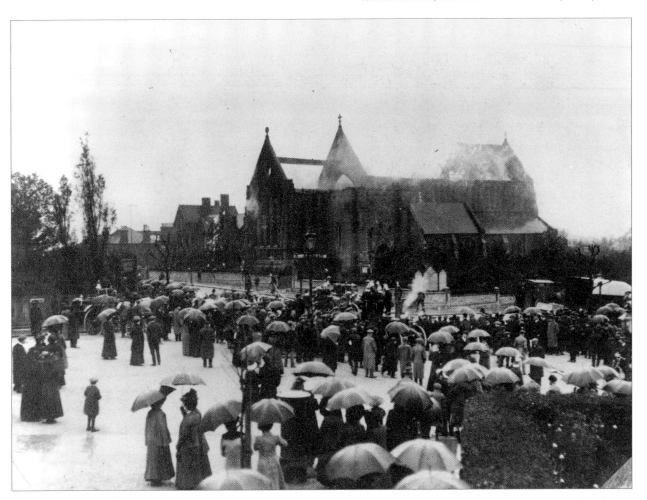

St Catherine's church, Hatcham, London, burnt down by suffragettes on 6 May 1913. A comparatively new church, just twenty years old, it was destroyed in just over an hour.

A TRAGIC TOTTERING SHELL

'*In the early hours of Thursday morning, 20 March, "Trevethan", the residence of Lady White at Englefield Green, near Staines, was burnt to the ground. The damage . . . is attributed to militant Suffragists. No arrests were made.*

'*About 1.20 the constable on duty in the district was informed that the house was on fire. He ran to the telephone and summoned the Egham Volunteer Fire Brigade, but by the time of their arrival, with their manual engine, the flames had obtained a firm hold.*

'*As the building stood on a hill a great length of the hose had to be unspun, and the pressure of the water was inadequate. It was impossible, therefore for the firemen to cope with the flames which spread with rapidity, leading to the belief that some inflammable material must have been used. Before long the roof of the north wing fell in, and almost the entire mansion, which consisted of fourteen rooms, became a wreck. It was a cold, clear night, and the strong wind helped the flames. . . .*

'*Underneath the rockery at the back of the house the police discovered pieces of paper, upon which were written the sentences:— "Votes for Women", and "Stop torturing our comrades in prison". . . . It is believed that before applying the match to the pile which would set the house on fire, the central staircase was soaked in oil, and the windows unlatched and fixed open so that the fire could be fanned by the draught. . . .*

'*Nothing was found which would give the slightest clue to the actual perpetrators of the deed.'*

THE SUFFRAGETTE, *28 MARCH 1913, P. 386.*

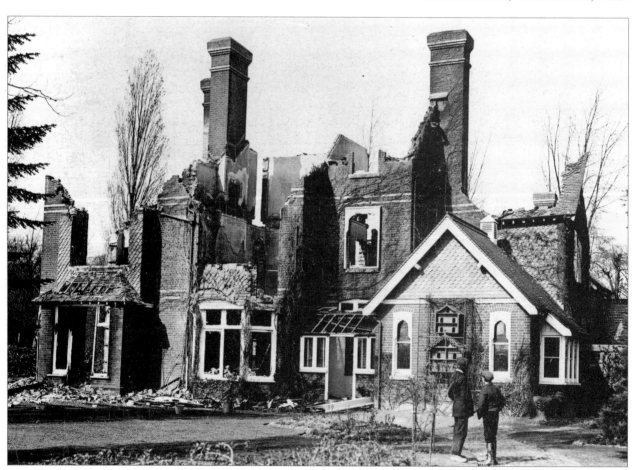

Lady White's house, burnt down by suffragettes on 20 March 1913. No one was hurt in the blaze. Like all buildings fired by the WSPU the house would have been reconnoitred to ensure that no humans or pets were killed in these attacks.

MANSION BURNT DOWN

'The most startling feature attributed to militancy this week has been the burning of a fine seaside mansion at St Leonards lately occupied by Mr Arthur du Cros, MP. The damage is estimated at £10,000.

'During Monday night . . ."Levetleigh" was discovered to be on fire. The firemen were helpless to subside the outbreak, and the building was completely destroyed. . . .When the firemen from Hastings and St Leonards arrived, it was evident that the fire had been started in different quarters, as the whole building was alight from end to end. . . .

'An entrance had been gained by smashing a window on which jam had been spread. This window was situated on the left of the front door, and the glass was broken with a hatchet, which was later found in the grounds.

'During the operation of the brigade two or three explosions were heard in various parts of the premises. . . .A quantity of Suffragist literature was found in the grounds.'

THE SUFFRAGETTE, 25 APRIL 1913, P. 471.

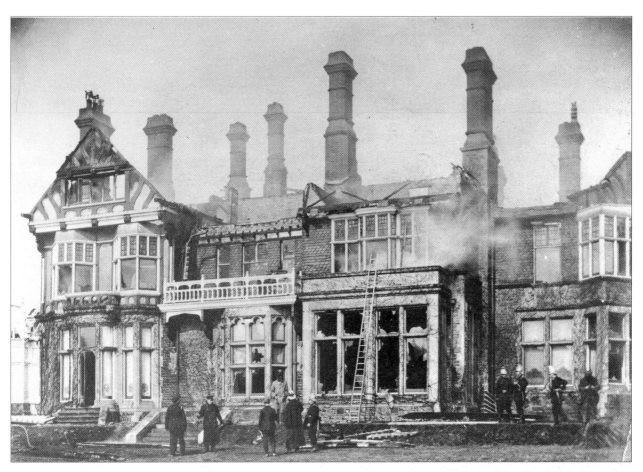

The house of Mr Arthur du Cros MP at St Leonards, Hastings, burnt down by suffragettes on 14 April 1913.
The Liberal MP was a pioneer of the pneumatic tyre and the founder of the Dunlop Rubber Company.

WOMEN CAPTURE THE MONUMENT

'The capture of the Monument by two Suffragettes who gave their names as Miss Spark and Mrs Shaw, caused great excitement in the City on Friday 18 April. Just after ten o'clock the women paid for admission in the usual way . . . when they reached the top of the flight of three hundred and forty five steps they stood talking for a few minutes to the attendants who are always on duty.

'One of the men withdrew to a little cubicle in the stonework at the top of the stairs, and the other went to speak to him. Immediately he got inside the small door by which access is gained to the gallery it was slammed to by the women and held securely by two iron bars evidently constructed for the purpose.

'Whilst one woman held the bars in position against the smooth, iron-covered outer face of the door, the other Suffragist ran to the great pole, hauled down the City flag, attached the purple, white and green of the Women's Social and Political Union to the cord under it, and triumphantly hoisted the two to the top of the mast. Then she unrolled a long banner bearing the motto, "Death or Victory". She deftly tied it to the outer railings, whence it could be seen and read from a great distance. Next a long streamer of Suffragist colours was unfurled, and fluttered gaily in the strong breeze. Finally, a number of Suffragist handbills were released, and fluttered over the surrounding houses and down to the ground.

'The crowd below assumed large dimensions, thousands being gathered at the foot of the Monument. Every point of vantage, including window sills, brewers' vans, fish carts, were occupied by spectators.

'The police and City Corporation employees made desperate attempts to dislodge the women.

'At length, with the aid of a twelve pound sledge-hammer, the barricade was forced and the flags pulled down. The women then quietly descended the stairs, and, conducted by the police, made their way to the Monument Station.'

THE SUFFRAGETTE, 25 APRIL 1913, P. 470.

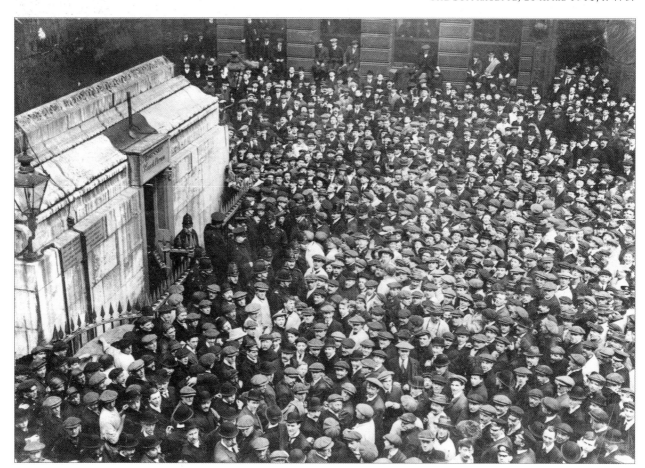

Onlookers gather at the Monument, captured by two suffragettes on 18 April 1913. Designed by Sir Christopher Wren, the Monument was built to mark the spot where the Great Fire of London had started in 1666. No charges were brought against the two women who were responsible for this publicity stunt.

'To the roll of the drums and the muffled chords of Chopin's Funeral March the great procession slowly moved forward, headed by the cross-bearer Miss Charlotte Marsh, her fair hair uncovered. Immediately behind her came twelve white-clad girls with laurel wreaths and a banner inscribed "Fight On And God Will Give The Victory". This, like all the banners of the WSPU, was in purple worked with silver. Following more girls in white came a dense throng of women in black carrying bunches of purple iris. These were succeeded by others in purple, carrying red peonies, and these in turn by a long stream of members in white with Madonna lilies. . . . The coffin, placed on a low, open bier, was covered with a purple silver-edged pall, which only showed the silver arrows and three laurel wreaths from the WSPU, inscribed "She Died For Women". . . .'

THE SUFFRAGETTE, 20 JUNE 1913, P. 594.

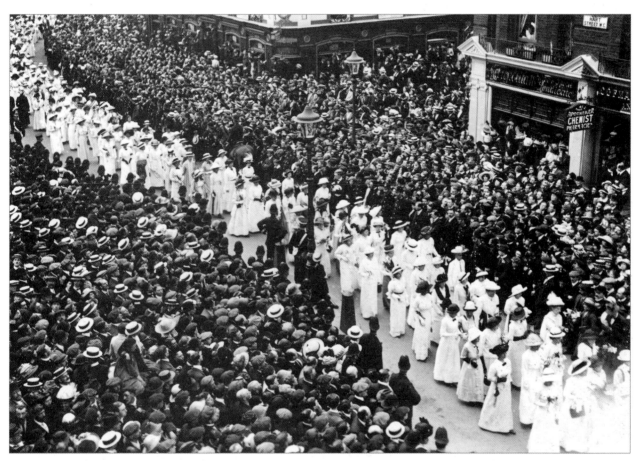

Emily Wilding Davison's funeral procession, organized by the WSPU, in Hart Street, 14 June 1913. Before her body was taken to Morpeth for burial, a service was held at St George's Church, Bloomsbury.

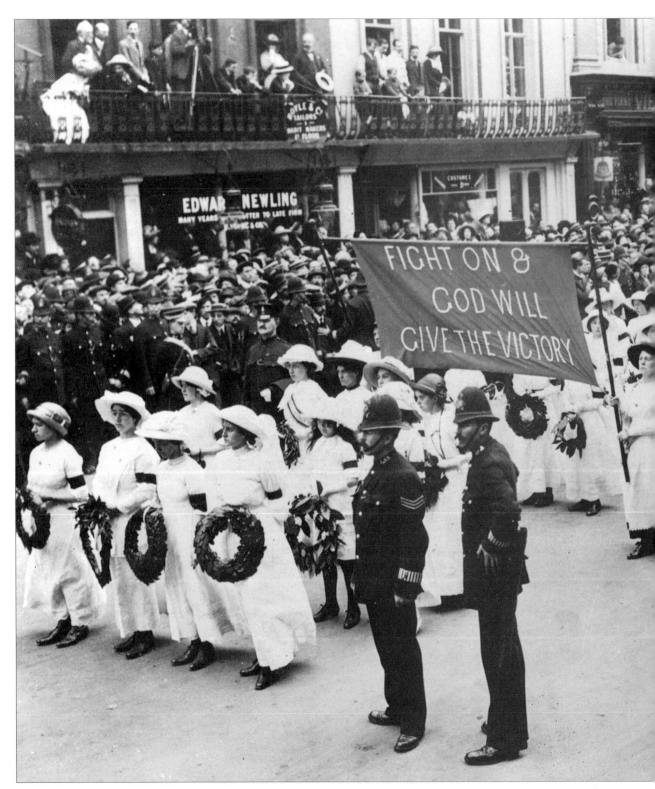

Suffragettes at the funeral of Emily Wilding Davison. They march ahead of the hearse, carrying one of the purple silk banners. Contrary to the mythology which surrounds this dramatic protest, Wilding did not throw herself at the king's horse – she stepped in front of it and tried to stop it. She chose the date carefully knowing that the king's presence at the most prestigious event of the racing calendar would guarantee plenty of press interest, and therefore maximum publicity for the WSPU's campaign.

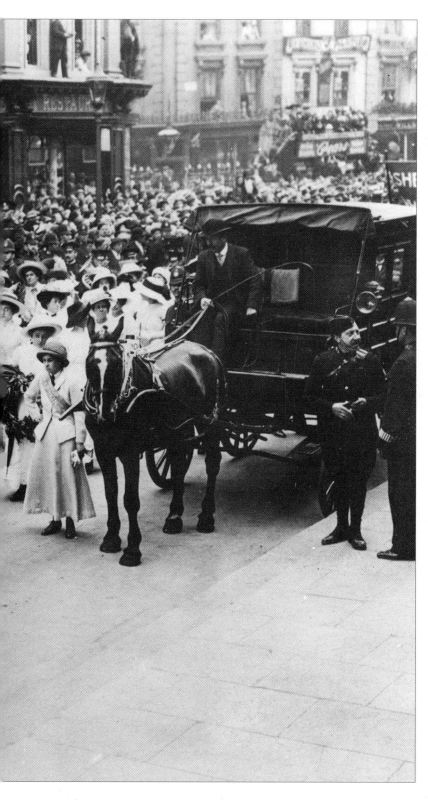

'Anmer struck her with his chest and she was knocked over screaming. Blood rushed from her nose and mouth. The King's horse turned a complete somersault, and the jockey, Herbert Jones, was knocked off and seriously injured. An immense crowd at once invaded the course. The woman was picked up and placed in a motor car and taken in an ambulance to Epsom Cottage Hospital.'

DAILY MIRROR, 5 JUNE 1913,
QUOTED IN THE SUFFRAGETTE.

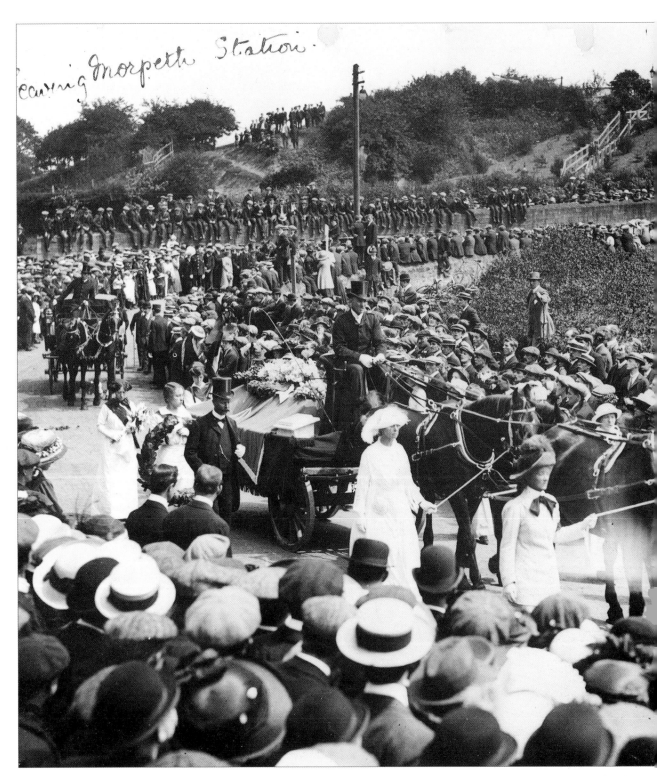

A large crowd watches Emily Wilding Davison's funeral procession leaving Morpeth station, 15 June 1913. On this day every year, up to the late 1960s, suffragettes would visit Morpeth on the 'Emily Davison Pilgrimage'. In 1915, her friend Mary Leigh, far left in the photograph with her head bowed, started the 'Emily Davison Club', and the 'Emily Davison Lodge', whose aim was: 'to perpetuate the memory of a gallant woman by gathering together women of progressive thought and aspiration with the purpose of working for the progress of women according to the needs of the hour'.

'All through the night the bodyguard of honour had kept watch over their fallen comrade.

'By the time the coffin was borne from the train to the open hearse that was waiting, a procession was drawn up and huge crowds of people assembled. People had been hanging around the station for a long while. They had gathered to watch the unpacking of the massed wreaths. The attitude was expressive of wonder and reverence. . . .

'Very slowly . . . the procession moved off. It was headed, as in London, by a girl cross-bearer, followed by six children carrying Madonna lilies. The Newcastle colours, streaming out proudly behind the group of white-clad women who marched in front of the band. . . .

'The route to the graveyard lay down a quiet country road. The trees and fields were wonderfully green on either side. But the chief impression was created by the crowd. The procession filed slowly through the dense and serried ranks of people. The banks on either side were lined with human beings. Masses of men and women had been streaming into Morpeth since an early hour in the morning. They waited reverently with bared and bowed heads to see it pass. Many of the women were moved to tears, and the faces of men betokened strong emotion. . . . These country men and women realized that they were privileged in paying honour to so fine a deed of selfless enthusiasm.'

THE SUFFRAGETTE, 20 JUNE 1913, P. 594.

A racecourse stand wrecked by suffragettes in 1913. The women vandalized recreation areas such as golf greens by burning 'No Votes, No Golf' into the turf, while others like this one were the subject of arson attacks. Most of these arson and bombing raids were carried out in the middle of the night, resulting in very few suffragettes being caught and sent to prison.

'In countries such as England, where an excess female population has made economic difficulties for woman, and where the severe sexual restrictions, which here obtain, have bred in her sex-hostility, the suffrage movement has as its avowed ulterior object the abrogation of all distinctions which depend upon sex; and the achievement of the economic independence of woman. . . .

'The proposal to bring man and woman together into extremely intimate relationships raises very grave questions. It brings up, first, the question of sexual complications; secondly, the question as to whether the tradition of modesty and reticence between the sexes is to be definitely sacrificed; and, most important of all, the question as to whether epicene conditions would place obstacles in the way of intellectual work.'

SIR A.E.WRIGHT, THE UNEXPURGATED CASE AGAINST WOMAN SUFFRAGE, 1913, PP. 61–2.

RUSHOLME EXHIBITION HALL GUTTED

'A disastrous fire broke out early last Saturday morning in South Manchester, when the Rusholme Exhibition Hall was burnt to the ground.

'That the outbreak was brought about by the Suffragists seems clear from the fact that nearby was found the imprint of a woman's boot, together with some literature and a note addressed to Mr Asquith: "This is your welcome to Manchester and Oldham.". . .

'The scene next morning was remarkable. Soon after four o'clock the front part of the Exhibition Hall, the last part to remain standing, had fallen with a crash, and the whole building was totally destroyed.

'Here and there a few burning embers were still being played upon by the firemen, and so complete had been the ravages of the fire that nothing at all was saved.

'The place looked as if there had been a huge bonfire. The plaster pillars that once adorned the front of the building were lying in a heap, and the office containing the safe and valuable documents connected with the Hall, was, of course, wiped out.'

THE SUFFRAGETTE, 12 DECEMBER 1913, P. 206.

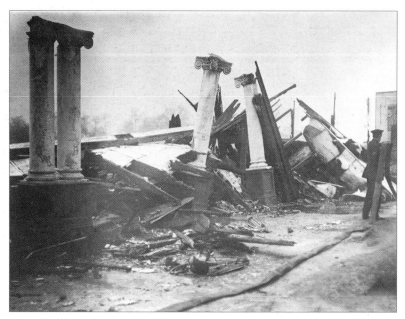

Rusholme Exhibition Centre, Manchester, wrecked by suffragettes on 7 December 1913. Emmeline Pankhurst's recent arrest proved a catalyst for an outbreak of fires in the north of England. This arson attack caused damage worth £12,000 (equivalent in modern terms to half a million pounds).

SENSATION AT NATIONAL GALLERY

'A great sensation was caused on Tuesday morning by the news that the Rokeby "Venus" of Velasquez had been attacked by a Suffragette and very seriously damaged. . . . It has been damaged, if not beyond repair, at least to a very serious extent, as the result of seven heavy blows with a meat-chopper.

'The first warning the attendant in charge had was the crash of breaking glass, and turning round he saw a woman raining blows on the Velasquez with a small axe. He and a policeman, who was also on watch, made a dash at her, but before they could reach her she had struck the picture seven fierce blows. . . .

'The woman was immediately seized and taken to the police station. She gave the name Mary Richardson. Perhaps no act of militancy has ever caused such a deep sensation or aroused so much comment in the Press and among the public.

'At present the National Gallery, the National Portrait Gallery, the Wallace Collection are all closed to the public.'

THE SUFFRAGETTE, 13 MARCH 1914, P. 491.

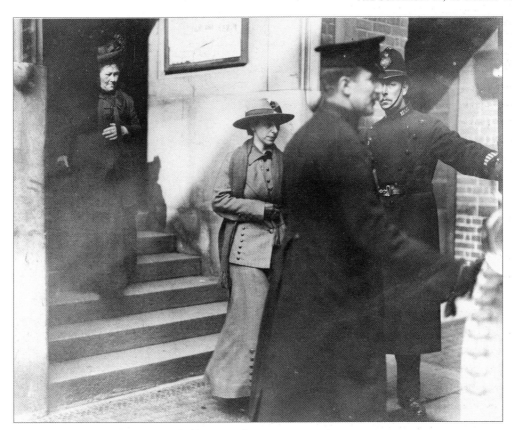

'Slasher' Mary Richardson leaving court. Richardson had attacked the *Rokeby Venus* at the National Gallery on 4 March 1914. Attacks on works of art prompted the closure of many of the country's art galleries and museums to women, and sometimes to the public completely. At places of historical interest the rule of 'No muffs, wrist-bags, or sticks' was widespread. Later, in May 1914, the Royal Academy and the Tate Gallery closed to the public. The British Museum was more flexible, opening to women accompanied by men who would accept responsibility for them. Unaccompanied women were only allowed in if they had a letter of recommendation from a gentleman who would vouch for their good conduct and take responsibility for their actions.

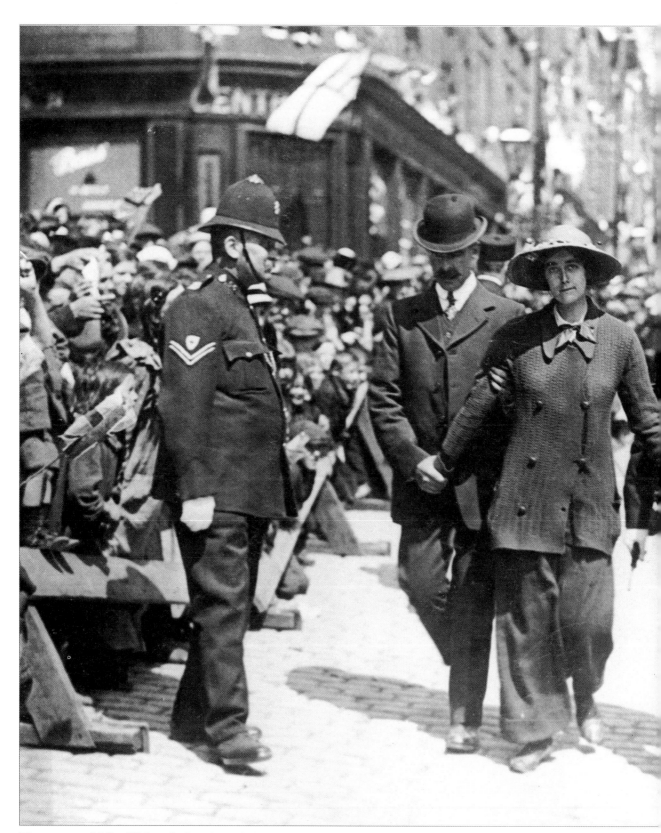

The arrest of Olive Walton in Dundee, 1914. She had travelled to Scotland determined to speak to King George V, and was charged with trying to 'rush' the king's carriage.

'Miss Olive Grace Walton, Honorary Organising Secretary of the Tunbridge Wells branch of the WSPU. . . . Joined 27 March 1911, avoided Census April 1911; 21 November 1911, joined Mrs Pethick-Lawrence's deputation to the House [of Commons]; arrested for obstructing the police; in Holloway Prison, 23 to 30 November 1911; 1 March 1912, arrested and charged with malicious damage; in Holloway Prison (on remand), 2 to 12 March, 1912; convicted and sentenced to four months on 27 March, 1912; in Aylesbury Prison, 27 March to 30 June 1912; hunger-strike and forcible feeding in April, also in June, 1912.'

OLIVE GRACE WALTON'S ENTRY IN
A.J.R. (ED.), THE SUFFRAGE ANNUAL AND
WOMEN'S WHO'S WHO, 1913, P. 387.

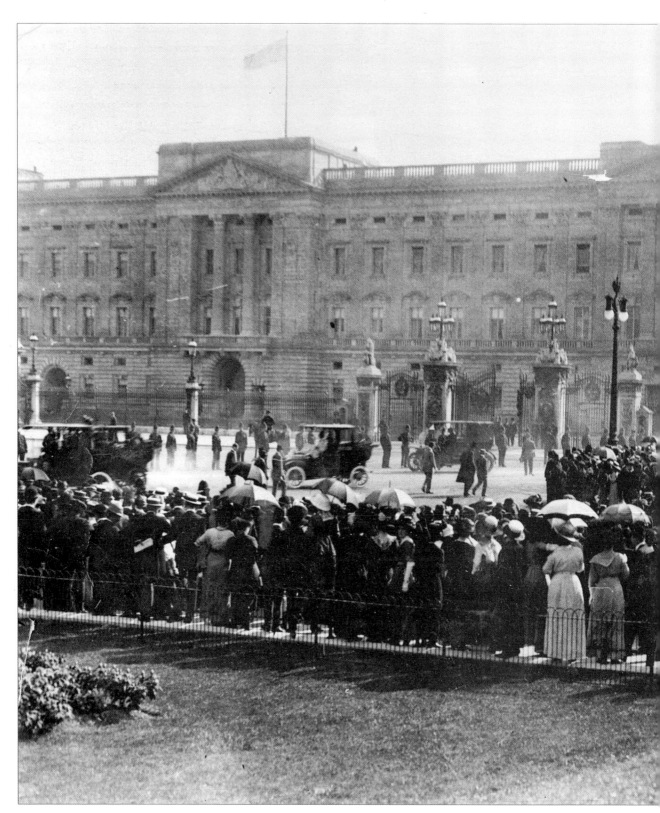

Crowds watch a suffragette deputation attempt to enter Buckingham Palace, 21 May 1914. Abandoning all hopes of any parliamentary progress on women's suffrage, the WSPU announced they would personally petition the king. He refused to see them. Undaunted by his refusal, they marched to the palace anyway.

'A large number of women from all parts of the country attempted to proceed to Buckingham Palace to wait on their King, the object of the deputation being to demand votes for women, to protest against torture, and to claim equal treatment with militant Ulstermen and militant Suffragists. They were met by serried ranks of the police, both mounted and on foot, who brutally ill-used the women and arrested about sixty including Mrs Pankhurst. . . .
Surrounding the police was a crowd estimated at between twenty to thirty thousand persons, who had formed up in Constitution Hill, the Mall and Buckingham Palace Yard.'

THE SUFFRAGETTE, 29 MAY 1914, P. 121.

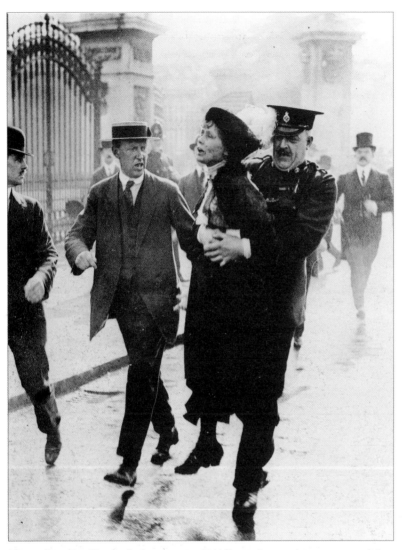

Emmeline Pankhurst being arrested while trying to present a petition to the king at Buckingham Palace, 21 May 1914. The arresting officer, Superintendent Rolfe, died two weeks later of heart failure.

MRS PANKHURST REACHES BUCKINGHAM PALACE

'It was not until nearly 4 o'clock that the great gate at the top of Constitution Hill was closed, but before that time, Mrs Pankhurst and the women with her had passed through the police cordon at the bottom of the hill, no attempt was made to arrest her, and she had reached the royal palace before she was recognized.

'A huge inspector seized her, and carried her bodily to a waiting motor car. She was lifted in, two detectives sprang in after her, and the car drove off at once to Holloway. While going towards the motor car two St John's Ambulance men ran forward and proffered their assistance, but it was not accepted.

'As she was being carried past the group of reporters, Mrs Pankhurst called out, "Arrested at the gates of the Palace. Tell the King!" '

THE SUFFRAGETTE, 29 MAY 1914, P. 121.

PUMMELLED THEM UNMERCIFULLY

'Some of the women rushed at the gate and railings and climbed on to the crossbars, while others attacked the police and tried to force them out of the way. There were a considerable number of police agents in plain clothes, most of them being men of a low and brutal type.

'Great roughness and brutality was also shown by the men in uniform. They pummelled the women and a man supporter unmercifully, and threw them about in a savage fashion, even after they had been taken into the station room. The women broke windows, the glass of the pictures, and anything they could lay their hands on, but that was no excuse for treating them in such a manner.'

<div align="right">THE SUFFRAGETTE, 29 MAY 1914, P. 121.</div>

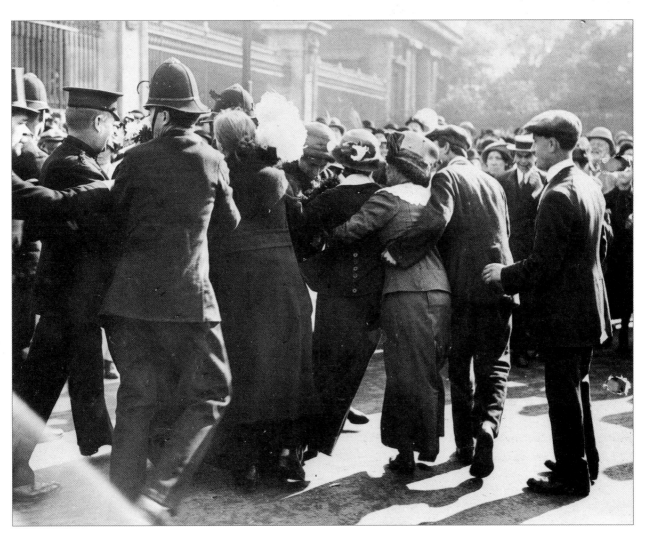

Suffragettes struggle to enter Buckingham Palace, 21 May 1914. A heavy police presence ensured they did not succeed in entering the palace gates.

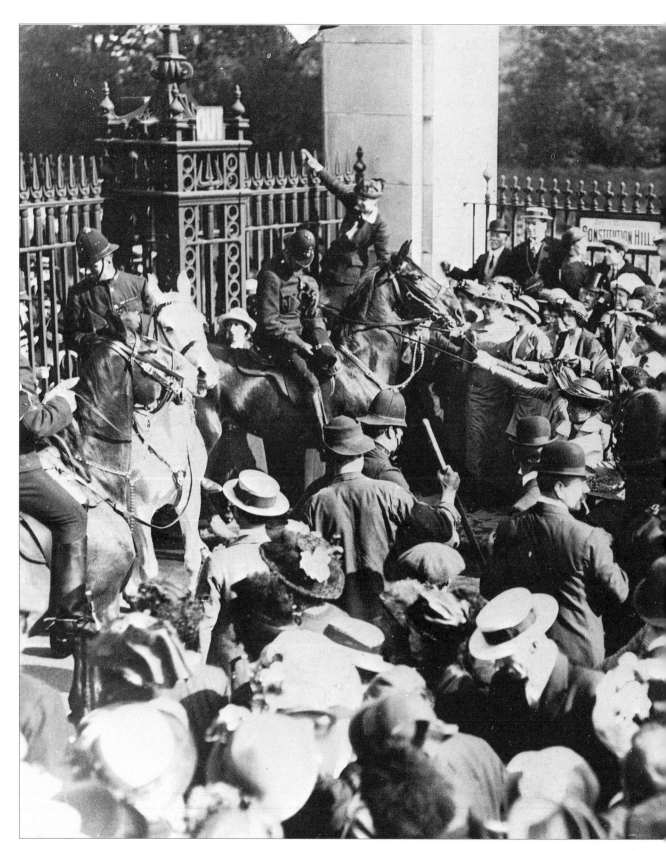

Riot at the Constitution Hill gate of Buckingham Palace, 21 May 1914.

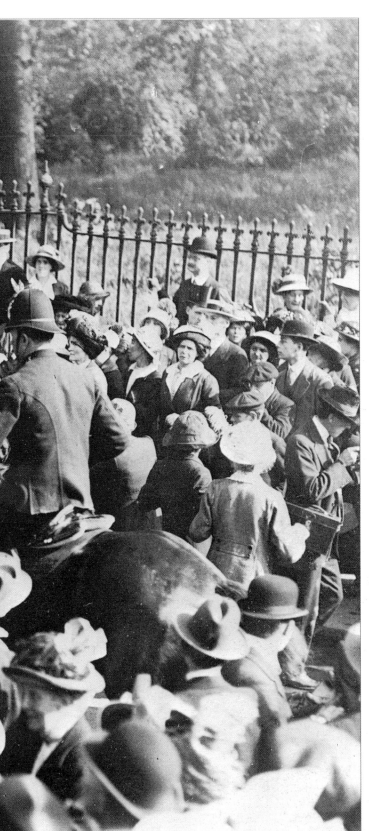

SHOES, FLOUR, AND OTHER MISSILES THROWN AT MAGISTRATES
'The women who were arrested on Thursday as a result of the scenes arising out of the King's refusal to receive the deputation, were brought before Sir John Dickinson at Bow Street on Friday. There were sixty-six women and two men.

'Practically all the women refused their names, and were allotted numbers. . . . In the course of the proceedings the strain of "The Marseillaise" played on a cornet reached those in the court, and Suffragists in the cells and corridors applauded loudly. . . . Number one was brought in, and, refusing to walk, was dragged in on her knees. She was charged with striking a constable in the face and was bound over. . . .

'Then a woman had to be held in the dock by the constable. Notwithstanding this, she wrenched herself free, and almost climbed over the dock rail. . . . A bag of flour was thrown and its contents scattered over the court. A man created a disturbance by shouting out something and several constables rushed to him. . . .

'"Number 11" pulled off her boot and flung it at the magistrate from the dock. Sir John caught it with his left hand and placed it on the table by his side. She was bound over. . . . "Number 14" shouted "Hip, Hip, Hurrah!" when she was brought into the court, and continued until she was ordered to be bound over.'

THE SUFFRAGETTE, 29 MAY 1914, P. 122.

'*Dear Mother*

'*I am fighting, fighting, fighting. I have four, five, six wardresses every day as well as two doctors. I am fed by stomach-tube twice a day. They prise open my mouth with a steel gag, pressing it in where there is a gap in my teeth. I resist all the time. My gums are always bleeding. . . .*

'*I am afraid they may be saying we don't resist. Yet my shoulders are bruised with struggling whilst they hold the tube into my throat.*

'*I used to feel I should go mad at first, and be pretty near to it, as I think they feared, but I have got over that, and my digestion is the thing that is most likely to suffer now.*'

WSPU HANDBILL, 18 MARCH 1913.

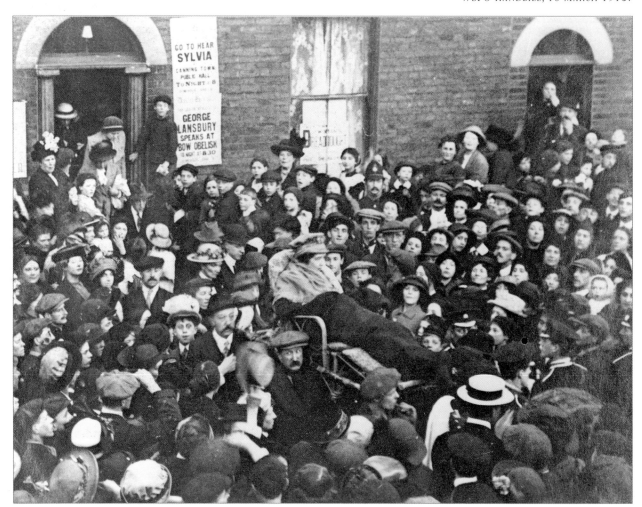

Sylvia Pankhurst leaving the East End of London in a bath-chair, June 1914. Weakened by hunger, thirst and sleep strikes, Sylvia had her own bodyguard of East End suffragettes and male supporters who tried to prevent the police re-arresting her while she was released from Holloway Gaol under the terms of the Prisoners' Temporary Discharge for Ill-Health Act, usually called the 'Cat and Mouse' Act.

'Another picture outrage was committed at the National Portrait Gallery at about half past 11 yesterday morning by a Suffragist. A young woman of refined appearance and very respectably dressed attacked Millais's unfinished portrait of Carlyle with a butcher's cleaver which she carried concealed beneath her blouse, and before she could be restrained made three large cuts on the face and head of the portrait. . . .

'The blows were delivered with lightning-like rapidity, and then an attendant sprang forward, and, grasping her round the waist, swung her away from the picture. On the way to Vine Street Police Station, she offered a string of energetic protests against Mrs Pankhurst's re-arrest. At the station she gave her name as Annie Hunt, but refused her address.'

MORNING CHRONICLE QUOTED IN
THE SUFFRAGETTE, 18 JULY 1914, P. 258.

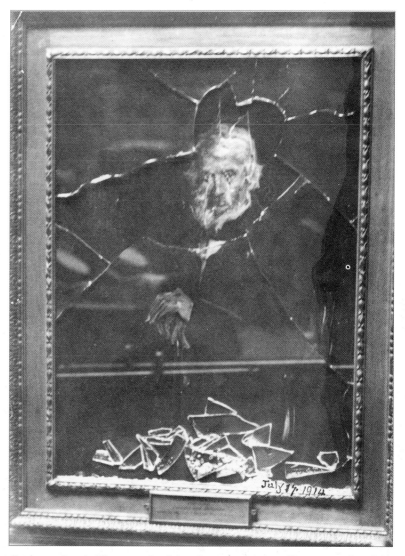

A portrait of Thomas Carlyle, damaged at the National Portrait Gallery on 17 July 1914.

'KEEP THE HOME FIRES BURNING'

Women and the First World War, and the Grant of the Vote

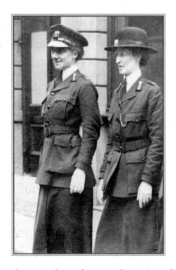

The suffragette campaign stopped more or less completely in August 1914. The First World War was an emergency which scaled down dramatically the fifty-year struggle waged by the moderate and militant women's suffrage movement. On 10 August the Government released suffragette prisoners on the understanding that violence would cease.

Within the women's suffrage movement response to the outbreak of war varied enormously. The moderates, led by Mrs Fawcett, took up a variety of war work and war relief work, although not all members were happy about this. Pacifists within the ranks objected not only to the fighting, but also to war work of any kind. Others, while admitting the need to continue fighting, tried to encourage an early peace treaty.

Emmeline and Christabel Pankhurst and their followers in the WSPU stopped campaigning for the vote and threw themselves wholeheartedly into anti-German propaganda, and recruiting women war workers for the Home Front. As far as they were concerned Germany had to be defeated at all costs. Out of unswerving patriotism they placed their support, propaganda and recruiting skills at the disposal of the Government. Some very patriotic suffragettes were even known to hand out white feathers, the symbol of cowardice, to young men not in uniform.

In 1917 the WSPU changed its name to The Women's Party, and their newspaper was re-titled *Britannia*. The party's priorities included campaigning

for the employment of women in munitions factories and condemning pacifism and workers who went on strike.

Sylvia Pankhurst and many other suffragettes disagreed with the majority of WSPU members who supported her mother and sister. Throughout the war Sylvia continued to campaign for votes for women and spoke on pacifist and socialist platforms. Her East London Federation of Suffragettes was renamed The Worker's Suffrage Federation in 1915, and provided practical help for the poorest people in the East End of London, who were hit badly by the affects of the war. Mother and infant welfare clinics and cost price restaurants were opened, and small factories employing women who had lost their jobs because of the war were opened and funded by Sylvia's organization. Her mother and her sister were furious at her left-wing beliefs and her attacks on wartime jingoism.

By the end of the war about one million more women were at work than had been in the summer of 1914. Most of them had taken jobs previously done by men who were in the armed forces. The large number of working-class women was nothing new; such women had always gone out to work. But for the first time women from the middle classes were seen to be earning a living; indeed, women from all social classes helped to 'keep the home fires burning' and joined in the war effort. They worked as coal-heavers, railway porters, land-girls, carpenters, mechanics, postwomen, policewomen and munitions workers. An enormous range of semi-skilled and labouring jobs was taken up by women, who previously would not have been allowed, or considered themselves able to do such work. By the end of the war, women had demonstrated that they were not weak, frail, unintelligent creatures. They had helped to win the war, and at the same time, overturned society's views about men's and women's roles.

The first positive moves towards votes for women were made during the war. Thousands of men who had volunteered to fight for their country had accidentally lost the right to vote; the law stated that those absent from home for more than one year relinquished this right, whatever the reason for their absence. This was potentially embarrassing to the Government, and so plans were made to re-enfranchise them. Plans were also made to give a limited measure of women's suffrage, to reward women for their war work. The All Party Speaker's Conference made several recommendations which were eventually included in the Representation of the People Act. This, the first act to give votes to women in Britain became law in February 1918.

Under this long-awaited Act a woman over the age of thirty was entitled to vote if she met one of the following criteria: being a householder; being the wife of a householder; being the occupier of property with an annual rent of £5; being a graduate of a British university, or similarly qualified but not a graduate. And so, approximately eight and a half million women were entitled to vote in the General Election of 1918. At last, some women had the vote. Also, importantly, women became eligible to stand as MPs, although none of the suffragettes and suffragists who stood in this, their first election were successful.

The women's suffrage movement was disappointed at the imposition of the age limit. They had hoped that, like men, women over the age of twenty-one would get the vote. The Government was wary of doing this for two reasons. First, because if all women over twenty-one had been enfranchised then they would have been the majority in the electorate and would have outnumbered male voters, and second, it was felt that women under thirty were 'flighty' and not responsible enough to choose an MP.

Historians have debated at length the issues surrounding this first granting of the vote to women. Rewarding them for their war work was certainly a factor, but not the only one. It would have been difficult for the Government to refuse to give women the vote in the light of their contribution. Also, many of the arguments against women's suffrage seemed hollow in the aftermath of the war. However, it was not only the war which changed politicians' minds – after May 1915 the Government was a coalition government which included several senior politicians who actively supported the women's suffrage movement. Asquith, the suffragettes' toughest opponent, had resigned in 1917 and was replaced by Lloyd George, who by this time was more sympathetic to the women's claim. Gradually political opinion came round to support a limited measure of votes for women. The fact that women had played an important role during the war simply made it easier for politicians to support a bill.

The first instalment of women's suffrage opened the door to a series of important acts which started to redress some of the many inequalities between men and women. It was the start of a slow and gradual process. The Sex Disqualification Removal Act of 1919 made it illegal to exclude women from jobs because of their sex. This meant that women could now become solicitors, barristers and magistrates. Soon most of the professions opened the door to women, albeit in some cases, like the Civil Service, slowly and reluctantly.

During the 1920s important improvements were made regarding the position of British women in society. 'Women's Questions' were discussed more seriously in Parliament, helped undoubtedly by the presence of eight women MPs there in 1923. Universities were offering more degrees to a growing number of women students. Divorce laws became more favourable towards women; for the first time they could divorce their husbands for adultery. The 1920s also witnessed the beginning of the Equal Pay campaign, although the Equal Pay Act was not passed until 1970. For the first time widows were given state pensions. Other acts followed which tried to deal with the many inequalities that women faced. The legislation of the 1920s proved the WSPU's thesis: only when the sex barrier in the franchise was breached would laws affecting women's lives in a positive way make their way in to the statute books.

The second instalment of women's suffrage was granted a decade later. In 1924 the Conservative Government said it would consider this issue. Various groups canvassed for support, pointing out the absurdity of men being able to vote at the age of twenty-one, and women having to wait until they were thirty. A bill was introduced in March 1928, and by May it had easily passed all the necessary stages. There was little serious opposition and it was never in danger of being defeated. Emmeline Pankhurst died just before the bill became law on 2 July 1928. All women over the age of twenty-one could vote in elections. It was a time of great celebration.

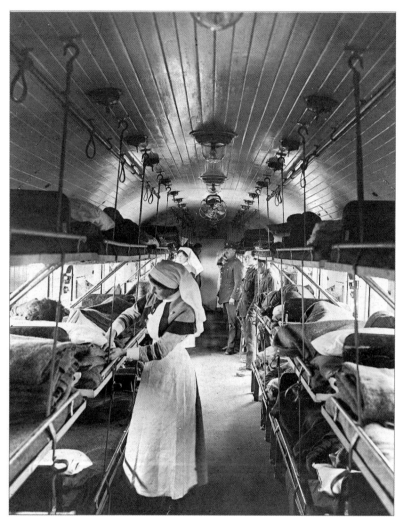

'As I write a dreadful war-cloud seems about to burst and deluge the peoples of Europe with fire, slaughter, ruin – this then is the World as men have made it, life as men have ordered it. . . . Had women been equal partners with men from the beginning human civilisation would have been wholly different from what it is. The whole march of humanity would have been to a point other than we have reached at this moment of horrible calamity. . . . Women of the WSPU there will be much suffering for women in this war. . . . We must protect our Union through everything. It has great tasks to perform, it has much to do for the saving of humanity.'

CHRISTABEL PANKHURST,
THE SUFFRAGETTE, 7 AUGUST 1914,
P. 301.

Nurses tending wounded soldiers on a British ambulance train, France, April 1918. Between 1914 and 1918 the number of military nurses grew from 3,000 to 23,000 because of the huge casualties in the various theatres of war around the world: ¾ million dead, and 1½ million wounded. Qualified nurses were assisted by members of the Voluntary Aid Detachments (VADs). In 1916 the severe shortage of these unpaid volunteers led to the Government introducing an annual salary of £20 to £30. (Photograph by kind permission of the Imperial War Museum)

'A very considerable amount of displacement of men's labour by women is undoubtedly going on quite apart from the register of women for War Service. It is taking place in banks, offices, railways, shops, and factories of many kinds. . . . Much of this new women's labour is of necessity temporary in character; in some cases the women will give place to the men when the latter return from the war; in other cases the work will cease with the cessation of the war. But there will result some changes in women's position in industry which will be permanent: women will prove their value in certain occupations in which they have not previously had the opportunity of testing their powers, and they will not altogether lose their footing at the close of the war. It must now be remembered, too, that the terrible loss of men now going on must increase the disproportion between the sexes in the future, and an even larger number of women than in the past must rely upon their own resources for a livelihood.'

THE ENGLISHWOMAN, JULY 1915, PP. 28–9.

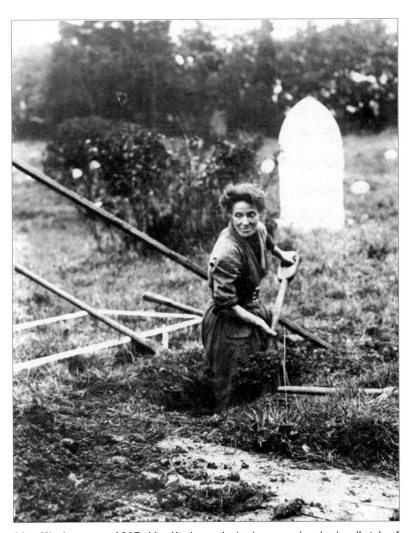

Mrs Kitchener, c. 1917. Mrs Kitchener had taken over her husband's job of gravedigger while he was away on active service. By 1918 women were working in an enormous range of jobs – many of which had previously been 'men only'. The Government's recruiting campaign for the armed forces was a huge success. By the middle of September 1914, a month after the outbreak of war, a quarter of a million men had taken the 'King's Shilling' and joined up. Many of their wives and daughters, mothers and sisters, took on their jobs in order to keep them open when, and if, their menfolk returned from the war. (Photograph by kind permission of the Imperial War Museum)

'The decision come to by the National Union of Railwaymen at their annual general meeting, held last week at Nottingham, to admit women is one of the most important and encouraging events of the year. Everyone is aware that women are largely replacing men as ticket-collectors, booking-clerks, and in other capacities on the railways; but not everyone has paused to ask whether women are getting the same wages as the men whose places they have taken. We pointed out in our leading article last week the absolute necessity, from the point of view of national salvation, of "equal pay for equal work"; we explained, and shall not cease to explain till the evil is finally scotched, that the "undercutting" of men by women always inevitably tends to lower the standard of life, but in war-time entails, over and above that lowering, other dangers too vast to envisage. We insisted that, seeing how great in any case must be the dislocation of industry after the war, to complicate it still further by creating all the conditions of a sex-war is nothing short of criminal.'

VOTES FOR WOMEN, 2 JULY 1915, P. 325.

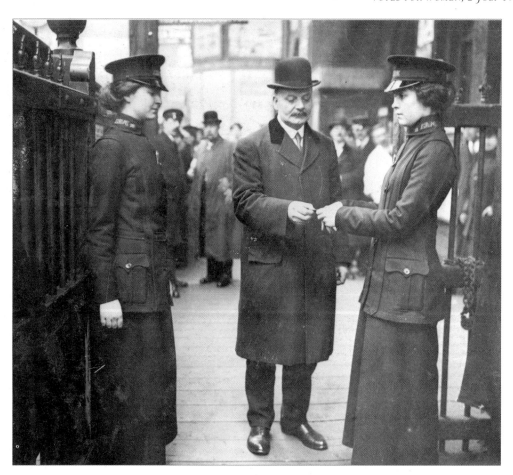

Women ticket collectors at London Bridge station, May 1915. The increased presence of women working in transport demonstrated the importance of women's contribution to the war effort in general. Owing to the exigencies of the war, the long-established attitude that 'a woman's place was in the home' had to be put to one side.

'Upon women will fall in the absence of the men, the upkeep of the home and the preservation of the race. But this is not all; everywhere women will have to take the public places left vacant by men. . . . There will be work of all kinds that will want doing, and women will have to do it. . . . But while they give of themselves without sparing to the common weal, they must never forget the full dignity of their womanhood; there must be an absolute determination not to go back after the war to the old position of subordination. The new spirit of woman inculcated during the last decade must strike through all their labours and illuminate all their actions.'

VOTES FOR WOMEN, *7 AUGUST 1914, P. 678.*

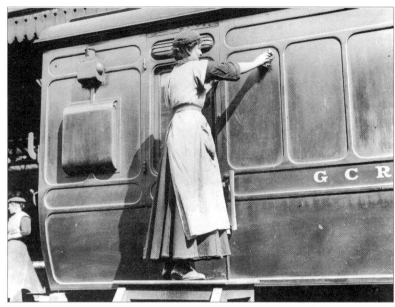

A woman cleaning railway carriages at Marylebone station, April 1915. Before the war women had been employed as cleaners and charwomen by the railway companies, hence this work did not have the novelty value of many of the other jobs in public transport such as ticket collectors and porters.

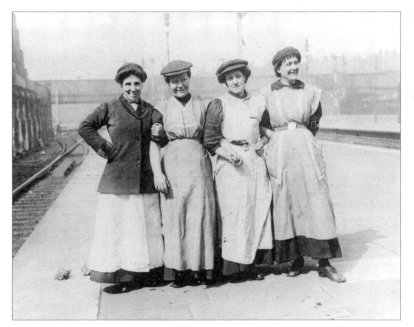

Women porters at Marylebone station, May 1915. Images like this were used to illustrate an article in the *Suffragette* entitled 'What Women are Doing to Release Men for The Front', which reminded readers that while women were doing 'sterling work' their efforts should not be taken for granted, not should they be underpaid. The issue of women's war work and their low wages was a frequent theme in all suffrage and feminist literature of the war period.

'The Great Central Railway is making experiments to see how far women can be employed as railway porters to set free men of military age. For the present, employment of women on the platforms is being strictly limited, but it is thought they can be employed more extensively at country stations, and even in the large town stations. The experiments are the result of suggestions from the general committee of Railway Managers. It is expected that other lines will follow the Great Central's example.'

THE SUFFRAGETTE, *16 APRIL 1915, P. 12.*

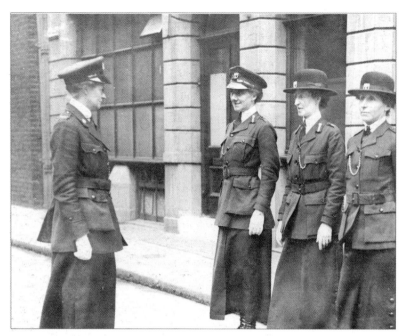

'Patrol-leaders . . . have voluntary part-time Patrols working under them; the Leader being the link between these workers and all authorities, civil and military, and directing the energies of their subordinates into helpful channels. These usually run in the direction of regular 'beats', befriending women and girls, warning them, inviting them into Recreation Rooms in the evening, making observations of various kinds, and administering such parts of the law as it is the right of private citizens to enforce or in which it pleases the local Police to seek their co-operation.'

THE ENGLISHWOMAN,
OCTOBER–DECEMBER 1916, P. 24.

Policewomen being inspected in London, May 1915. Mary S. Allen (left) had been a WSPU organizer and had a vivid career as a suffragette. It is perhaps surprising to realize that she who had been imprisoned three times, staged a hunger strike, and been force-fed while in prison for breaking the windows of Government buildings in London and Bristol in 1909, eventually enrolled for this form of war work. After the war she ultimately attained the rank of Commandant.

'We used to go to Charing Cross and we used to watch the wounded come in the Red Cross ambulances, and we used to throw roses and flowers into the ambulances. They never used to let us look at them, we just threw flowers into them, that was all. . . .'

CAROLINE RENNLES, A SHELL-FILLER AT
SLADES GREEN AND WOOLWICH ARSENAL,
REMEMBERING THE WAR. (CAROLINE RENNLES
INTERVIEW, IMPERIAL WAR MUSEUM SOUND
ARCHIVE, 556/7, 1975)

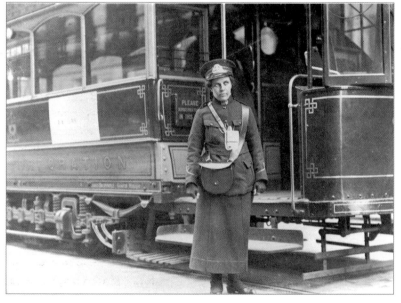

A tram conductor in her winter uniform, possibly in Glasgow, 1915. Glasgow pioneered the use of female operatives on its public transport system during the war. Male colleagues opposed their presence, declaring such work to be 'unwomanly', physically demanding and morally dangerous.

'...Even the rain seemed but a deliberate test of the hardihood and endurance of the women. But the test became a triumph, organised by an army, the procession never faltered in its purpose. Way before 3.30 pm – the time due to start – the women were assembling in their appointed places along the Victoria Embankment. There were in all 125 contingents, each with its numbered standards, its red-sashed marshals, its blue-sashed assistant marshals, its section-captain. The first section was massed at Westminster, the last at Blackfriars. In close formation the procession was two miles long.

'At the strike of half past three came the clear note of a bugle; all the 90 bands accompanying the procession struck up the brave battle music of those who loved liberty at Marseilles, and the Army of Womanhood of England set out on its march. . . . By 6 o'clock, when the procession had again mustered on the Embankment, there was something like 60,000 people assembled in front of the platform built in the garden of "Munitions House".'

DAILY CHRONICLE, 19 JULY 1915, QUOTED IN THE SUFFRAGETTE, 23 JULY 1915, P. 233.

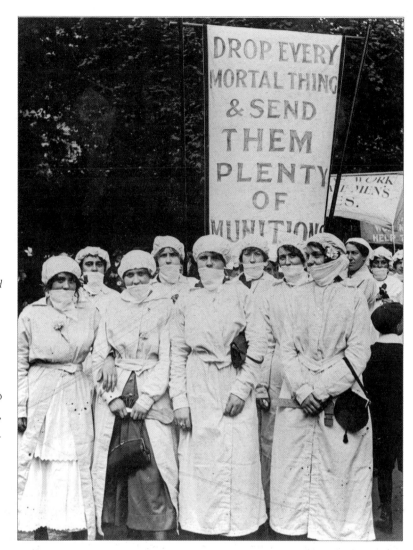

Munitions workers, or 'munitionettes' as they were nicknamed, at the Women's Right to Serve march in London, Saturday 17 July 1915. A political scandal and public outcry arose in the spring of 1915 when it became known that munitions production was not keeping pace with demand and that there was a shortage of shells. After lengthy discussions with the relevant trade unions, it was agreed that a number of the processes in munitions and engineering would be divided up and de-skilled: women would be trained to do the work. This 'dilution' of skills was agreed upon for the war period only. At the request of Lloyd George, the Minister of Munitions, Emmeline Pankhurst organized this highly successful procession which recruited women into munitions and all types of war work. The masks remind us that working with TNT was extremely dangerous, causing the skin to go yellow and sometimes leading to death through poisoning. Notice that the marchers carry their handbags, then known as 'wrist bags'.

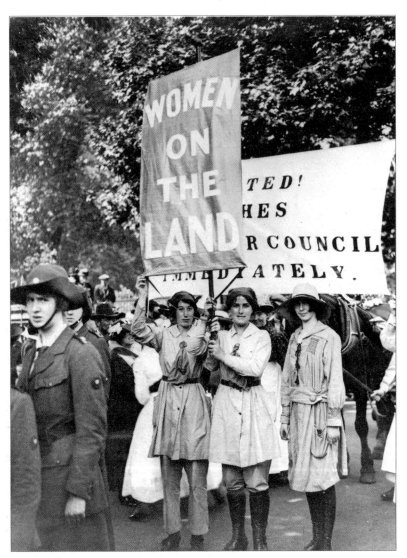

'It was impossible for the spectators not to feel touched and stirred and proud of these women of England as, mingled together regardless of class or creed, they trooped through the rain with one fixed aim — the serving of their country in the hour of its need. . . . At points all along the route were little tables — the women's recruiting stations — at which women, intent on war work, were signing on. They were signing away their full time and all their energies till peace be won. Here and there groups of soldiers cheered the women, as well they might. The heart of every man went out to them, they were the true women of England, the women of whom to be proud.'

DAILY EXPRESS, 19 JULY 1915, QUOTED IN THE SUFFRAGETTE, 23 JULY 1915, P. 233.

Land-girls at the Women's Right to Serve march in London, Saturday 17 July 1915. For centuries women had worked on the land but by the end of the nineteenth century women's agricultural work was casual and highly seasonal. The intense recruiting drives and staggeringly high casualties of the war meant there was an acute shortage of labour for the production of food. The land-girls' often practical and 'mannish' short hairstyles and their trousers and breeches uniform were often commented on, and greatly disapproved of.

'The outbreak of war in August 1914, brought a great increase of membership to the Guide Movement, for young girls who could not join in any women's work owing to their age, saw in joining the Guides a way of helping their country.

'At the suggestion of the Founder, Sir Robert Baden-Powell, warm clothes were knitted and made for the Boy Scouts on coast-watching duty, and a great deal of such work organised for sending abroad to the troops.

'In 1915 a small room in a basement in Westminster was white-washed and fitted out by London Guides to be used in case of air raids, and gradually Guides all over the country were able to offer their services as messengers, orderlies, washers and cleaners in Red Cross hospitals and V.A.D. depots.

'In June 1917 another big effort was made through waste-paper collections, etc., and a motor ambulance was bought and equipped and presented to the Army in France through the Princess Mary, then County President for Norfolk.'

ANONYMOUS; REPRODUCED FROM THE DEPARTMENT OF PRINTED BOOKS 'WOMEN'S WORK COLLECTION', BY KIND PERMISSION OF THE IMPERIAL WAR MUSEUM.

KEEP THE HOME FIRES BURNING
Keep the home fires burning
While your hearts are yearning
Though your lads are far away
They dream of home.
There's a silver lining
Through the dark clouds shining
Turn the dark clouds inside out
Till the boys come home.
CHORUS FROM THE POPULAR SONG BY IVOR NOVELLO.

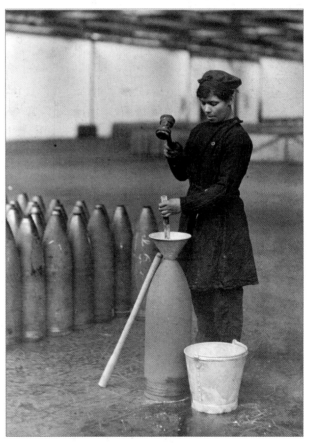

A woman filling high explosive artillery shells at a factory in Hereford, 1917. The risk of explosions and poisoning made munitions work extremely dangerous. During the war at least a hundred women died of TNT poisoning; the symptoms were a yellow skin, hence the nickname 'canaries', violent nosebleeds, vomiting, dizziness, anorexia, rashes and swollen limbs. If the work was not ended quickly, death was certain and rapid. Gradually safety precautions were introduced: masks, gas-masks, veils, and extra milk drinks were provided. (Photograph by kind permission of the Imperial War Museum)

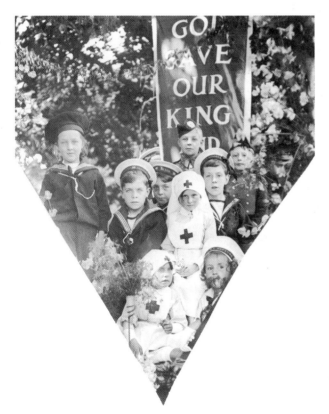

Children in nurses', soldiers' and sailors' uniforms at the Women's Right to Serve march in London, Saturday 17 July 1915. Even young children were expected to do their patriotic duty and make a contribution to the war effort. Fruit picking, and especially blackberrying for jam-making were favourite tasks for school pupils.

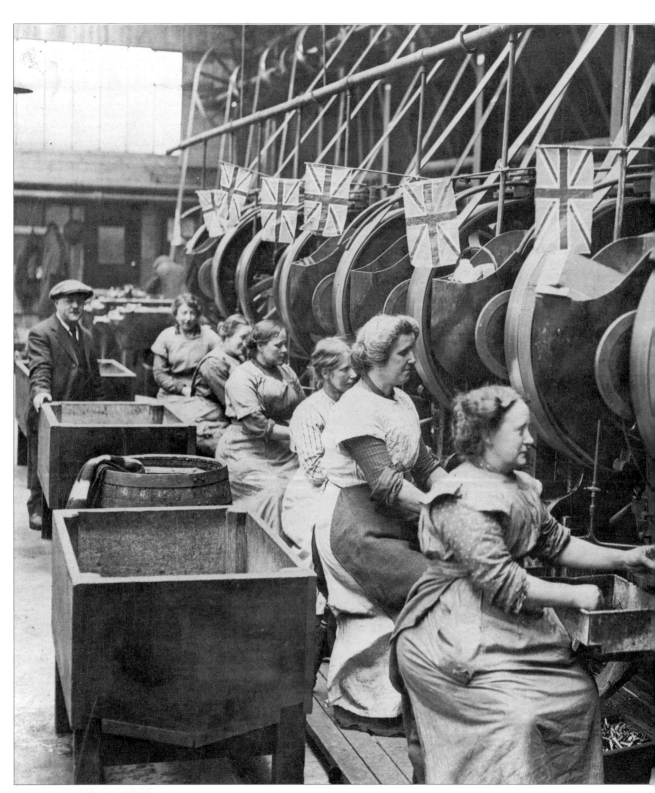

Women making bullets, May 1915. The camaraderie and high wages of between £3 and £5 a week helped make the very long hours in the munitions industry more tolerable. For those women who had been domestic servants before the war, earning £18 a year, the attractions of munitions work were obvious. The film industry made hundreds of short films extolling the hard work of women like these and encouraging others 'to do their bit' for the war effort.

'This week we have to record our gratitude to the New Statesman for making public the following disgraceful case of the bullying of girls under the Munitions Act.... The worst tales are not told. One, indeed, came up in court the other day, when a number of girls insisted on leaving because of the literally indescribable behaviour towards them persisted in by a foreman. The firm nevertheless refused them their discharge, and insisted, in the Munitions Court, on their submissive return to work. The girls were too shy to state plainly to a tribunal exclusively masculine what the foreman had done, and the presiding lawyer made light of the case and was about to order them back with a fine. It was, however, quietly intimated to him that, for the girls' protection, any such decision would immediately be followed by a criminal prosecution, whereupon he decided to grant the girls their leaving certificates. This case illustrates the dangerously irresponsible and one-sided way in which the Munitions Act is administered. It also incidentally emphazises the importance of appointing a woman assessor for any case in which women are concerned.'

VOTES FOR WOMEN, 26 NOVEMBER 1915, P. 68.

SUCCESS OF WOMEN VAN-DRIVERS

'Messrs Harrods have already employed eight women drivers and a number of women porters, who are accompanying the drivers on the van. . . ."These women have proved most satisfactory", said Mr Allen, the Staff Superintendent, to a Press Representative. "They show no sign of being tired at the end of a day's work." A representative of the firm who was in charge of the packing and delivery van garage was most enthusiastic about the work of the women. "The women drivers we have so far are most satisfactory", he said. "They do not, of course yet know the districts so well as the men, but they are learning very quickly. They are really good and careful drivers. They have had few accidents, and what they have had have been unavoidable. Down in the packing and sorting departments as well, where now almost all are women, the women seem much less tired at the end of the day than the men."'

<div align="right">

THE SUFFRAGETTE, 7 MAY 1915, P. 63.

</div>

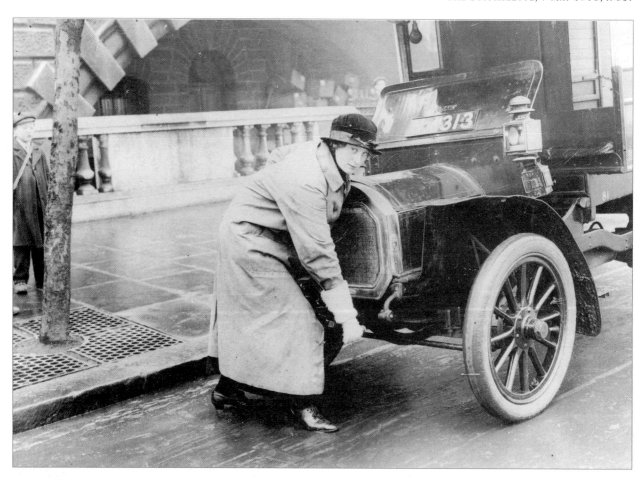

Driver Charlotte Marsh, who had been a suffragette, starting up a van, April 1915. This image was used to illustrate an article in the *Suffragette* newspaper entitled 'What Women Are Doing'. Later in the war, Marsh became chauffeur to David Lloyd George, the Minister of Munitions.

WAR GIRLS

There's the girl who clips your ticket for the train,
And the girl who speeds the lift from floor to floor,
There's the girl who does a milk-round in the rain,
And the girl who calls for orders at your door.
Strong, sensible, and fit,
They're out to show their grit,
And tackle jobs with energy and knack.
No longer caged and penned up,
They're going to keep their end up
Till the khaki soldier boys come marching back.

There's the motor girl who drives a heavy van,
There's the butcher girl who brings your joints of meat,
There's the girl who cries 'All fares please!' like a man,
And the girl who whistles taxis up the street.
Beneath each uniform
Beats a heart that's soft and warm,
Though of canny mother-wit they show no lack;
But a solemn statement this is,
They've no time for love and kisses
Till the khaki soldier boys come marching back.

JESSIE POPE

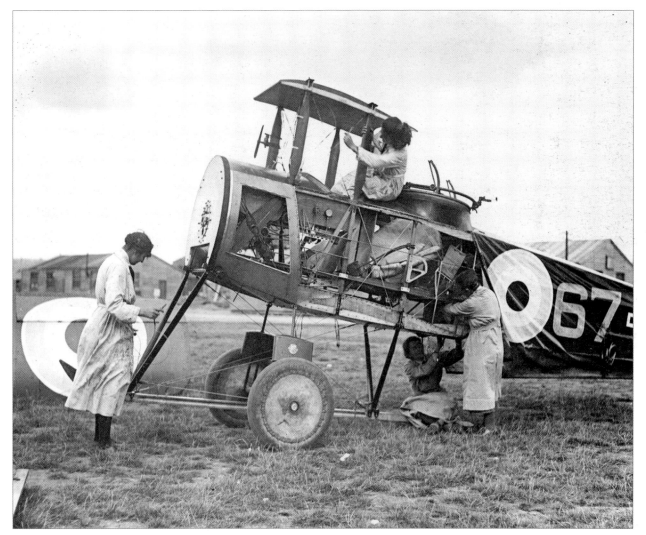

Women air mechanics of the Women's Royal Air Force working on an Avro 504 aeroplane, c. 1919. Founded in the spring of 1918 and disbanded two years later in 1920, the formation of the WRAF gave women an unprecedented opportunity to enter, albeit briefly, the male world of aero-engineering. This image would undoubtedly have astonished most people in pre-war Edwardian Britain. (Photograph by kind permission of the Imperial War Museum)

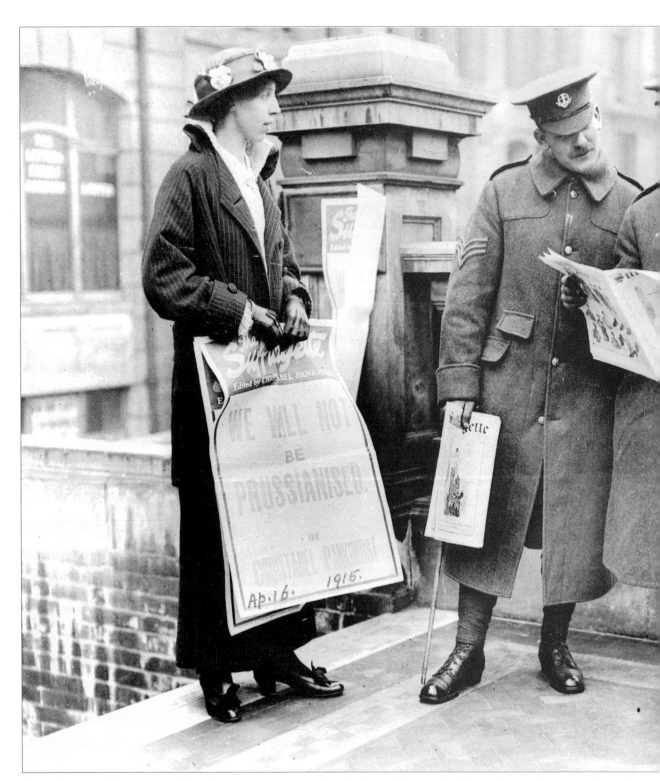

A suffragette sells a copy of the *Suffragette* newspaper to soldiers, April 1915. The headlines on the poster she carries describe the content of that week's editorial by Christabel Pankhurst, who expressed intensely anti-German sentiments typical of the time. The front cover image is a reproduction of a French cartoon of Joan of Arc (St Joan) in full military armour, hovering as an angel above Rheims Cathedral, which had been badly damaged in September 1914. The headline screams: 'That which the Fire and Sword of the Germans Can Never Destroy'.

'During this war, and after it, let this be our watchword:— We will not be Prussianized, either by violence or intrigue, or any means whatever. We know too well what Prussianism has done to destroy the soul of Germany, and to kill the spirit of liberty in the German people. As for Suffragettes, their whole fight has been against that evil which is disavowed and discredited in their own country, even though it lingers on in its long death struggle, but which in grosser form is glorified and enthroned and more alive than ever in Prussia. The women's cause is one and the same as that of the Belgians, and as that of all the peoples who, whether they are actually fighting or not, are looking to this war to lift the fear of Prussia from their hearts.'

THE SUFFRAGETTE, 16 APRIL 1915, P. 6.

'Wednesday January 2nd 1918: *I went over to the Kings [a local wealthy family] and did war work there all afternoon. Cut up rags for pads. I stayed to tea.*

'Thursday January 3rd: *Went over to the Kings and rolled bandages all morning. Only Lady Stenning and Miss Willett there.*

'Tuesday January 15th: *At about 2.30 went to the cinema in East Grinstead. A huge place. We did enjoy it so, "A Munition Girl's Romance" was topping. Had tea at the station, it warmed us up splendidly, caught the 5.45 train home. Collis [a servant] and the trap met us at the station. A cold drive home.*

'Monday February 11th: *Came in at 12.45. After lunch I did some writing till 3, then went into the Billiard room where the Red Cross Sewing Party were at work.*

FROM THE DIARY OF A YOUNG UPPER-CLASS WOMAN LIVING IN SUSSEX IN 1918, IN THE PRIVATE COLLECTION OF THE AUTHOR.

A woman welding an aerial bomb, 1918. Not all munitions and engineering work was conducted in large factories: this image reminds us of the importance of small workshops and even backyards to the war effort. Every small industrial workshop space in the country was utilized to maintain supplies of armaments. (Photograph by kind permission of the Imperial War Museum)

'When the men come back from the war, their sisters who have taken their industrial places will withdraw from them. But all the men will not come back. And, whether they come back or not, a fair percentage of the changes now taking place will be permanent. Female secretaries of trade unions are sure of that. There is an idea abroad that what is now occurring will give a new impetus to female industrial labour. Women will prove their industrial (and professional) adaptability, and realize that through their growing industrial power they may soon obtain social and political privileges that have been denied them heretofore. The War will create many new conditions in life, and not the least of these will arise from the demonstration of women's practical ability in connection with the real work of the world.'

THE ENGLISHWOMAN, JULY 1915, P. 37.

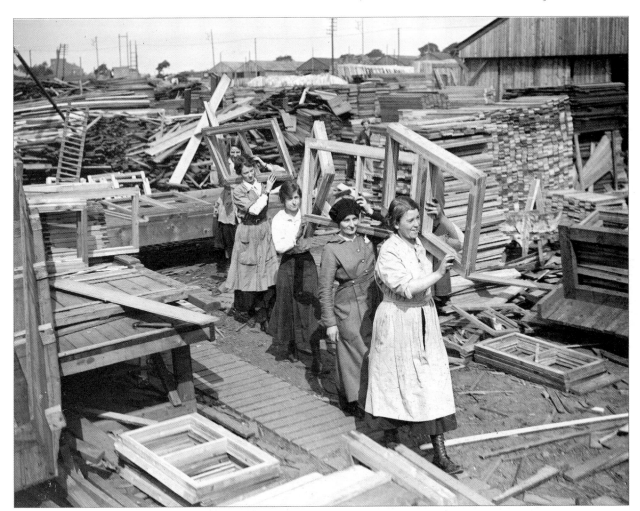

Women carpenters building huts for British troops in France, 1918. The sight of women engaging in such manly work as carpentry underlines the unfairness of many of the opinions of those who opposed women having the vote. Here two of their points of view, that women were physically frail, and that they were incapable of doing skilled work, are clearly being disproved. (Photograph by kind permission of the Imperial War Museum)

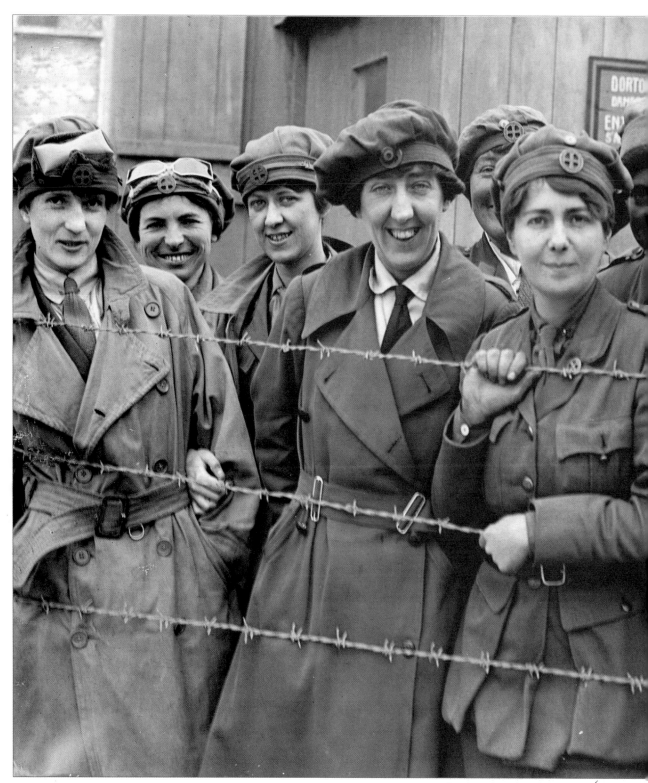

Members of the First Aid Nursing Yeomanry (FANYs), in France, May 1918. The movement was founded in 1907 to bring in wounded soldiers on horseback, but by the time of the outbreak of the First World War its *modus operandi* had changed to reflect the development of the motor car. 'FANYs' were usually from upper-class backgrounds, and many of them drove ambulances for the Red Cross.

SILVER THIMBLES WANTED

'Further Development of Disused Trinkets Scheme

'In addition to quantities of broken silver and the like, 16,000 old silver thimbles have been collected within the past year by Lady Maud Wilbraham and her busy partner, Miss E. Hope-Clarke, at the headquarters of their fund, 2, Crescent Road, Wimbledon. This brilliant achievement in one year has meant the establishment of 4 motor ambulances (2 for the front and 2 for London) . . . a disinfector . . . 4 motor hospital boats for Mesopotamia etc. These two clever war workers, who had the happy thought of turning out old treasures from jewel caskets for the benefit of our fighters, have now in hand a fund for crippled sailors. . . . This development of the Silver Thimble scheme is to give a start in some new occupation to those of our sailors who have been disabled, but not totally crippled. After they have been taught a trade they have not the means to turn it to advantage for want of a small grant to start them with a stock-in-trade.'

REPRODUCED FROM THE DEPARTMENT OF PRINTED BOOKS 'WOMEN'S WORK COLLECTION', BY KIND PERMISSION OF THE IMPERIAL WAR MUSEUM.

'I was fantastically patriotic. We trained in two weeks. It was awful, we were at Hastings which was very nice, but we had to get up at about 6 and do PT [physical training] and go for a march. We were drilled in the square and were the laughing stock of all the men of course which was absurd. None of us had ever done the drill that the Army does. . . . And then we went for a route march for breakfast. Our last meal had probably been before 7 the night before and not adequate anyway. We had two weeks in all and just the day before we sailed for France, we were issued with our uniforms. I think mine was down to my ankles. They were one piece dresses, so you can imagine how it looked with no shaping. We had to leave England and go to France of all places in this type of uniform. We were not allowed to wear gloves because we might look like officers if we wore gloves. We had these terrible great coats that weighed a ton and of course when we arrived in France it seemed to rain all the time and the roads were liquid mud, and our skirts of course trailed in the mud.'

RUBY ADELINA ORD, WHO WAS A WAAC, REMEMBERING THE WAR. (RUBY ADELINA ORD INTERVIEW,
IMPERIAL WAR MUSEUM SOUND ARCHIVE, 44/5, 1973)

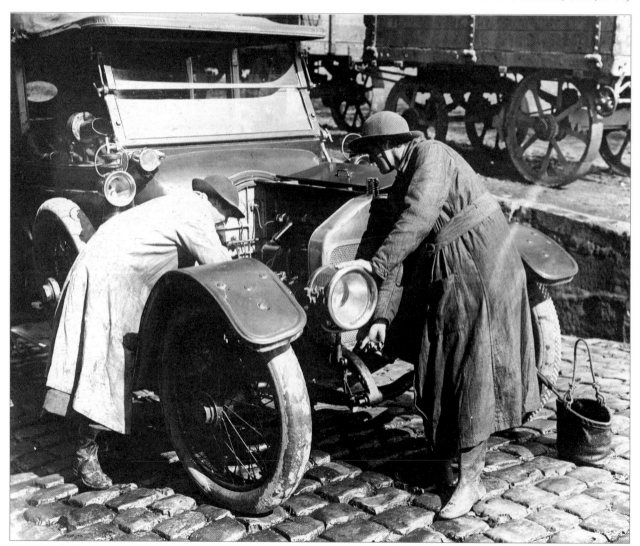

Members of the Women's Army Auxiliary Corps (WAACs) repairing an officer's car in France, 1918. The Corps was founded in early 1917, and members carried out a variety of tasks including cooking, canteen work, store-keepers, telephonists and clerks. The women in this image were considered to have the more dashing and challenging jobs of car maintenance and driving. When the war was over a number of them stayed on in France as gardeners, tending the graves of those who had been killed in action.

'Monday, November 11th 1918, Armistice Day

'Quite a mild day as far as the weather was concerned. I went to town [London] by the 9.36. While sipping some coffee at Euston I heard a frantic noise and gathered that the ARMISTICE HAD BEEN SIGNED. At 11 the guns boomed, flags went up and the maroons went off and cheers and yells made the air fairly wobble. It was gorgeous to think that the killing was all over. I went by underground to Hammersmith, there everybody seemed to be crazy. I had my Elocution lesson, then went by bus to Kensington. It was some ride! The sights I saw! People absolutely lost their heads. Decided to catch the 4.16 instead of the 4.55 home as things were getting even more lively every minute. It took quite a bit of doing dodging drunken men. In my first class carriage there were 16 people, it was quite a crush. Later that night I went with friends to see the crowds in the local street, fireworks were let off on the King's Field and the band paraded in the streets. There was a tremendous excitement. It's hard to realise that the Gigantic World War is over, after 4 long years of it. This is History, glad I haven't got to learn all about it as some will have to.'

FROM THE DIARY OF A YOUNG UPPER-CLASS WOMAN LIVING IN SUSSEX IN 1918, IN THE PRIVATE COLLECTION OF THE AUTHOR.

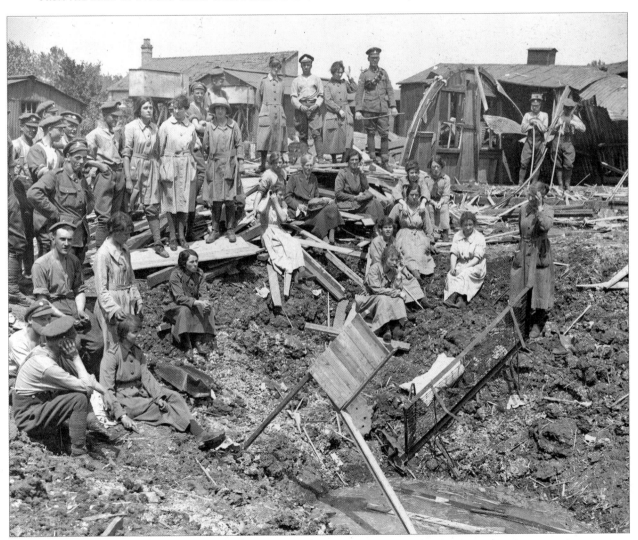

Members of the Women's Army Auxiliary Corps (WAACs) sitting in a bomb crater in France, May 1918. None of the WAACs at this camp were killed in this air raid, but a week later nine lost their lives and six were wounded. The dead were buried with full military honours. (Photograph by kind permission of the Imperial War Museum)

'The pageantry and rejoicing, the flaming ardour, which in pre-war days would have greeted the victory, were absent when it [the vote] came. The sorrows of the world conflict precluded jubilations, alike to those who believed it as a war of freedom against oppression, and to all those who deplored it as a tragic blot on the escutcheon of all the combatant nations. The groups which held to the Suffrage cause through the dark days of the war, and struggled for it doggedly to the end, had clung to it as one of the influences which might aid in the building of a kinder future.'

SYLVIA PANKHURST, THE SUFFRAGETTE MOVEMENT, 1931, p. 608.

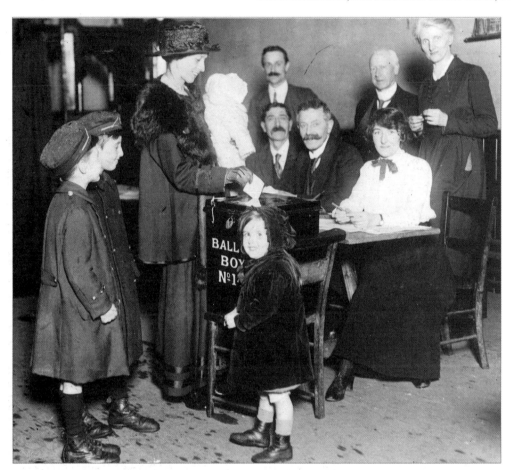

A London mother votes in the General Election, 11 December 1918. Her four young children accompany her. The newly enfranchised female electorate made up 40 per cent of the voters. Some of the most strongly expressed feelings to be articulated in the period leading up to this election were not about feminist demands, but women's anger and the sorrow at the staggering casualties of the war, and calls that the Kaiser should be severely punished. Hence, the worst fears of the opponents of women's suffrage – that women voters would insist that parliamentary candidates put up a feminist legislative programme – were not realized during the election campaign. (Photograph by kind permission of the Hulton Getty Picture Collection)

'Surveying [in the 1920s] the whole female population . . . and comparing it with that over which Queen Victoria began to reign, it is easy to see that there has been progress in every direction . . . ignorance, ill-health, and the dangerous spirit of dependence have been banished with it, and in their place there is education and self-reliance. No woman of to-day would go back if she could to the conditions which her grandmother suffered. No girl would submit to the clothing and the restraints of 1837; no wife would be content to merge her whole legal and financial existence in that of her husband; no matron would agree to put on her cap and retire from life at thirty-five. And even if women do these things, men would not approve! For as the Women's Movement has gone along its course men, too, have been influenced thereby. They have found better comfort and joy in companions who have shared their own world, and neither sex would now, even if it could, turn back the hands of the clock. What lies in the future no one can tell. The Women's Movement will go forward, as all the other movements for human progress will go forward, in the hands of the men and women of this generation.'

RAY STRACHEY, A SHORT HISTORY OF THE WOMEN'S MOVEMENT IN GREAT BRITAIN, 1928, P. 392.

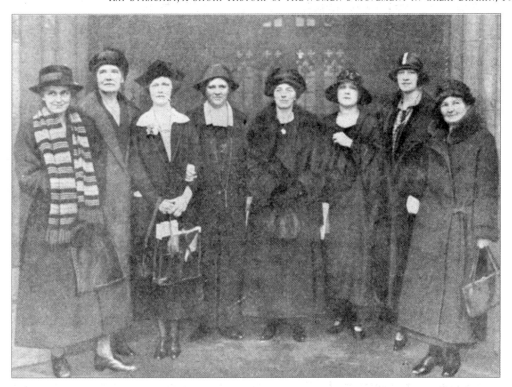

Eight women Members of Parliament on the terrace of the House of Commons prior to the General Election, January 1924. From left to right: Dorothy Jewson (Labour); Susan Lawrence (Labour); (Lady) Nancy Astor (Unionist); Margaret Wintringham (Independent Liberal); the Duchess of Atholl (Unionist); Mabel Hilton Philipson (Unionist); (Lady) Vera Terrington (Liberal) and Margaret Bondfield (Labour). Only fourteen of the forty-one women parliamentary candidates would be elected to Parliament later that month. Of this group, Jewson, Wintringham and Terrington failed to be re-elected. Bondfield became a Parliamentary Secretary at the Ministry of Labour in 1924 and Cabinet Minister, for the same ministry, from 1929 to 1931. The Duchess of Atholl was a Parliamentary Secretary at the Ministry of Education from 1924 to 1929, and Susan Lawrence was a Parliamentary Secretary at Education in 1924 and held the same post at the Ministry of Health from 1929 to 1931. (Photograph by kind permission of Mary Evans Picture Library)

'The Act of 1928, which swept away the absurd restrictions of 1917, came virtually without effort. It was quietly received. Women had already taken a wide and important part in Parliamentary politics, and both men and women had completely assimilated the view that all women were potential voters. Thus the extension was regarded as a matter of course. The old prediction that the classes of women first enfranchised would oppose the extension of the vote to new classes proved utterly false; every women's organization, every section which had joined on the original movement advocated further extension. . . . That the women who went forward to seats in Parliament and to Government office were not they who had taken a foremost part in the struggle was of no moment; the fight of the pioneers had been waged for generations yet unborn.'

SYLVIA PANKHURST, THE SUFFRAGETTE MOVEMENT, 1931, P. 608.

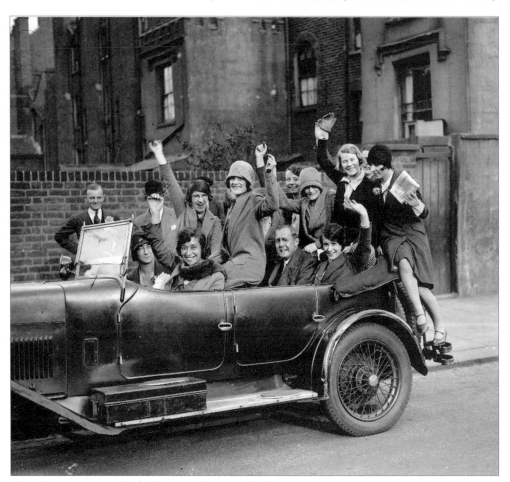

Captain Ian Fraser, the blind Conservative candidate, accompanied by a group of recently enfranchised young women. The women, or 'flappers' as they were described disparagingly, were on their way to vote for Captain Fraser at North St Pancras, London, in the General Election of 1929. Sixty-nine women stood as parliamentary candidates and fourteen were successful, comprising a tiny 2.3 per cent of members of Parliament. A number of 'women's issues' which included widows' pensions, equal pay, and maternal and child welfare were raised at electioneering meetings all over the country. (Photograph by kind permission of the Hulton Getty Picture Collection)

APPENDIX 1

What Happened To . . . ?

Emmeline Pankhurst

Stood as a candidate for the Women's Party (the renamed WSPU) in the 1918 General Election, but failed to win a seat. Between 1920 and 1925 she lived in Toronto, after which she returned to London. She joined the Conservative Party and was adopted as candidate for Whitechapel and St George's in 1926. She died in 1928.

Christabel Pankhurst

Stood as a candidate for the Women's Party in the 1918 General Election, but failed to win a seat. She was created a DBE in 1936 and thereafter was known as Dame Christabel. She spent much of her later life in America, becoming religious and waiting for the Second Coming of Christ. She died in 1958.

Sylvia Pankhurst

Joined the British Communist Party after the First World War, but was expelled because of her insistence on freedom of expression. She opened a café with Silvio Corio, an Italian left-wing exile and father of her only child, born in 1927. She spoke out against Italian Fascism. In 1936 she began to work for Ethiopia, where she was very much admired by the Emperor Haile Selassie. She lived in Ethiopia from 1954 to her death in 1960.

Frederick Pethick-Lawrence

Tried unsuccessfully to become a Labour MP in 1921. However, he defeated Winston Churchill in local elections in 1923 to become MP for West Leicester. He became financial secretary to the Chancellor of the Exchequer in 1929. In 1945 he was awarded a peerage and entered the House of Lords, becoming Secretary of State for India and Burma, and playing a part in negotiations for Indian independence. His first wife Emmeline (see overleaf) died in 1954 and in 1957 he married Helen Craggs, who had also been a suffragette. He died in 1961.

Emmeline Pethick-Lawrence	Stood as a candidate for the Pacifist Party in the 1918 General Election, but was not successful. She spent many years working with the Women's International League. In 1926 she became president of the Women's Freedom League, and was vice-president of the feminist Six Point Group. She died in 1954.
'General' Flora Drummond	After the First World War founded the Women's Guild of Empire, an anti-strike organization of mainly working men's wives. It opposed all state welfare and family allowance. She presided at the unveiling of the statue of Emmeline Pankhurst in 1930. Her second husband was killed during the Second World War. She died in 1949.
Annie Kenney	Gave up politics after women were given the vote in 1918, exhausted by the suffragette campaign and her work during the First World War. She got married in 1920 and had a child. She devoted herself to theosophy and became an official of the Rosicrucian Order. (Her sister Jessie was also a Rosicrucian.) She died in 1953.
Charlotte Despard	Stood unsuccessfully as a Labour candidate in the 1918 General Election. After 1921 she moved to Dublin and devoted all her time to international socialism and Ireland, giving all her wealth to Sinn Fein. She died (penniless) in 1939.
Teresa Billington-Greig	Served as Chairman and Honorary Director of Women for Westminster, which worked to improve women's access to politics. She died in 1964.
Constance Lytton	Suffered poor health after a stroke in 1912. She died in 1923.

APPENDIX 2

Chronology of the Suffragette Campaign

1903	Women's Social and Political Union (WSPU) is founded in Manchester; its slogan is 'Deeds Not Words'.
1905	First militant incident at the Free Trade Hall, Manchester. Christabel Pankhurst and Annie Kenney are arrested.
1906	Liberals sweep into power after a landslide election victory.
Autumn	WSPU moves its HQs to London, taking two rooms at No. 4 Clement's Inn, The Strand. Decides to fight the Liberals at all by-elections until votes for women are granted.
October	Ten well-known WSPU members are arrested at the House of Commons.
1907	
February	First Women's Parliament meets at Caxton Hall, London. Sixty women are arrested at a demonstration at the House of Commons.
September	Three senior members are expelled from WSPU – they form the Women's Freedom League, also militant, but democratic.
October	*Votes for Women* newspaper is founded by Frederick and Emmeline Pethick-Lawrence, the joint editors.
1908	Two suffragettes chain themselves to the railings at No. 10 Downing Street. Five women are arrested.
11 February	The 'Trojan Horse' incident takes place: suffragettes try to get into the House of Commons hidden in a furniture van.
April	Prime Minister Sir Henry Campbell Bannerman dies. Henry Asquith takes over, strongly opposed to votes for women.
21 June	WSPU holds Women's Sunday in Hyde Park. Huge crowds attend, and seven hundred banners are displayed.
30 June	Mary Leigh and Edith New become the first suffragette window-smashers. Acting

independently, they attack the windows of No. 10 Downing Street, and are sentenced to two months in Holloway Gaol. This tactic is to become an element in WSPU's more militant campaign in the autumn of 1911.

13 October Following a 'rush' on the House of Commons planned by WSPU, their leaders and more than thirty other members are arrested. Politicians are heckled by suffragettes at meetings all over the country. Many more women are sent to prison.

1909

Spring There are now seventy-five staff on WSPU payroll. Branches are opening nationwide.

May The Women's Exhibition is held at Princes' Skating Rink, Knightsbridge, London. The equivalent of over £100,000 profit (in modern terms) is made by this two-week event.

29 June Government office windows are smashed by suffragettes because Asquith consistently refuses to see their deputations. The fourteen window-smashers each serve one month in Holloway Gaol.

July The sculptor Marjorie Wallace Dunlop goes on the first hunger strike in protest at the treatment of suffragettes in prison.

September Force-feeding of suffragette prisoners begins. Cabinet ministers are 'pestered' by suffragettes all over the country.

1910 Conciliation Committee is formed to draft a women's suffrage bill – the Conciliation Bill. (Between 1910 and 1912 three conciliation bills are drafted and debated; all fail.) WSPU calls a truce, and plans peaceful protests only. Hundreds of meetings are held all over the United Kingdom and a great deal of money is raised.

July Two huge demonstrations are held in Hyde Park.

November There is no progress on the Conciliation Bill. WSPU is furious.

18 November 'Black Friday'. A riot takes place outside the House of Commons. One hundred and twenty women are arrested; many are seriously assaulted by the police. Similar riots occur the following week in Parliament Square. WSPU renews its truce, optimistic about a second Conciliation Bill.

1911 Most forms of protest are peaceful this year.

April Many suffragettes refuse to fill in their Census forms.

17 June The Women's Coronation Procession, a huge WSPU demonstration, takes place in London. Other societies, such as the Actresses' Franchise League, the Women Writers' Suffrage League and the Gymnastic Teachers' Suffrage Society, are represented too. Over sixty thousand women march with a thousand banners.

Autumn	There is still no progress on the Conciliation Bill.
November	A new bill is announced by the Government, which gives more votes to men, not women. WSPU is angered.
21 November	Widespread window smashing occurs. Government and commercial properties are attacked. Over two hundred women are arrested and sentenced to up to two months in Holloway Gaol. Window-smashing is now official WSPU policy. Guerrilla warfare dominates the campaign from now on. Public opinion is completely alienated by the firing and bombing of churches, private houses and public amenities. Golfing greens are attacked with acid, hundreds of letters burnt in post-boxes, buildings defaced with graffiti. All targets are chosen to avoid any loss of life.

1912

1 and 4 March	More windows are smashed in the West End of London. The general public are shocked.
5 March	Police raid WSPU HQs. The Pethick-Lawrences are arrested; Christabel flees to Paris to a self-imposed exile. Conspiracy trial finds the Pethick-Lawrences and Emmeline Pankhurst guilty of conspiracy to incite violence; all are sentenced to nine months in prison. A nationwide hunger strike is called by suffragette prisoners.
October	The Pethick-Lawrences deplore the increased violence advocated by Emmeline and Christabel Pankhurst and are expelled from WSPU. A new paper, the *Suffragette*, is started, and new office premises are opened at Lincoln's Inn House, Kingsway. WSPU policy and propaganda are presented in a much more strident and militant manner in the *Suffragette*.
1913	During 1913 feelings against suffragettes run high. They are often roughly handled and beaten up by gangs of men and boys, and medical students.
February	Lloyd George's new country house is fire-bombed. Few culprits are caught for this type of crime. Hunger strikes and force-feeding continue.
April	The Prisoners' Temporary Discharge for Ill-Health Act (known as the Cat and Mouse Act) is rushed through the House of Commons. Hunger-striking suffragettes are thereby released only to be rearrested when they have recovered. The Act fails because many women commit more crimes while out of prison on special licence. Also many evade rearrest.
30 April	Lincoln's Inn House HQs is raided by the police; senior staff are arrested and their papers confiscated. WSPU shops and offices are attacked by an indignant public. WSPU bomb hoaxes annoy the public.
June	Emily Wilding Davison dies from injuries caused by her protest at the Derby horse race at Epsom. WSPU organizes a spectacular funeral procession through the streets of London. Doctors who do not denounce force-feeding, or who are involved at Holloway Gaol, are physically attacked by suffragettes. Church

services are interrupted by chanting suffragettes protesting at the treatment of their colleagues in prison.

October

Force-feeding is reintroduced. WSPU is forced underground even more. Under pressure from the Government proprietors of the Royal Albert Hall refuse to hire its facilities to WSPU.

December

A bomb at Holloway Gaol fails to cause any real damage.

1914

Sylvia Pankhurst is expelled from WSPU because her sister Christabel disapproves of her East London Federation of Suffragettes. WSPU accuses prison authorities of drugging suffragettes to reduce their resistance to force-feeding. WSPU attacks reach their climax.

March

'Slasher' Mary Richardson attacks the *Rokeby Venus* painting at the National Gallery; she is sentenced to eighteen months with hard labour. WSPU members are frequently attacked by the public.

21 May

Deputation to see King George V at Buckingham Palace fails. More than sixty women are arrested. There are wild scenes in court the next day. Many art galleries and museums are now closed to the public or open to men only. Homes of suffragette sympathizers are raided by the police. Firms who print the *Suffragette* are threatened by the authorities. WSPU is forced to move its HQs twice more. The public remain outraged, and attacks on suffragettes continue.

4 August

Britain at war. The Suffragette Campaign stops.

1918

The Representation of the People Act becomes law in February. It gives certain women over the age of thirty the vote. Women are entitled to become MPs.

1919

The Sex Disqualification Removal Act opens all the professions (except the Church) to women. Lady Astor becomes the first woman MP, although Countess Markiewicz is the first woman to win a place in Parliament in her own right. She is the only woman to win a seat in the 1918 General Election, but as an active member of Sinn Fein she refuses to take the oath of allegiance and is not allowed to take her seat in the House of Commons. Lady Astor takes the seat left vacant by her husband, when he became a member of the House of Lords.

1928

The Representation of the People Act allows all women over the age of twenty-one the vote.

1969

The Representation of the People Act gives the vote to all men and women over the age of eighteen.

BIBLIOGRAPHY

Place of publication is given only if outside London

Adam, R. *A Woman's Place, 1910–1975*, Chatto & Windus, 1975

Adams, C. *Ordinary Lives*, Virago Press, 1982

Alberti, J. *Beyond Suffrage: Feminists in War and Peace, 1914–1928*, Macmillan, 1989

Atkinson, D. *Votes For Women* (document pack), Huntingdon, ELM Publications, 1986

——. *Suffragettes*, HMSO, 1988

——. *Votes For Women*, Cambridge University Press, 1988

——. *Mrs Broom's Suffragette Photographs*, Nishen Photography, 1988

Barnes, A. *Tough Annie: From Suffragette to Stepney Councillor*, Stepney Books, 1980

Billington-Greig, T. *The Non-Violent Militant: Selected Writings of Teresa Billington-Greig*, eds Carol McPhee and Ann Fitzgerald, Routledge and Kegan Paul, 1987

Bolt, C. *Feminist Ferment: The 'Woman Question' in the United States of America and England, 1870–1940*, University College London Press, 1995

Caine, B. 'Feminism, Suffrage and the Nineteenth Century Women's Movement', *Women's Studies International Forum*, vol. v, no. 6, 1982

Castle, B. *Sylvia and Christabel Pankhurst*, Harmondsworth, Penguin, 1987

Close, D. 'The Collapse of the Resistance to Democracy: Conservatives, Adult Suffrage and Second Chamber Reform, 1911–1928', *Historical Journal*, vol. xx , no. 4, 1977

Condell, D. and Liddiard, J. *Working for Victory? Images of Women in the First World War 1914–1918*, Routledge and Kegan Paul, 1987

Dangerfield, G. *The Strange Death of Liberal England*, Paladin, 1966

Fulford, R. *Votes For Women*, Faber & Faber Ltd, 1958

Garner, L. *Stepping Stones to Women's Freedom: Feminist Ideas in the Women's Suffrage Movement, 1900–1918*, Heinemann, 1984

Garrett Fawcett, M. *The Women's Victory and After: Personal Reminiscences 1911–1918*, Sidgwick and Jackson, 1920

——. *What I Remember*, T. Fisher Unwin, 1924

Harrison, B. *Separate Spheres: The Opposition to Women's Suffrage in Britain*, Croom Helm Ltd, 1978

——. *Prudent Revolutionaries*, Oxford, Clarendon Press, 1987

Holdsworth, A. *Out of the Doll's House: The Story of Women in the Twentieth Century*, BBC Books, 1988

Holledge, J. *Innocent Flowers: Women in the Edwardian Theatre*, Virago Press, 1981

Hollis, P. *Women in Public: The Women's Movement, 1850–1900*, Allen and Unwin, 1975

Holton, S.S. *Feminism and Democracy: Women's Suffrage and Reform Politics in Britain, 1900–1918*, Cambridge University Press, 1986

Kamm, J. *Rapiers and Battleaxes*, Allen and Unwin, 1966

Kazantzis, J. *Women in Revolt*, Jonathan Cape, 1967

Kenney, A. *Memories of a Militant*, Edward Arnold, 1924

Kingsley, Kent S. *Sex and Suffrage in Britain, 1860–1914*, Princeton, 1987

Koss, S. *Asquith*, Harmondsworth, Hamish Hamilton Ltd, 1976

Kraditor, A.S. *The Ideas of the Woman Suffrage Movement, 1890–1920*, W.W. Norton & Company, 1981

Leneman, L. *'A Guid Cause': The Woman's Suffrage Movement in Scotland*, Aberdeen University Press, 1991

Levenson, L. *With Wooden Sword: A Biography of Francis Sheehy Skeffington*, Dublin, Arlen House, 1983

——. *In Her Own Right: A Biography of Hannah Sheehy Skeffington*, Dublin, Arlen House, 1985

Lewis, G. *Eva Gore-Booth and Esther Roper*, Pandora Press, 1988

Lewis, J. *Women in England 1870–1950: Sexual Divisions and Social Change*, Wheatsheaf Books and Indiana University Press, 1984

—— (ed.). *Before the Vote was Won: Arguments For and Against Women's Suffrage, 1864–1896*, Routledge and Kegan Paul, 1987

Liddington, J. *The Life and Times of a Respectable Rebel: Selina Cooper 1864–1946*, Virago Press, 1984

—— and Norris, J. *One Hand Tied Behind Us: The Rise of the Women's Suffrage Movement*, Virago Press, 1978

Linklater, A. *An Unhusbanded Life*, Hutchinson, 1980

Mackenzie, M. *Shoulder to Shoulder: A Documentary*, Harmondsworth, Penguin, 1975

Marcus, J. (ed.) *Suffrage and the Pankhursts*, Routledge and Kegan Paul, 1987

Marwick, A. *Women at War*, Fontana Press, 1977

McDonald, I. *Vindication! A Postcard History of the Women's Movement*, McDonald/Bellew, 1989

Mitchell, D. *Women on the Warpath: The Story of Women in the First World War*, Jonathan Cape, 1965

Mitchell, G. (ed.) *The Hard Way Up: The Autobiography of Hannah Mitchell*, 1968, reprinted Virago Press, 1982

Mitchell, S. *The New Girl: Girls' Culture in England 1880–1915*, Columbia University Press, 1995

Moore, L. *'Feminists and Femininity: A Case Study Of WSPU Propaganda and Local Response at the Scottish By-Election'*, Women's Studies International Forum, vol. v, no. 6, 1982

Morgan, D. *Suffragists and Liberals: The Politics of Women's Suffrage in England*, Oxford, Blackwell Publishers, 1975

Morley, A. (with L. Stanley) *The Life and Death of Emily Wilding Davison*, The Women's Press, 1988

Morrell, C. *'Black Friday': Violence against Women in the Suffrage Movement*, Women's Research and Resources Centre, 1981

Mulvihill, M. *Charlotte Despard: A Biography*, Pandora Press, 1989

Murphy, C. *The Women's Suffrage Movement and Irish Society in the Early Twentieth Century*, Brighton, The Harvester Press, 1989

Nield Chew, D. *Ada Nield Chew: The Life and Times of a Working Woman*, Virago Press, 1982

Norquay, G. *Voices and Votes: A Literary Anthology of the Women's Suffrage Campaign*, Manchester University Press, 1995

Owens Cullen, R. *Smashing Times: A History of the Irish Women's Suffrage Movement, 1889–1922*, Dublin, Attic Press, 1984

Pankhurst, C. *Unshackled: The Story of How We Won the Vote*, Hutchinson, 1959

Pankhurst, E. *My Own Story: The Autobiography of Emmeline Pankhurst*, 1914, reprinted Virago Press, 1979

Pankhurst, R. *Sylvia Pankhurst: Artist and Crusader*, Paddington Press, 1979

Pankhurst, S. *The Suffragette*, London and New York, Gay & Hancock, 1911

——. *The Suffragette Movement*, 1931, reprinted Virago Press, 1977

Pugh, M. *Electoral Reform in War and Peace 1906–1928*, Routledge and Kegan Paul, 1978

Purvis, J. (ed.) *Women's History: Britain, 1850–1945*, University College London Press, 1995

Raeburn, A. *The Militant Suffragettes*, Michael Joseph Ltd, 1973

Rolfe, D. 'The Origins of Mr Speaker's Conference during the First World War', *History*, vol. lxiv, 1979

Rolley, K. 'Fashion, Femininity and the Fight for the Vote', *Art History*, vol. xiii, no. 1, 1990

Rosen, A. *Rise Up Women: The Militant Campaign of the WSPU 1903–1914*, Routledge and Kegan Paul, 1974

Rover, C. *Women's Suffrage and Party Politics in Britain, 1866–1919*, Routledge and Kegan Paul, 1967

Rowbotham, S. *Hidden From History*, Pluto Press Limited, 1973

Rubinstein, D. *Before the Suffragettes: Women's Emancipation in the 1890s*, Brighton, The Harvester Press, 1986

Stowell, S. *A Stage of Their Own: Feminist Playwrights of the Suffrage Era*, Manchester University Press, 1992

Strachey, R. *The Cause; A Short History of the Women's Movement in Great Britain*, 1931, reprinted Virago Press, 1978

Taylor, R. *In Letters of Gold: The Story of Sylvia Pankhurst and the East London Federation of the Suffragettes in Bow*, Stepney Books, 1993

Tickner, L. *The Spectacle of Women: Imagery of the Suffrage Campaign 1907–1914*, Chatto and Windus, 1988

Vicinus, M. *Suffer and Be Still: Women in the Victorian Age*, Methuen, 1972

—— (ed.). *The Widening Sphere: Changing Roles of Victorian Women*, Methuen, 1972

Wells, H.G. *Ann Veronica*, 1909, reprinted Virago Press, 1980

Wiltsher, A. *Most Dangerous Women: Feminist Peace Campaigners of the Great War*, Pandora Press, 1985

Wollstonecraft, M. *The Vindication of the Rights of Women*, 1792, reprinted Harmondsworth, Penguin, 1982

Wright, Sir A.E. *The Unexpurgated Case Against Woman Suffrage*, Constable & Co. Ltd, 1913

INDEX

References for illustrations are given in italic; references for colour plates are given in bold

The
Suffragettes

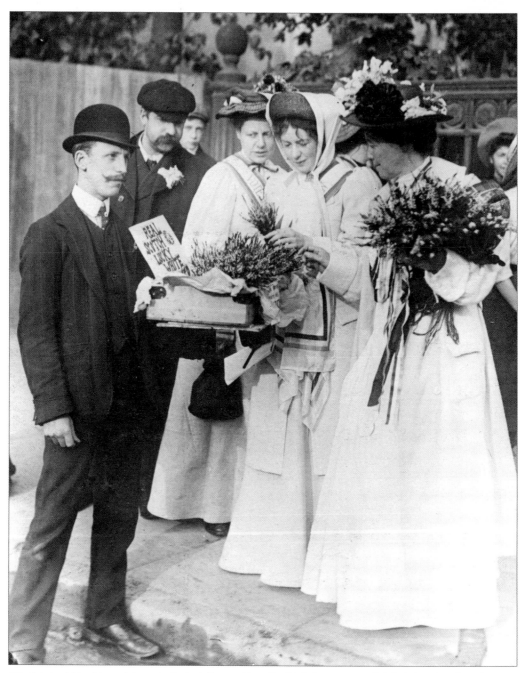

Christabel Pankhurst (centre) and Emmeline Pethick-Lawrence (right) buying heather to welcome 'the Scotch lassie' Mary Phillips on her release from Holloway Gaol on 18 September 1908. Imprisoned for her part in the suffragette deputation to the Houses of Parliament on 30 June, Mary Phillips was the longest-serving suffragette prisoner. The arrangements for this day were typical of the detailed and carefully stage-managed 'Welcomes' and 'Breakfast Receptions' organized by the Women's Social and Political Union (WSPU) for its members who went to prison in the struggle for the vote. The women here are dressed in the WSPU's colour scheme of purple, white and green: Christabel wears a silk scarf as a 'motor-veil', and a 'Votes for Women' sash, and Emmeline a sash and tricolour ribbons.